Flowers in Art from East and West

綺霞
花漫結羅
帶葉新裁
筥

Flowers in Art from East and West

PAUL HULTON AND LAWRENCE SMITH

Published for the Trustees of the British Museum by BRITISH MUSEUM PUBLICATIONS LIMITED

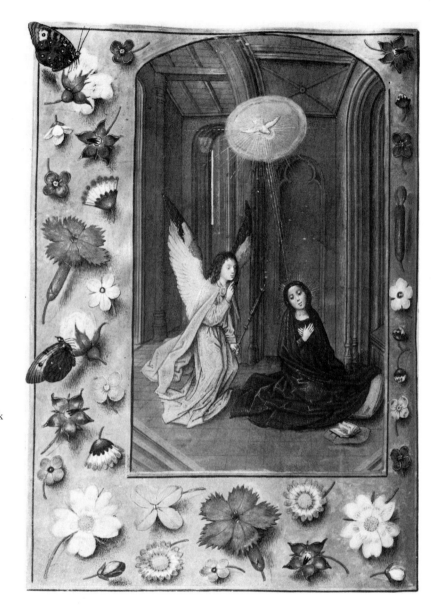

Cover picture: Section of sixfold screen in ink
and colours on gold paper, by Nakamura
Hōchū, *c.* 1800.
Right: Annunciation, with borders of floral
motifs. From the Hastings Hours *c.* 1480.
©1979. *The Trustees of the British Museum*
ISBN 0 7141 0098 6 cased
ISBN 0 7141 0099 4 paper
Published by
British Museum Publications Ltd,
6 Bedford Square, London, WC1B 3RA
Designed by Roger Davies
Printed in Great Britain by
Jarrold and Sons Ltd. Norwich and London.

Contents

Acknowledgments

The production of this book has been greatly assisted by the generosity of Mr Paul Mellon, to whom the authors are very grateful.

We would also like to thank the many people who gave such valuable assistance in the preparation of the book. In the European section Mr Paul Goldman (Prints and Drawings Department, British Museum) helped in

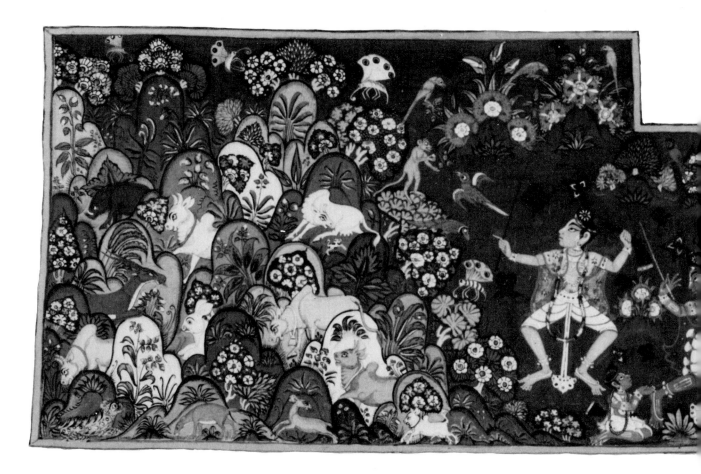

acquiring the photographs, and we are grateful to Miss M. Holloway for her assistance with the typing and the proof-reading. We should also like to thank the following people for their generosity, help and advice in producing the illustrations: Mr Paul Mørk (Department of Ethnology, National Museum of Denmark); Mr J. R. Cowell (Secretary of the Royal Horticultural Society); Mr P. Stageman (Lindley Library, Royal Horticultural Society); Mr David Scrase (Department of Prints and Drawings, Fitzwilliam Museum); Mr H. Berkley (Department of Prints and Drawings, Victoria and Albert Museum); Professor Otto Pächt (Vienna); Dr Eckhart Knab and Mr Erich Lünemann (Graphische Sammlung, Albertina, Vienna); Mr M. J. Rowlands (Library, British Museum, Natural History) and his colleagues of the Photographic Section; and Miss P. Edwards (formerly Librarian, the Botany Library, British Museum, Natural History).

Almost every member of the Department of Oriental Antiquities in the British Museum has helped in some way with this book, but we are particularly grateful to Jessica Rawson, Roderick Whitfield, Wladimir Zwalf, Michael Rogers and Robert Cran for the bulk of the academic information on Islamic, Indian and Chinese painting. In addition, the following have been generous with both information and help in obtaining photographs: Norah Titley and Jerry Losty (Oriental Manuscripts and Printed Books, British Library); Derek Turner and Tom Pattie (Department of Manuscripts, British Library); Oliver Impey (Ashmolean Museum, Oxford); Robert Skelton (Victoria and Albert Museum); Nicholas Conran; Jack Hillier; Beatrix von Ragué (Museum of Far Eastern Art, Berlin); Wen Fong (Metropolitan Museum of Art, New York).

Special thanks are due to Prof. William T. Stearn (formerly British Museum, Natural History) for identifying plants; and to Mrs Paul Hulton and Mrs Lawrence Smith for enduring domestic dislocation.

The author and publishers are grateful to the following people and institutions for permission to reproduce the photos listed below. Figures in bold type refer to colour plates.

By gracious permission of Her Majesty The Queen 11, 12; Albertina Collection, Vienna 9; Bodleian Library, Oxford 5; British Library, London 3, 6, 7, 8, 8, 9, 10, 13, 14, 15, 16, 17, 18, 19, 19, 20, 20, 21, 22, 23, 23, 24, 24, 25, 26, 27, 29, 30, 33, 34, 37, 39, 40, 41, 45, 47, 48, 49, 50, 51, 66, 67, 113, 114, 115, 116, 117, 118, 119, 120, 121, 122, 123, 124, 129; British Museum (Natural History) 15, 16, 17, 35, 36, 38, 40, 41, 42, 43, 44, 46, 53; Danish National Museum, Copenhagen 32; Fitzwilliam Museum, Cambridge 38, 39, 128; Verlag Paul Haupt, Berne 50; Jack Hillier Collection 74, 76, 82, 99, 100, 102, 104, 105, 106, 108, 109, 110, 111; Istanbul Museum of the Topkapy Saray (photo Erkin Emiröglu) 4; Kunsthalle, Bremen 10; Lindley Library, London 37, 47, 52, 54, 130, 132; Mr and Mrs Paul Mellon 12; Metropolitan Museum of Art, New York 92; Musée des Antiquités, Rouen 6; Museum of Far Eastern Art, Berlin 1 (photo K-H Paulmann), 84; National Gallery, London 7; National Library, Vienna 2; Private Collection 81, 87; Royal Library, Brussels 11; Uffizi Gallery, Florence 45; Urs Graf Verlag, Zürich 14, 125; Victoria and Albert Museum, London 26, 46, 49, 51, 54, 57, 61.

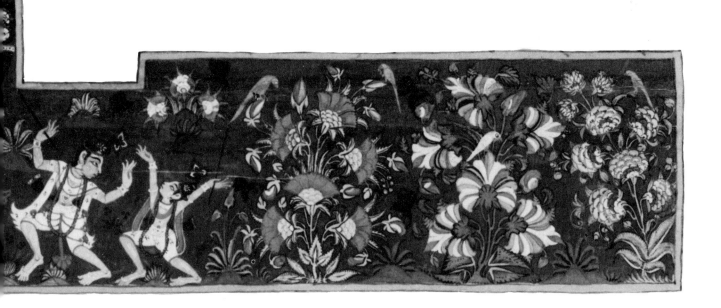

colte de la uigna e po meterli unto fugo cum un cado obauo. Oriadoduo
uen fura questa lagrema a muo fuoorellba uertu demorcare le ueruçe
che uen chiama mituuçe. La uertu de la cenoere. de questa uenceia e oela
cenoere oele graffe oe lauua oe questa quando fen fa enplaftro cum

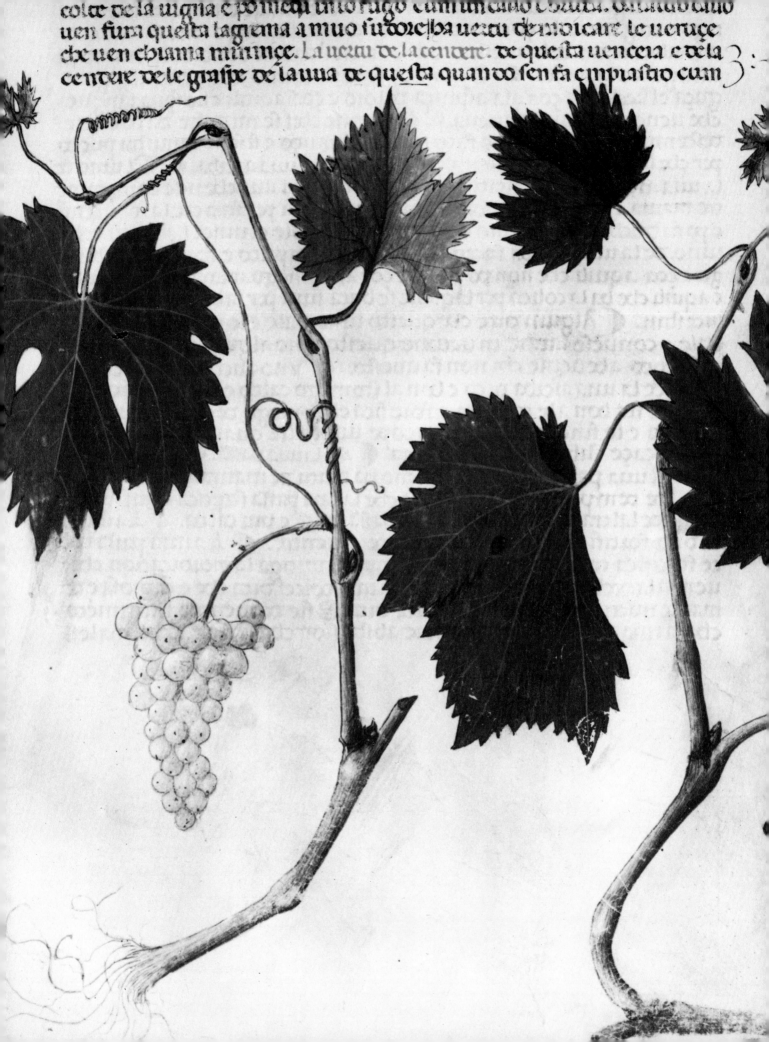

Introduction

Flowers in Art from East and West is a title in need of some explanation and definition. 'Flowers in art' is here used to mean plants and trees of all kinds – nearly always individually distinguishable ones – represented in paintings (except oils), drawings and prints. Oil painting has been excluded as it has not formed part of the basic collections of the British Museum and the British Library and in fact has had little to contribute to the recording of plants, an idea central to the kind of art discussed in this book. For the same reason the flower-piece, so much a feature of seventeenth-century Dutch oil painting, and a genre on its own, is not considered here.

Sculpture, ceramics and other three-dimensional forms of art and the wide field of applied floral decoration have not been taken into account as they would extend the range of this book far too widely. In European art this distinction is easier to draw than in that of Asia, where specifically scientific, botanical representation of plants is much rarer. But even in Asia it is often surprisingly clear whether the artist has used plants simply as decorative motifs or whether he has chosen them out of affection for and interest in them. When he has taken the latter course, then almost inevitably he has studied the growth, structure and individual characteristics which make those plants recognizable, and has successfully communicated them in his art.

This is as far as we wish to take the distinction between the words 'naturalistic' (or 'realistic') and 'decorative' which are used frequently in this book. We are aware, of course, that 'naturalistic' can in any case be only a very relative term in two-dimensional art. The artist is, after all, producing an illusion of a three-dimensional plant on a flat surface and usually in reduced scale, however lifelike he may persuade us his work is.

For this reason we adopt an arbitrary definition. When we speak of 'naturalistic' flower painting we mean that the artist *looked* at and *analysed* that flower before working, or while working; that he was trying to convince his viewers, by the use of more cunning and more considered techniques than his predecessors had used, that they were seeing the flower more 'really' rendered than before, and that they in turn accepted his claim. Of course, the acceptance depended on the particular culture. In Europe, for example, 'real' often meant accurate detail of structure, while in China and Japan it meant more the sense of the plant's being alive.

We have thus eased our own task at the expense of exploring the crucial

rôle played by plant motifs in formal decoration in all the cultures we discuss. Floral interlace in European medieval manuscript illumination, Islamic floral arabesque decoration, lotus scrollwork in East Asia and other subjects of that kind are too complex to be included in a short book with the already wide scope of this one.

We have taken 'East and West' to refer to the Old World. All the artists mentioned come from Europe and Asia. We felt that to talk of 'The World' when we had very little to represent the continents of Africa, North and South America and Australasia would be rather less than truthful. However, in one sense flowers of the whole world are the subject of this book, for in chapter four we describe some of the European artists who from the sixteenth century up to the present have explored and recorded the flora of the globe.

The omission of the botanical or floral art of certain areas of Europe and Asia was inevitable, usually because of lack of information. It is always dangerous to assume lack of achievement without very thorough knowledge, and for that reason we have left Eastern Europe and South-East Asia until there are more adequate materials available for informed discussion. Korea is omitted partly because of incomplete information and partly because so little has come down to us from her ravaged past, including painting of the last five centuries. There is no doubt, however, of the importance of Korea in early woodblock printing and in floral painting, which had a still unacknowledged influence on Japanese art in the Edo Period. The Koreans were the great herbalists of East Asia, and it is a pity more of their herbal prints and drawings do not survive.

The study which has gone into making this book has revealed that each of the three main areas described in it are dominated by one mode of floral art. In Europe it has been scientific and analytic; in Western Asia and India it has been decorative and hedonistic; and in East Asia, aesthetic and even philosophical. By 'aesthetic' is meant having the pretensions of high or serious art. The scientific bias of European floral art from the seventeenth century onwards is one of our major themes. The very close link between the science of botany and the artists who depicted plants resulted in ever greater demands for minute accuracy. It is hoped that these generalizations will not blind the reader's eyes to the fact that in all three areas all three attitudes were at certain periods to be found together. But in each of them there was certainly a dominant approach which, once realized, helps to explain why the art was as it was.

Flowers have been very lucky in the world of art. On the whole those who have painted and drawn them have enjoyed them, whatever their object in depicting them. Flowers have mostly escaped the attentions of artists who wished only to express themselves. Only among the scholarly ink-painters of China were they the subject of high art seeking to express a personal vision; but these artists painted in a medium so wonderfully disciplined and with such genuine love for their subjects that the flowers and trees were even enhanced by it. Skilful floral art is relaxed, objective and joyous, and those who study it must be considered almost as fortunate as those who create it.

Flowers in Art from East and West

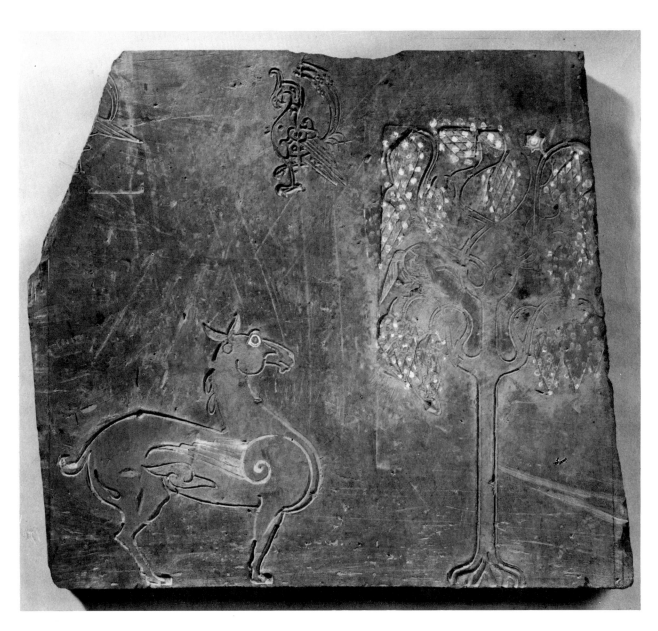

1 Pottery tile from Chin-ts'un. China, 1st century BC.

1
Naturalism in Sung China

In Europe in the later Middle Ages we shall talk of a 'Rebirth of Naturalism', a revival, that is, of something which had existed much earlier in the classical world, but which was then lost. In China, however, a very high level of naturalistic painting was reached in the twelfth and thirteenth centuries in the 'bird-and-flower' paintings which have remained famous down to the present day. They did not appear suddenly. Rather, they were the climax of a certain sort of art which Chinese civilization and thought made almost inevitable once the right techniques were found. The perishable materials (mostly silk) on which these early paintings were done have caused us to lose all but a few floral works from before the Sung Dynasty (AD 960–1279), but we have enough evidence to show that from at least as early as the Han Dynasty (206 BC–AD 220) there was a very lively interest in the natural world which was gradually being recorded in art.

A splendid pottery tile, for example, from Chin-ts'un and datable to the first century BC is incised with a horse and a flowering tree (1). Both horse and tree already have that special East Asian quality of expressing in line how a living thing moves and grows. Here it is perfectly clear how the tree develops from its roots and divides into intertwining boughs, and the skilfully placed dabs of white pigment make it obvious to us two thousand years later that it is a tree in blossom.

This calm sympathy with the world of nature was very characteristic of China. It arose partly from philosophical, religious and political ideas which were themselves a reflection of national temperament. The most important of these were the shamanistic practices and the philosophies of nature which by the third century AD came together as Taoism; the Confucianist political philosophy, which dominated every succeeding dynasty of the Chinese Empire from the Han onwards and the imported Buddhist religion, which, from when it reached China in the first century AD preached that people should humanely respect the forms of life around them. All of these saw the human race as part of nature and in harmony with it, not dominated by it, nor controlling it. Even mountains had their 'dragon veins' of life in them. Artists therefore sought to understand their subjects, not to analyse them, nor, at least until a much later date, to prettify them. From this comes the strong sense in many Chinese paintings of flowers, animals or even landscapes, that the artist has somehow conveyed the essence of the subject.

As seen in the tile, much of this feeling already existed in the Han Dynasty. There is a striving towards naturalism in agricultural scenes painted on bricks in tombs of the third century AD recently excavated at Chia-yü-kuan in Kansu Province which is reminiscent of later European illuminated manuscripts such as the English fifteenth-century Luttrell Psalter in the British Library. In the succeeding Six Dynasties period (AD 221–589) we hear of the first painters on silk and paper, like Ku K'ai-chih (fourth century). No works of this period survive, but the famous eighth or ninth-century copy in the British Museum of Ku's handscroll illustrating advice to court ladies, although it lacks floral portraits, shows that he already had most of the techniques in brush, ink and colour to depict living things in a living manner. The earliest surviving scroll painting from China

2 *right* The Bodhisattva Kuan Yin on a throne in a lotus pond. Anonymous painting. China, 9th–10th century.

3 *far right* Bodhisattva among lotus scrolls. Ink rubbing of a carved stone stele from Pei–lin. China, AD 736.

of a landscape is *Spring Excursion* by Chan Tzu-Chien (AD 581–618) in the Palace Museum, Peking, a work full of atmosphere and entirely confident in its handling of trees in ink outline and colour.

Ink outline filled in with colour was to remain one of the standard conventions in China, as in Europe, India and Western Asia, for drawings of plants. We can see it in a Buddhist painting of the early tenth century (2) from Tun Huang in Chinese Central Asia, where the merciful Buddhist divinity Kuan Yin is seated on a lotus throne by a lotus pond, with bamboo growing nearby. This is a provincial work, but the ever more confident use of line in metropolitan T'ang China survives in the tall, elegant figures of tomb paintings, such as that of Prince Li Chung-jun (died AD 701) where the trees are drawn with complete assurance. It is also reflected in the sinuous, naturally detailed yet formally patterned twining lotuses in a Buddhist *stele* (standing stone) from Pei-lin dated AD 736 of which we illustrate an ink rubbing (3). Rubbings from inscribed and incised stone monuments form part of the Chinese print tradition and will be mentioned in chapter eight.

At the same period a delight in plants for their own sake, a characteristic of stable and advanced urban civilizations, shows itself in their lighthearted use as decorative motifs, strewn round the borders of ninth-century bronze mirrors, for example (4). The mock-careless placing of these flowers

4 Bronze mirror decorated with birds and sprays of flowers. China, 9th century.

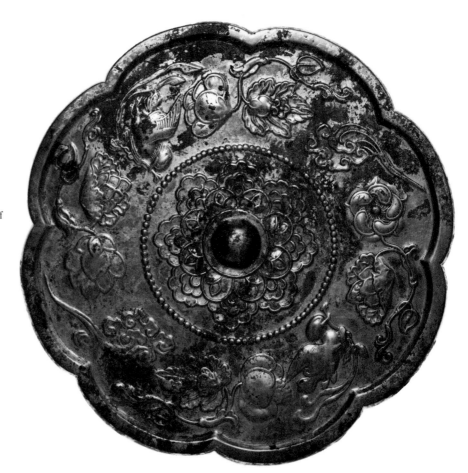

strongly anticipates a similar stage in fifteenth-century Europe in the 'strewn flower' borders of the Burgundian manuscript decorators.

It is natural therefore that we first hear in the T'ang Dynasty of individual artists famous for their skill in animals, birds or fish. One of these is Han Huang (723–87). A handscroll on paper of five remarkably lifelike bulls survives in the Palace Museum in Peking. The setting up of an Imperial Academy of painters in the eighth century was a development only to be expected in the highly centralized court and capital of the world's greatest empire. In this Academy flourished the earliest great flower painters, but their works have not come down to us, though we can be confident that

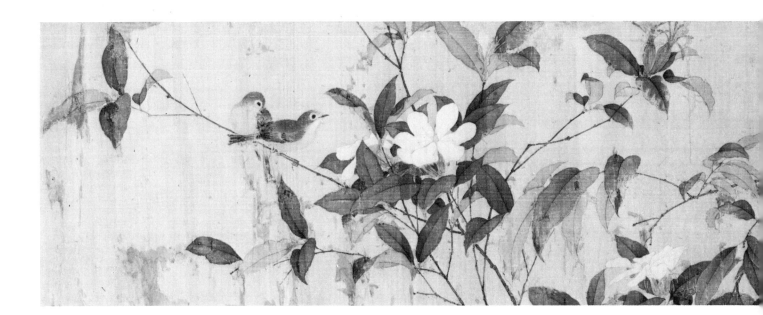

5 Gardenia and birds. From a painted handscroll attributed to the Emperor Hui Tsung (reigned 1101–26). China, 13th century.

they reached as high a level of skill and naturalism as Han Huang did.

When the T'ang Empire broke up into separate areas (the Five Dynasties Period, 907–60), the idea of court painters remained. In two of those courts flourished the artists later acclaimed as the ancestors of the two central styles of coloured flower painting. Huang Chüan at the court of Shu developed the style using ink outline and detailed and brilliant colour. Hsü Hsi at the Southern T'ang court preferred to work in quieter and subtler washes of ink and colour.

The long centuries of improving technique, increasing interest in nature and ever greater official encouragement resulted in a splendid age of flower and bird painting under the Sung Dynasty (960–1279). This was a long period, and there were many changes of theory and direction among the painters during it, the biggest being the move of the court south of the Yangtze River in 1127 to escape from the nomadic invaders from the North (Southern Sung Dynasty 1127–1279). But through it there remained an ideal of faithfulness to nature by the use of fine line and refined colours in the

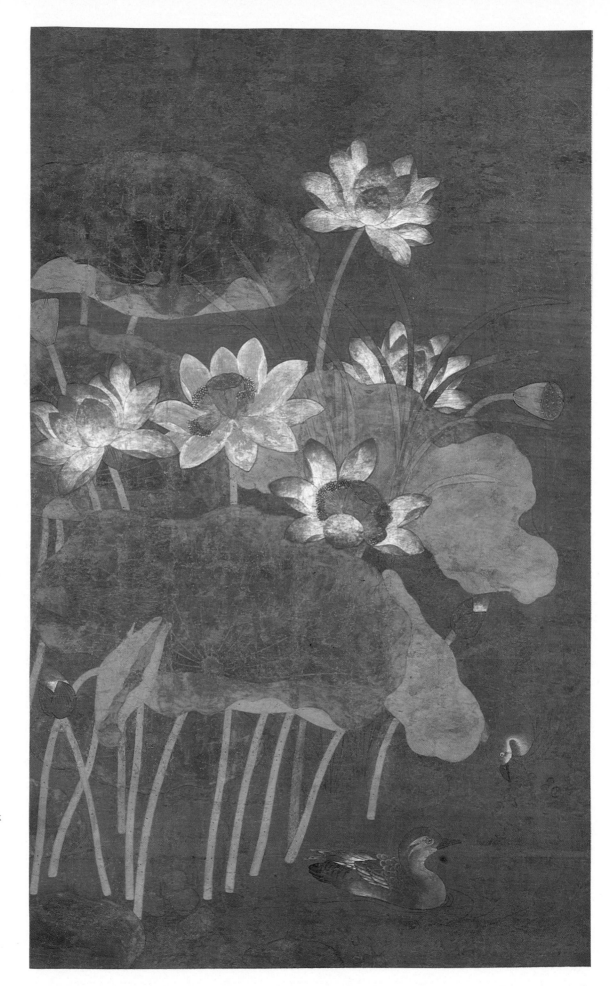

1 Sacred lotus, *Nelumbo nucifera*, with ducks in a pond. Hanging scroll in ink and colours on silk, by an anonymous artist, China, probably P'i-ling, Kiangsu Province, 13th century. Painted area 1280 × 780mm.

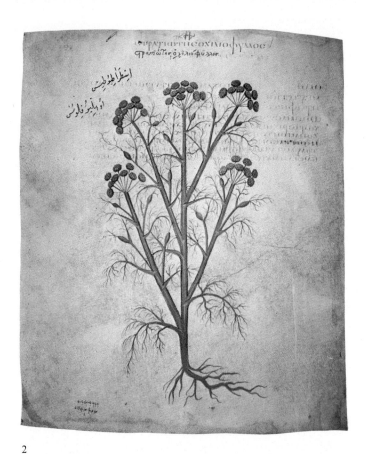

2

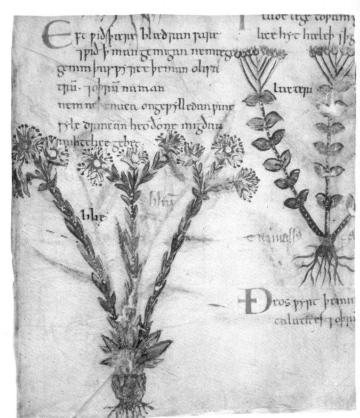

3

4

5

2 *Ferula* sp. By Krateuas (?) from Dioscorides, *Codex Vindobonensis*, AD 512. 365 × 310 mm.

3 Lily, fanciful, *Lilium candidum* (?). By an anonymous artist from an Anglo-Saxon MS., *c.*1050. 259 × 192mm.

4 Grape-vine. *Vitis vinifera*. Gouache on paper by an anonymous artist, from a manuscript of Dioscorides, *De Re Medica*. Iraq, AD 1229. 235 × 195 mm.

5 Bramble, *Rubus fruticosus*. By an anonymous English artist, from a Bury St Edmunds MS., *c.* 1120. 245 × 183mm.

manner of Huang Chüan, whose style was approved by the Imperial patrons. Hui Tsung (reigned 1101–26) was the greatest aesthete and patron of the arts of all the Chinese emperors. He particularly loved 'bird-and-flower' paintings, and the records of his collection report over 2700 works of this type, amounting to more than one third of the total. The term 'bird and flower' is used, although it would be more accurate to say 'birds, insects and flowers', because it was quite rare, though not unknown, to show a plant without any accompanying birds or insects, or indeed birds without a flowering bough or some other form of plant life, to set them off.

Hui Tsung's enthusiasm extended to teaching his court painters personally and awarding prizes to those who had depicted them most accurately from observation. He also painted very competently himself, and it was therefore natural that a great many paintings came to be attributed to him. One of these is the splendid handscroll (5, plate 27), which is in fact a work of the thirteenth century from the Southern Sung Court, but which Hui Tsung would surely have approved of. It depicts on a plain silk background boughs of a flowering gardenia tree and fruiting lichees. Their intertwinings are so carefully worked out and the details of the blooms, leaves and twigs are done with such precision and naturalness that one almost forgets this is a painting which, because it is flat, must use artificial conventions. There is an intensity in the artist's contemplation which distinguishes the Sung painting from later decorative flower-and-bird works of East Asia, and is rarely touched in Europe's more scientific tradition, though we shall find it again in the pure-ink artists of China and Japan (chapter seven). When we look at this handscroll we feel in the presence of nature herself. That this is an illusion is proved by the artifice of using black outline which after all does not normally appear in nature; but the artist's conviction carries us with him.

This intensity is yet more striking in a lotus painting (plate 1) in the form of a large hanging scroll in the Museum of East Asian Art in Berlin. This is also from the thirteenth century, and was probably preserved in a Japanese temple where it was taken by a visiting monk. A number of lotus paintings have been kept in this way, and one may suspect that they were painted with at least half a religious intention. The lotus is the central symbol of Buddhism, raising its pure and brilliant blossoms out of the mud of the swamp as the Buddha's pure doctrines grew out of this imperfect world. In this example the glow of the flowers is so overwhelming that their precision is almost overlooked. But it is this faithfulness to nature that makes them live. Lotus paintings continued to be done in later periods, but their religious significance was not enough to replace the vitality lost when artists no longer observed the original plants. In the Sung works, there is always a sense of natural movement, of space being created by the images on the silk or paper. This was partly lost in the decorative styles which developed in the Ming Dynasty, although there always remained in Chinese floral painting some sense of life and movement.

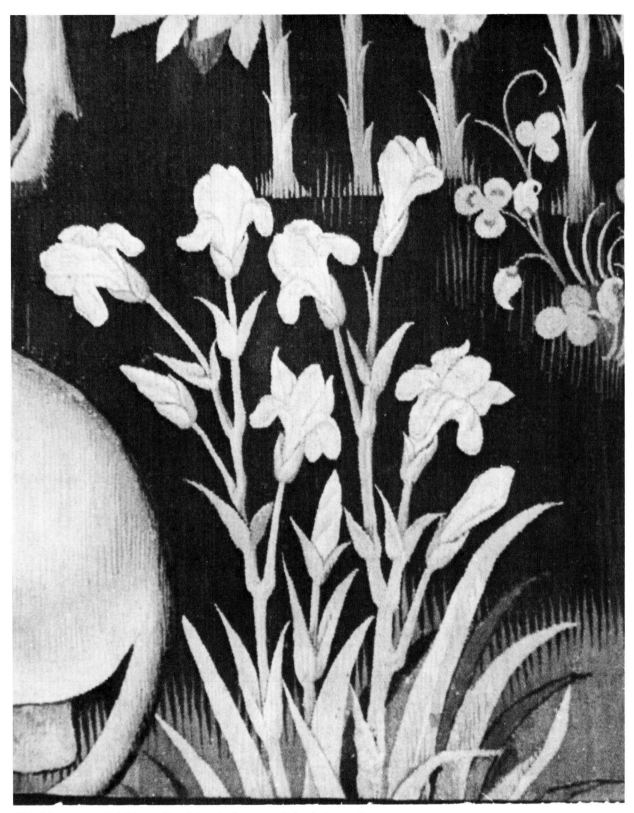

6 Iris, *Iris germanica*. Detail from a French tapestry known as *Cerfs-volants, c.* 1460.

2
The rebirth of naturalism in Europe

Though in Europe no drawings of plants have survived from antiquity there is little doubt that plant portraits were made to illustrate books on plants in the Ancient World. The Elder Pliny, author of the *Natural History*, who lived in the first century AD, mentions the names of artists who drew plants in colour for herbals a hundred years before his time. The existence of a manuscript volume of nearly four hundred remarkable coloured drawings of plants seems to bear out Pliny's evidence. This famous manuscript, in the National Library, Vienna, and known as the Juliana Anicia Codex or *Codex Vindobonensis*, contains the *De Materia Medica* of Dioscorides, Pliny's contemporary, which is principally concerned with the healing properties of plants. But the drawings rather than the text give the volume its special significance (plate 2). Though uneven in quality many of them are so strikingly naturalistic that the identification of the plants generally presents no difficulties to the modern botanist. The illustrations were made in 512 AD in Constantinople but stylistically have nothing in common with the known products of early Byzantine culture. There is little doubt that they were copied from Hellenistic models and are perhaps the work of Krateuas of the first century BC, one of the artists mentioned by Pliny. These copies were themselves copied again and the images repeated in manuscripts found in many different parts of western Europe giving an ever fainter reflection of the quality and naturalism of the originals. This attempt to hark back to classical models, to preserve a tradition rather than to observe afresh, was characteristic of earlier medieval times.

It seems that the naturalistic representation of the living world in past history is found in urban civilizations which had reached a certain level of refinement and stability – the Minoan, the classical Greek, the Hellenistic civilization of Alexandria which so strongly influenced the Roman world, the Chinese from Han to the Sung Dynasties. With the break-up of the Roman Empire and the long unsettled period of the barbarian invasions this naturalistic tradition was largely destroyed. It may have lingered on in a few isolated areas of southern Europe where Roman remains with their elements of naturalistic sculpture were still comparatively common. Only in the tenth and eleventh centuries with the establishment of the Benedictine Order, in particular the monastery of Cluny and its sister houses in France, did conditions become suitable for some revival of naturalism, dependent as it was on the observation of nature. Within the monastery walls, where the necessities and securities of life could again be taken for granted, the contemplation of nature became part of the contemplative life. Natural objects were often thought of as symbols of spiritual realities and plants with their short-lived beauty especially so – the rose as an image of the passion of Christ, the vine as a symbol of life, the apple as the emblem of knowledge and so on.

From the contemplation of plants as symbols to the observation of plants for their own sake was a short and certain step. Naturalistic decorations in church architecture began to appear and foliage, birds, animals and plants are found carved on the capitals of pillars and in mouldings, some of them strikingly realistic. This use of naturalistic motifs in architecture was extended to the Gothic cathedrals and smaller churches of the thirteenth

9

century, especially in France and England. Less easy to explain is the comparative rarity of naturalistic imagery, including figures of plants, in manuscript illumination of the same period. For the work of the illuminator was by its nature peculiarly limited by tradition and obeyed its own laws of development. An essential part of the artist's training must have been the study and copying of earlier examples of the illuminator's art. Whereas the plants illustrated in medieval herbals were nearly always traditional and stylized, the leaves of many of the same plants could, at the same period, be found more realistically treated in church carvings. Of course it is true that there must always have been artists who needed to look afresh at the plants they drew. For example, we discover in an Anglo-Saxon herbal of the middle of the eleventh century (British Library, Cotton Vitellius C. iii) drawings showing some understanding of plant form and structure. Some species included in this manuscript are of Mediterranean origin and the drawings may therefore have been taken from an Italian model. Yet the artist draws as if he had first-hand experience of at least some of his subjects (plate 3), even though he often introduces fanciful elements.

To move from the fear of nature to its contemplation, then to an appreciation of its diversity, and finally to an indulgent enjoyment of the pleasures of the natural world betokened a profound transformation of man's outlook in the West. Such a change was becoming apparent by the fourteenth century. It was as if man had discovered a garden in nature where before there had been a hostile wilderness. And certainly an essential element in the formation of this new outlook was the man-made garden. It existed in the earliest monastic houses to provide food and medicines but by the fourteenth century, as a planned part of monastery and castle, it was also planted with flowering plants for enjoyment. Charles VI of France at the end of the fourteenth century planted red and white roses, lilies, irises and laurels in the garden of his Hôtel Saint-Pol. Gradually plants were brought inside such buildings in the form of motifs in paintings on walls or in embroideries or tapestry hangings. The paintings have disappeared but tapestries such as the *Cerfs-volants* (Rouen, Musée des Antiquités; ill. 6) show not only beautiful but extremely lifelike designs of flowers and plants. This pleasure in gardens is reflected in the characteristic theme of later medieval art, the *hortus conclusus* – the small enclosed garden where the pleasures to be discovered were both mystical and sensuous. This was an idea which perhaps originated in Persian miniature but its acceptance and expansion in the West was the result of a new consciousness of the beauty of flowers, this in addition to their long-felt value economically or medicinally. Not surprisingly with this awareness came a renewed interest in the identity of plants and in the characteristics which make one class of plant different from another. Earlier even than the fresco or easel-painter the miniaturist by the middle of the fifteenth century was moving towards the modern conception of landscape. The highly naturalistic landscapes in the *Très Riches Heures*, executed for Jean, duc de Berry by the brothers Limbourg early in the fifteenth century, include birds and animals illustrated with keenly observed realism and there is a border of flowers drawn more or less from nature. In the work of the Van Eycks and other early Flemish painters,

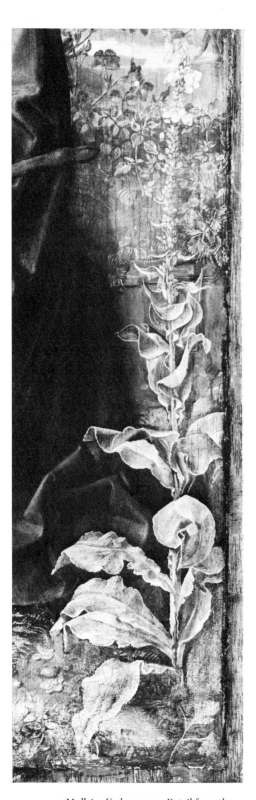

7 Mullein, *Verbascum* sp. Detail from the painting, *St Giles and the Hind*, by the Master of St Giles, *c.* 1500. Approx. 235 × 40 mm.

within a generation or two of the Limbourg miniatures, there appear individual flowering plants fully observed and painted in loving detail (7). At least fourteen readily identifiable species are shown in the meadow of the *Adoration of the Lamb* in the Ghent altarpiece, while in Jan van Eyck's *Rolin Madonna* flowers appearing as in a window-box beneath the opening of the central arch are treated with the same detailed care as the elements of the extensive landscape behind. This suggests that careful studies of plants were being made well before this time.

Perhaps the most powerful as well as the earliest stimulus to the observation and portrayal of individual plant species came originally from southern Italy. The impulse to formulate theories based on the observation of the natural world which was so characteristic of Greek thought had become almost extinct in medieval Europe. It was thwarted by a religious and social organisation where the free communication of the ideas of the individual was severely limited by authority and tradition. But the scientific thought of the Greeks, including Greek botanical writings, had been kept alive by Arabic scholars in the formerly Greek centres of the Near East, since the influence of Islamic culture which followed the Arab invasions of the Mediterranean lands persisted over a long period. Through Arabic translations and commentaries Greek thought entered into southern Europe, in particular the teachings of Greek philosophy and natural science. Salerno, in the Norman Kingdom of Sicily, in the late eleventh century became a renowned centre for the study of medicine, a study which made necessary the understanding of plants from which medicines were obtained. Only by means of illustrations could the identity of plants be made clear and only by observation could their portrayal achieve any real accuracy, although the necessity for this was not at first understood. It was earlier thought that original Greek texts with illustrations, where they existed, or Arabic translations with copies of such illustrations, available perhaps in ancient libraries like that of Monte Cassino, might suffice. But gradually these transmitted images, formerly unquestioned, began to be corrected from the observation of actual plants.

The growth of this new empirical attitude favoured not only botany but also the study of the natural sciences in general. An example of this transformation of outlook and practice was the thesis on falconry produced at the court of Frederick II where the influence of Arabic thought was strong. This work was illustrated by lifelike studies of hawks which relied for their effectiveness on the artist's keen eye rather than on any established tradition of bird drawing. There were no contemporary examples of plant drawings of the same quality or realism. Padua later succeeded Salerno as the most advanced centre of medical studies in Europe and from an anonymous Paduan artist came the first book of plants we know of with illustrations which are entirely convincing in their naturalism. This artist's patron was Francesco Carrara, the last lord of Padua, who died in 1403, and the volume was probably produced several years before 1400. The herbal is a translation of an Arabic text on medical botany (British Library, Egerton MS 2020). There are several striking features about the illustrations: the artist's innate sense of design in relation to the page of written

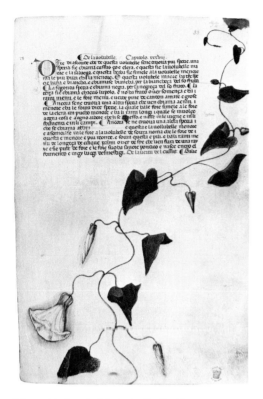

8 Large bindweed, *Calystegia silvatica*. By an anonymous Paduan miniaturist, from the Carrara Herbal, *c.* 1400. 350 × 235 mm. Egerton MS. 2020, f. 33 *r*.

9 Common honeysuckle, *Lonicera periclymenum*. By an anonymous English artist, from a surgical treatise and herbal, 15th century. Pen and brown ink. 310 × 210 mm. Add. MS 29301, f. 52 *r*.

text; the high artistic quality of the figures themselves drawn with great economy and with a most sensitive line; the understanding of the form and habit of each plant which is clearly based on the artist's unusual powers of observation (8). Hitherto plants had been illustrated from dried specimens laid out for instruction, roots and all. Now for the first time the plant was pictured as it grew in the soil, in colour, with its imperfections as well as its beauty apparent. The miniature of the violet (plate 6) is characteristic of the artist's particular skills. Unfortunately the manuscript has many blank spaces which were intended for illustrations. About a century was to pass before these studies from nature were equalled or excelled. But in the fifteenth century the practice of drawing and painting plants from the life became gradually more widespread and found its main centres of activity further north, particularly in Flanders and France. It is interesting to find that England, often considered to be out of the mainstream of European artistic developments, was part of this new movement. A volume of medical treatises in Latin and English of about 1450 (British Library, Add. MS. 29301) is illustrated with sixty-eight figures of English plants drawn with economy and a fine sense of design. They also show considerable understanding of the plants portrayed, as for example the honeysuckle ('wodebynde'; ill. 9).

In Flanders the use of flowers in the border decoration of manuscripts became throughout the century increasingly ornamental but also increasingly realistic. It culminated in the 'strew pattern' borders of the school of the so-called Master of Mary of Burgundy of which a particularly fine example is the *Hastings Hours* (British Library, Add. MS. 54782; ill. 10), and the miniatures of the Ghent-Bruges school produced in the last decades of the century (plate 7). Here the flower heads of iris, borage, columbine, pansy, pea, pink, lily, violet, and of course rose – all favourite garden plants – were treated in exquisite detail of colour, form and texture. Though the objective was a highly sophisticated piece of decorative design the illusion of reality was enhanced to a degree rarely excelled, in the best examples, by the work of eighteenth- and nineteenth-century botanical draughtsmen. But more significant in the long history of the flower portrait is the work of the French miniaturist and court painter, Jean Bourdichon. His *Hours of Anne of Brittany* (Paris, Bibliothèque Nationale, MS. Latin 9474), dating from the first decade of the sixteenth century, contains nearly three hundred and fifty plants, many of them framed by upright rectangles in the outer margin of the text. They are less naturalistic in colour and form than the best of the Flemish flower miniatures but unlike them portray the whole plant. They possess a strong sculptural quality, are painted in opaque pigments and stand out against a gold ground on which are cast *trompe l'oeil* shadows. Though compressed in their rectangular frames and somewhat formalized they bring out in an entirely new way the individual character of the species. It does not seem to matter greatly that the colours are not always true to nature. Bourdichon's pleasure in setting out this extraordinary and abundant display of plant portraits, each with its own name in Latin and French, is obvious. This volume has been called the first florilegium though it has to be remembered that the plants are a secondary

10 A border of floral motifs, from the Hastings Hours. School of the Master of Mary of Burgundy, *c.* 1480. 165 × 120 mm. Add. MS 54782 f. 73 *v.*

element in the devotional designs of the illuminator. Similar work by Bourdichon or his studio is found in other manuscripts, as for example the clover from one in The British Library (Add. MS. 18855: plate 8).

At about the same time that Bourdichon was painting his elaborate miniatures in the first years of the sixteenth century, the plant study was suddenly brought to maturity by Dürer. The two artists seem worlds apart. While Bourdichon's plants were understandingly observed their presentation was limited by the traditions and techniques of his school. In contrast Dürer's plants are seen in the full light of nature, analysed by an eye apparently unblinkered by tradition, the demands of patronage, or the purpose in mind. As an artist he was attracted by every natural form – trees, animals, rocks, rivers and lakes, clouds and all the elements which make up a landscape. He was equally inquisitive about the small plant forms which inhabit the microcosm of a clod of grassland. His study known as *Das grosse Rasenstück* (Albertina, Vienna; plate 9), the large piece of turf, is arguably the most remarkable drawing of plant life in its natural setting ever made. His worm's-eye view of blades of grass, seedheads of grasses and dandelion, leaves of dandelion, plantain and yarrow rising above water in full spring growth is portrayed with feeling and absolute mastery. The iris (Kunsthalle, Bremen; plate 10), drawn a few years later in 1506, is a true plant portrait in which Dürer's instinct for recognizing and expressing with masterful precision the plant's idiosyncrasies of habit is evident at a glance.

While the return to naturalism might seem complete by this time it is something of an illusion fostered by the genius of one artist. The movement was in fact developing sporadically and was not complete until the science of botany compelled the artist to rely entirely on his own skill, knowledge and powers of observation and that was many years in the future. One curious aspect of the movement was the comparatively small part played in it by many of the more famous Italian artists of the fifteenth and sixteenth centuries. Few studies of plants by any of them have survived although Antonio Pisanello must surely have made many such studies since he produced convincing drawings of animals, though only a few rather formal sketches of plants (Louvre) are known by him. Sculptors like Lorenzo Ghiberti, Donatello and the della Robbias introduced flowers and fruit into their work and these must have been based on naturalistic studies but none of these now survive. Jacopo Bellini has left a well-known study of an iris in watercolour (Louvre) comparable to that of Dürer and made about fifty years earlier but there is little else before the time of Leonardo. As the study of classical thought and literature advanced in Italy in the fifteenth century, the remains of classical antiquity occupied an ever more prominent place in the mind and imagination of artists. The preponderance of the human figure in statues and bas-reliefs accounted for a preoccupation with the body, particularly with the nude. This idealistic view of classical antiquity made the simple observation of things as they are unfashionable if not virtually impossible. Michelangelo's disdain of Flemish landscape is well-known – 'no proportion, no symmetry, no selective care, no greatness'. To quote Sturge-Moore, Michelangelo 'brushes aside the beauty of flowers, of trees, of gardens … in order to insist that the nature of virtue is action and

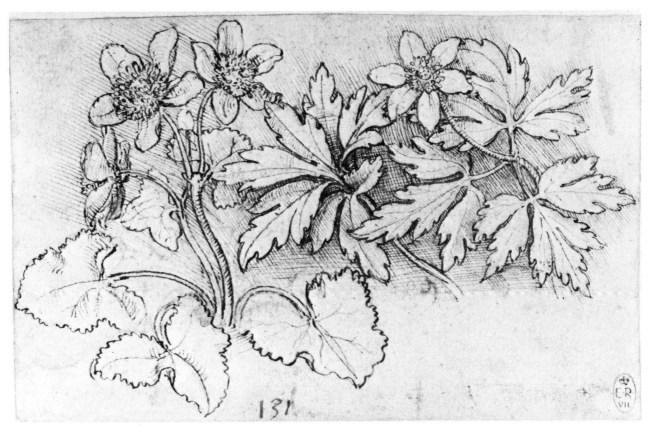

11 Marsh marigold, *Caltha palustris* and wood anemone, *Anemone nemorosa*, by Leonardo da Vinci. Pen and ink and black chalk, *c.* 1505. 85 × 140 mm.

the symbol of action the naked human body.'

As in so many other respects Leonardo's ideas were an exception to these widely held views. He was the author of the first treatise on landscape, and passages in the *Trattato della Pittura* show his keen enjoyment of natural beauty. Vasari's account of Leonardo suggests that he spent much of his time as a youth in Florence studying plant forms and the list of his works which he drew up soon after his arrival in Milan included 'many flowers drawn from life'. Only about thirteen such studies survive today. The most interesting of these were made in connection with the Leda cartoon in about 1506 – when Dürer drew the iris and close to the time that Bourdichon was executing his miniatures of plants. Unlike Dürer's, Leonardo's drawings are not complete plant portraits in themselves but the result of his exploration into the forms of plant life either for their own sake or for some composition he had in mind. This is true of the pen drawing of the marsh marigold and wood anemone with their sculptural quality and strong design (11). The red chalk drawing of a bramble (12) shows far more understanding of the plant's structure, habit and texture but the strongly drawn three-dimensional quality of the leaves again reveals Leonardo's preoccupation with form. The formal beauty of these and others of his plant studies and his equally convincing studies of trees where the use of light to enhance their form seems to anticipate Claude, only make us regret all the more the loss of so many of his drawings from nature. For Leonardo nature rather than man held the key to the universe. To his ceaselessly inquiring mind plants were no less important than other natural phenomena and their form and habit

of growth must reflect something of the laws of nature which he continually sought to discover and interpret. The re-creation of such forms in drawing, to be selected and given permanent shape in painting, was one of the objectives of his art.

By this time the printed book was beginning to reach a far larger readership than was ever possible for the manuscript. Tradition was already counting for less and the demand for naturalistic illustrations of plants was increasing with every year that passed. The herbals of Brunfels and Fuchs published in the first half of the sixteenth century made well-observed and well-drawn illustrations of plants widely available. The revival of naturalism had almost reached the stage where the identification of plants was beginning to develop into the science of botany.

12 Bramble. *Rubus* sp., by Leonardo da Vinci. Red chalk touched with white, c. 1505. 155 × 162 mm.

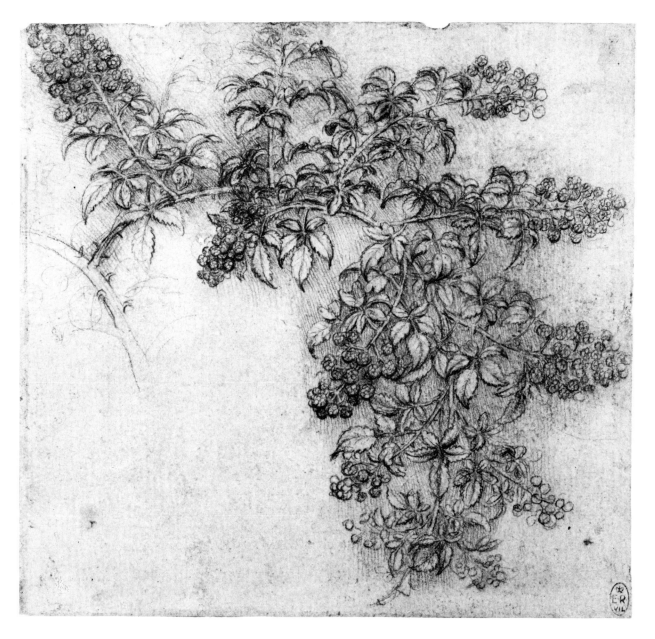

3
The herbal
tradition

13 Rue, *Rutus*, highly stylized. From an illuminated English herbal, *c*. 1200. 292 × 199 mm. Sloane MS 1975, f. 38 *r*.

The earliest English printed book (1525) containing information on plants defines the herbal as a book which shows and treats of the virtues and properties of plants. This emphasis had persisted since Greek times and it would be true to say that until a late stage in its evolution the herbal was valued chiefly for the information it gave about medicines and food. The purpose of illustrations, and not all early herbals were illustrated, was severely practical – to supply further means of identification where verbal descriptions alone were inadequate. The ancient pictorial tradition was never quite lost. This was largely the result of the excellent copies in the Vienna Dioscorides (plate 2) made at a time when the means and the will to reach back perhaps six centuries might have been thought to have died. Between the early sixth and the late twelvth and thirteenth centuries, when its revival in western Europe began, the herbal had degenerated into a poorly understood commentary on Greek or Roman prototypes which, if it was illustrated, showed figures which hardly resembled at all the living plants they pretended to portray (13). The *De Materia Medica* of Dioscorides in eastern Europe, and in western Europe a compilation of medicinal recipes by a certain Apuleius Platonicus, often called Pseudo-Apuleius, were the ancient authorities most often drawn upon in earlier medieval herbals. Stylized and almost useless as their illustrations had become for the purpose of identification, they at least kept alive the will to discover more about plants and their healing properties.

Occasionally the illuminator of these manuscript herbals seems to have turned his back on the lifeless derivatives he set out to copy to look afresh at living plants. As we have seen, this perhaps happened to the illustrator of the mid-eleventh century Anglo-Saxon herbal (British Library, Cotton Vitellius C. III). The illuminator of the early twelfth-century herbal produced at Bury St Edmunds in about 1120 (Bodley MS. 130) also seems to have drawn the local flora in place of his unintelligible models without reference to the order of the text of the manuscript he was copying. Here the bramble (plate 5) is a particularly good example of an illustration of a plant whose identity is clearly understood and expressed even if its sinuosity is exaggerated for decorative purposes at the expense of realism.

The stimulus for the regeneration of the herbal began in Italy in the new medical schools of Salerno towards the end of the eleventh century, and later of Padua. The preservation and translation of Greek texts by Syriac and Arabic scholars kept alive the tradition of Dioscorides, and the influence of Arabic studies was at this period strong in Italy, particularly in the south. It was one of the main factors which helped to create a new interest in plants as the primary source of medicines and at the same time stimulated a demand for more practical and better illustrated plant manuals. In Salerno a certain Platearius collected together and edited a compendium on plants, at first unillustrated, which became widely popular. This new herbal of the twelfth century was variously named, sometimes *Secreta Salernitana*, more usually *Liber de Simplicibus Medicinis*, the book of medicinal plants. By 1300 it had been illustrated but no contemporary copies of this work have survived. Yet we have some idea how these illustrations looked from a later Italian manuscript in the British Library (Egerton MS. 747; 14) which dates

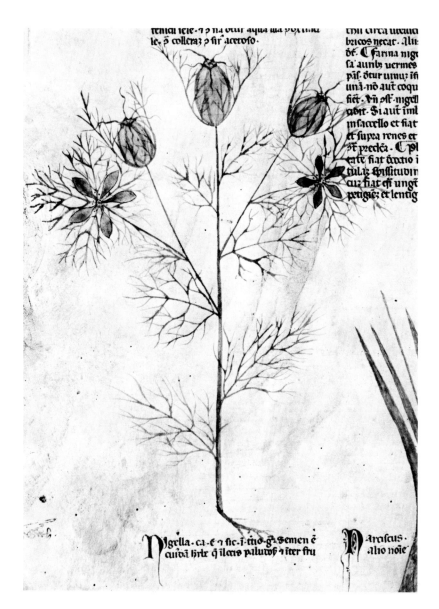

14 Love-in-a-mist, *Nigella damascena*. From an illuminated Italian herbal, earlier 14th century. 260 × 248 mm. Egerton MS 747, f. 68*v*.

from the earlier part of the fourteenth century and is a product of southern Italy. It must therefore be in the direct line of descent from the *Secreta Salernitana*. The pictures it contains show many details accurately observed and set down within stylized and flat designs which reveal nothing of the plants' real structure or habit. Naturalistic details have been superimposed on traditional images but as means of identification the advance is considerable. It points the way ahead to the remarkable herbal written for Francesco Carrara and illuminated by an anonymous Paduan (British Library, Egerton MS. 2020) which has already been noticed. Here are true plant portraits where the illusion of reality is the main concern of the artist with no thought of smoothing out the irregularities of nature and with no respect for tradition. It is extraordinary that such exquisitely naturalistic studies should have appeared before 1400. In the sixteenth century the manuscript belonged to the great botanist, Ulisse Aldrovandi, who must

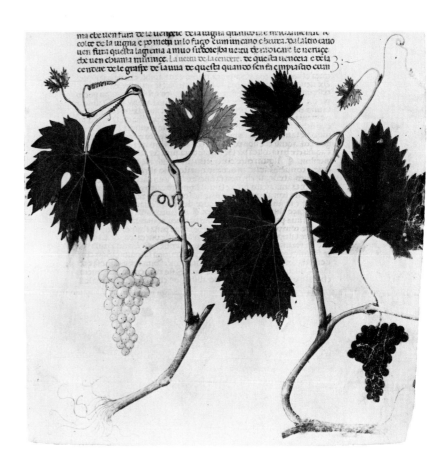

15 Grape-vine, *Vitis vinifera*. By an anonymous
Paduan miniaturist, from the Carrara Herbal,
c. 1397. 350 × 325 mm. Egerton MS 2020, f. 28 *r*.

have derived much pleasure and perhaps even some scraps of botanical
information from such convincing figures. The structure of the vine and the
hang of its wilting leaf (15) is beautifully expressed. Similarly the
convolvulus, a piece of which has been gathered a little time before and
is already drooping slightly, is drawn with the utmost sensitivity. The
portrait is completely convincing. But these outstanding plant drawings are
not isolated examples though their quality is exceptional, for a number of
other herbals were produced in northern Italy, particularly in the region of
Venice, within a decade or two of the Carrara herbal. The most famous of
these is the Benedetto Rinio manuscript, now in St Mark's Library, Venice,
which contains nearly five hundred paintings of plants by an otherwise
unknown miniaturist named Andrea Amadio. Some of these drawings are
copied from the Carrara herbal and reveal the usual weaknesses of copies
when compared with their models but many of the others are undoubtedly
first-hand studies from life. This is perhaps the richest of all medieval herbals
and of a quality which so impressed Ruskin that he had a page of it copied
for the inspiration of his Oxford students.

The invention of moveable type did not for many years make available to
the readers of the printed herbal the quality of plant illustration found in
these north Italian manuscripts or indeed in the best then being produced
by Flemish and French miniaturists. The printed book simply carried on the
tradition of the stylized and degenerate illustrations found in manuscript

16 Wallflower, *Cheiranthus cheiri*. Woodcut, from *Cube's Herbal* (1485). 285 × 200 mm.

17 Daffodil, 'Narcissus'. Woodcut, from the *Ortus Sanitatis* (1491). 100 × 60 mm.

herbals in central and western Europe at the time. However, the earliest printed work which contains illustrations of plants, *Das Půch der Natur* (1482), by Konrad of Megenberg, though not strictly a herbal has cuts with crude figures of individual plants which have been vigorously and recognizably drawn.

Just as the woodcut was more widely and skilfully practised in Germany in the fourteenth and fifteenth centuries than elsewhere so the more notable herbals at this period were German. The best example of these is the *German Herbarius* or the *Herbarius zu Teutsch* (1485), also known as the *German Ortus* [or *Hortus*] *Sanitatis* and *Cube's Herbal*. It was published by Peter Schöffer in Mainz. The compiler says in his foreword that he has commissioned a 'master learned in physic' to collect information on the uses of herbs from every source. He realised that he could only obtain authentic pictures of local German flora and so had set out with an artist on a journey to Italy, Greece, the Balkans, Palestine and northern Africa to record the plants he found. The non-German plants are in fact mostly less successfully drawn than the majority of the three hundred and fifty plants portrayed 'in their true forms and colours'. Unquestionably the best were drawn from life (16). It is likely that the editor made use of drawings by different hands and that these were very variable in quality. It is clear that the woodcuts in this and other herbals of the period and of the sixteenth century were executed largely in outline for colouring either by the purchaser or by the publisher before sale.

The *German Herbarius* was immensely influential. Many of the figures of plants were used in later herbals and its text was copied or translated widely. The *Ortus Sanitatis*, also published at Mainz, in 1491, enlarged the text of its predecessor and used copies of its figures on a reduced scale. Some of the latter were cut with great skill but some of the new figures were fanciful, as for example the 'narcissus' (17). *The Grete Herball* (1526), one of the earlier English herbals and the most important before Gerard, was a translation of a French work but many of its illustrations were rather poor derivatives of those first appearing in the *German Herbarius*. It includes a great deal of medieval lore, as for example the dangers of bathing and drinking cold water, and is enlightening on the early names of British plants.

The publication of Otto Brunfels's *Herbarum Vivae Eicones*, living portraits of plants, at Strasbourg in 1530, set an entirely new standard of plant illustration. Something will be said below about the quality of the herbal (p. 113), the pre-eminence of which lies almost entirely in its illustrations (18). It is significant of Brunfels's traditionalism that he feels obliged to apologise for the figure of the pasque-flower (see ill. 113) – a woodcut of such excellence that it must have interpreted the original drawing by Weiditz to perfection – because, he says, the plant is not used by the apothecaries and has no Latin name, poor qualifications indeed! Apart from the mediocrity of the text the design of the book leaves something to be desired. The woodcuts vary from full-page illustrations to miniscule figures fitted often haphazardly in the text. The herbal of Fuchs, *De Historia Stirpium* (1542), more than remedied these defects. Leonhart Fuchs, an eminent

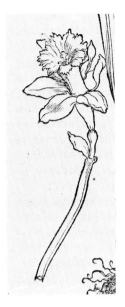

18 Daffodil, *Narcissus pseudonarcissus*. Woodcut, after Hans Weiditz, from Otto Brunfels, *Herbarum Vivae Eicones* (1580). 93 × 30 mm.

20 Dragon tree, *Dracaena draco*. Woodcut, from Charles de L'Écluse, *Rariorum aliquot stirpium per Hispanias . . .* (1576). 135 × 78 mm.

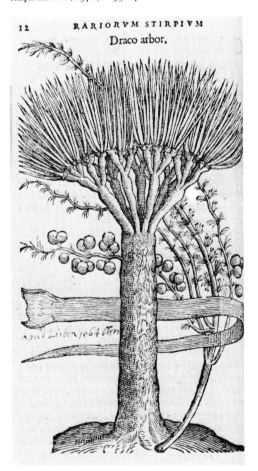

professor of medicine, was clearly a plant lover. He writes in his preface:

… there is no reason why I should dilate at greater length upon the pleasantness and delights of acquiring knowledge of plants, since there is no one who does not know that there is nothing in this life pleasanter and more delightful than to wander over woods, mountains, plains … and to gaze intently on them. But it increases that pleasure and delight not a little if there be added an acquaintance with the virtues and powers of these same plants.

His herbal was the product of learned enthusiasm on his part and the powers of a remarkable team of artists and craftsmen – the original designer, the one who transferred his designs to the wood block, and the cutter. Their names are known but only in relation to this herbal. Without the individual genius of a Weiditz, evident in some of the plates in Brunfels though distorted in others, Fuchs's team produced a more scientific, better designed and probably on the whole a better herbal, which was certainly more prolifically illustrated. Fuchs made his aim clear in his preface; 'As far as concerns the pictures themselves, each of which is positively delineated according to the features and likeness of the living plants, we have taken peculiar care that they should be most perfect …' The book contains about four hundred native German (19) and one hundred foreign plants and was published in two editions, the first in Latin, the second in German, the *New Kreüterbůch* (1543). The influence of the illustrations is found in almost every subsequent herbal over a long period of years; occasionally the same blocks were used, more often the smaller versions from the octavo edition of 1545 were copied or adapted.

Though the German herbal tradition continued with great vigour it would be true to say that later in the sixteenth century the publication of herbals became established most actively in the Low Countries. Here the printer and publisher, Christophe Plantin, played a key role. He was instrumental in assembling woodblocks at Antwerp which served as a common stock for illustrating the herbals of Dodoens, L'Écluse and L'Obel. Undoubtedly the consistently high level of woodcut illustrations apparent in the herbals of these three Flemish botanists is the result of this fact and of Plantin's overall control. The friendly rivalry of the three which allowed them to make use of each other's knowledge was another important factor. The works of Rembert Dodoens (1517–85), except for his first book, were all published by Plantin. The best known of them is his collected works, *Stirpium Historiae Pemptades Sex* (1583). Charles de l'Écluse (Carolus Clusius; 1526–1609) was a characteristic figure of the Renaissance who spoke many languages and travelled widely, making contact with scholars throughout Europe. He collected many previously unidentified plant species on an expedition to Spain and Portugal and these were published by Plantin in 1576 under the title *Rariorum aliquot Stirpium per Hispanias observatarum Historia* (20). Finally, as professor of medicine at Leyden, a post which Dodoens had also held, he published, again from Plantin's press, a compendium of his collections in Austria and Hungary as well as in the Spanish peninsula. This work, entitled *Rariorum Plantarum Historia* (1601), shows the author's wide range and his interest in plants for their own sake apart from their utilitarian value. Far from apologising for including species

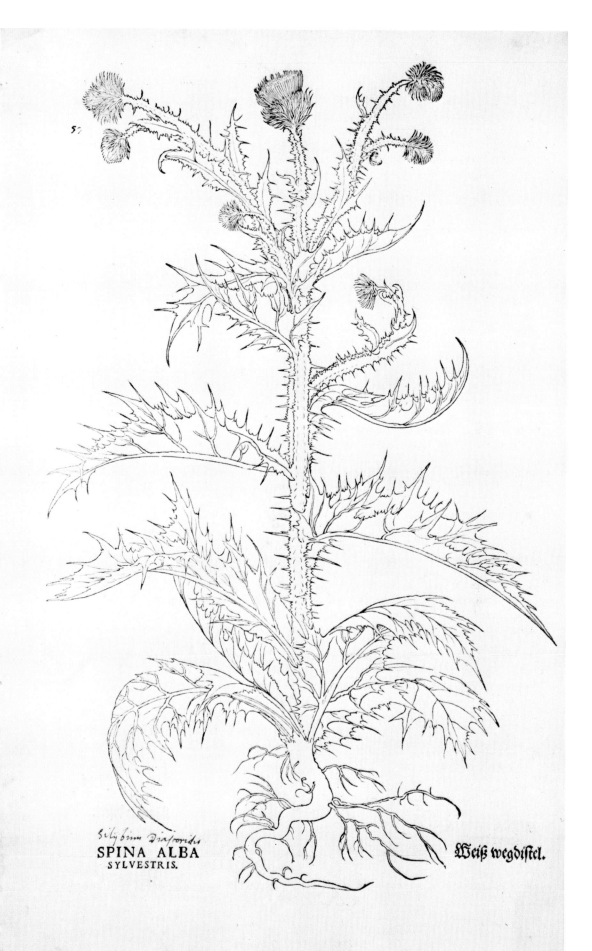

19 Cotton thistle,
Onopordum acanthium.
Woodcut, from Leonhart
Fuchs, *De Historia Stirpium*
(1542). 320 × 203 mm.

SPINA ALBA
SYLVESTRIS.

Weiß wegdistel.

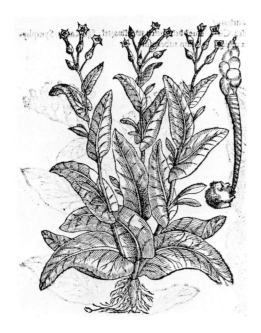

21 Tobacco, *Nicotiana tabacum*. Woodcut, from Mathias de L'Obel, *Stirpium Adversaria Nova* (1570). 115 × 105 mm.

23 Irish potato, *Solanum tuberosum*. Woodcut, from John Gerard, *Herball* (1597). 135 × 105 mm.

which the apothecaries cannot use he includes many new introductions without therapeutic virtues. He was a great plantsman, was particularly interested in bulbous plants of the Near East and the Mediterranean and was one of the founders of the bulb culture of the Netherlands. He introduced the potato into Germany and planned and arranged a botanical garden at Leyden. The youngest of the three Flemish herbalists, Mathias de l'Obel (1538–1616), had particular connections with England where he was put in charge of Lord Zouche's botanical garden at Hackney and was at the end of his life appointed botanist to James I. His most famous work was *Stirpium Adversaria Nova* (1570; 21) which he edited with the Provençal botanist, Pierre Pena, and which was dedicated to Queen Elizabeth.

Apart from the woodcuts found in Brunfels and Fuchs and those which came from Plantin's stock, there was one other major source of original plant illustrations which was almost as widely used in herbals – the figures in the works of Pierandrea Mattioli (1501–77). We have no knowledge of the original designer but the kind of illustration is markedly different from those we have been considering. Mattioli was a herbalist of the type of L'Écluse and his great work, *Commentarii in Sex Libros Pedacii Dioscoridis* (first published 1544), was not simply a commentary on Dioscorides but contained descriptions of all the plants Mattioli knew. It went through many editions and was enormously successful and influential. The later editions published in Venice and Prague had larger, finer woodcuts than the earlier. They are more elaborate and generally more decorative than those used in the German and Flemish herbals and often the foliage and fruit of the plant are concentrated together into a highly ornamental design far from its natural habit of growth. Yet the finer details of veins, hairs and the needles of pines for example are often beautifully delineated and show the highest degree of perception (22).

The woodcut herbals which proliferated towards the end of the sixteenth and into the seventeenth century made full use of the illustrations which had already been published to the extent that it is often difficult to trace the history of any particular figure. The re-use of wood blocks usually presents no difficulties but the copies and their modifications often raise problems of provenance. The information in the texts might be a straight translation or a digest of ideas contained in earlier publications. Certainly there was an ever growing demand for adequately illustrated plant manuals and a proportionately increasing appetite for new information on their virtues and properties.

John Gerard's *The Herball or Generall Historie of Plantes* (1597) is the best-known of English herbals and in many ways one of the most characteristic of the type. It appeared before conditions were quite ready for the new kinds of plant books which copper plate engraving and higher standards of education made possible: the more strictly botanical works and the finely illustrated manuals of cultivated plants, the florilegia. Gerard was both a medical man – he was to become master of the Barber-Surgeons' Company – and a renowned horticulturist who had been in charge of Lord Burghley's gardens in the Strand and at Theobalds. In his book he makes use of the cuts found in *Eicones plantarum* of Tabernaemontanus (1590) which in turn

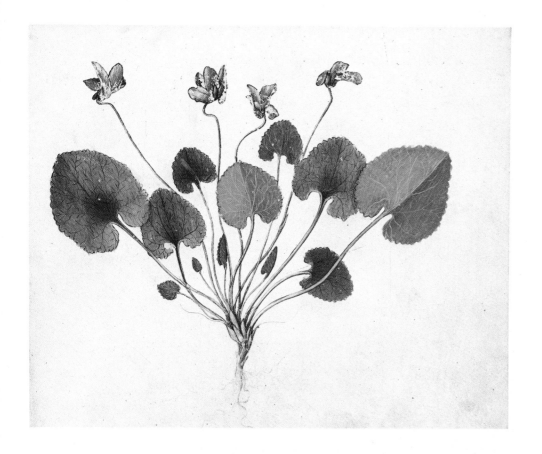

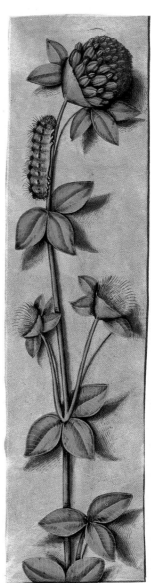

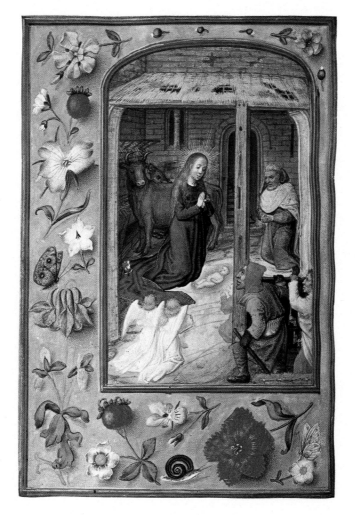

6 *above* Dog violet, *Viola reichenbachiana* (?). By an anonymous Paduan miniaturist, from the Carrara Herbal, *c.* 1400. 350 × 235 mm.

7 *right* Nativity, with borders of floral motifs. By a miniaturist of the Bruges-Ghent School from a Book of Hours, *c.* 1490. 155 × 107mm.

8 *above* Red clover, *Trifolium pratense*. By a French miniaturist of the School of Jean Bourdichon. Detail from a Book of Hours, *c.* 1510. 173 × 45 mm.

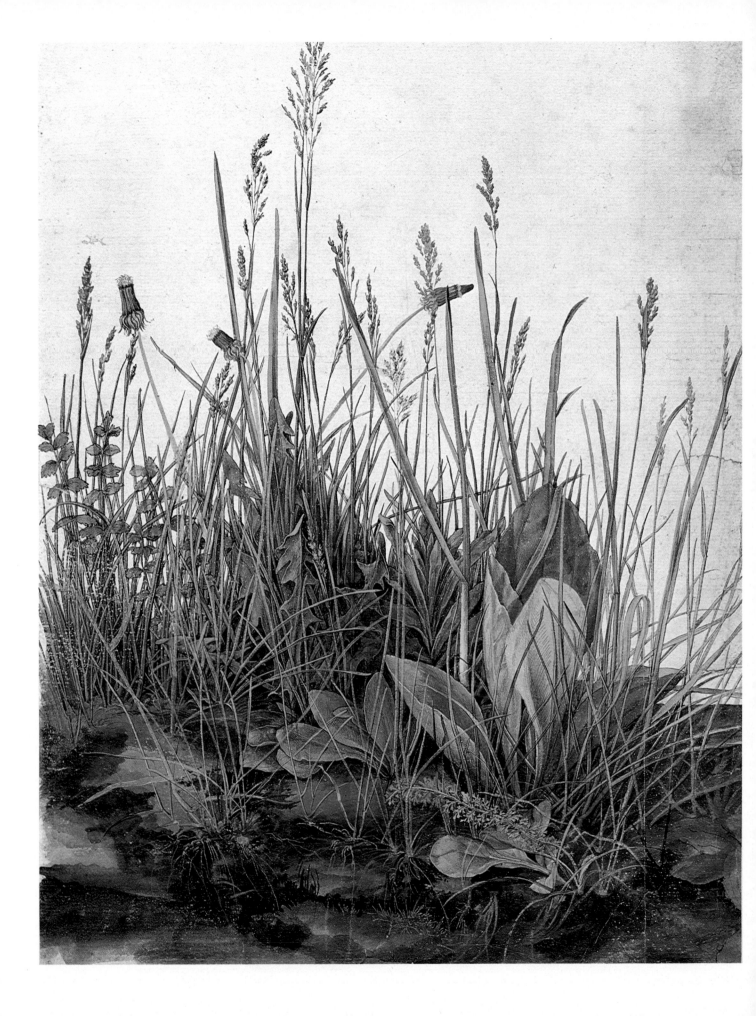

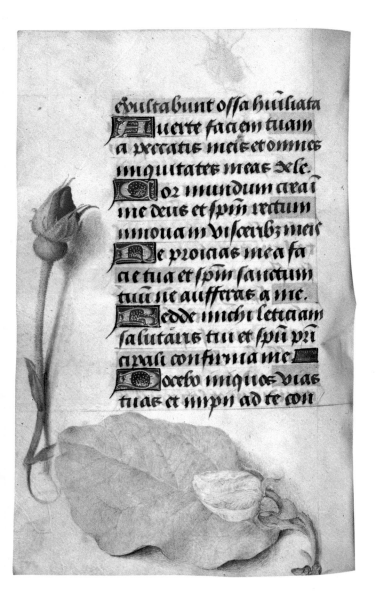

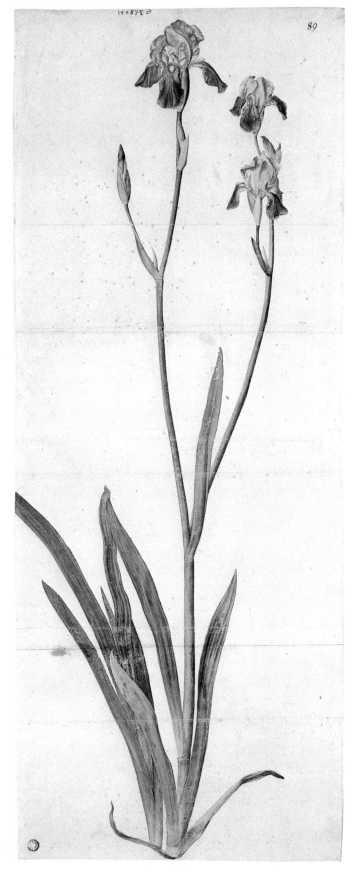

9 *left* 'Das Grosse Rasenstück'. Watercolours and bodycolours, by Albrecht Dürer, 1503. 410 × 315mm.

10 *right* Iris, probably *Iris trojana*. Watercolours and bodycolours, by Albrecht Dürer, *c.* 1506. 770 × 310mm.

11 *above* Garden rose, *Rosa*. By Georg Hoefnagel, *c.* 1590. Illuminated border added to the 15th-century Hours of Philip of Cleves. 130 × 90mm.

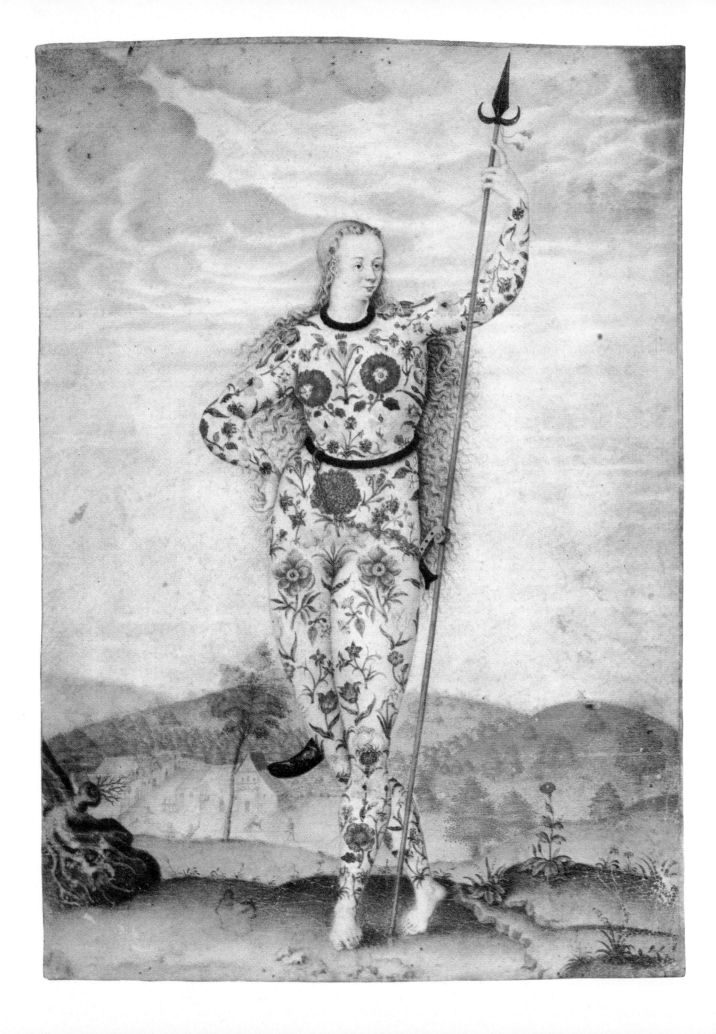

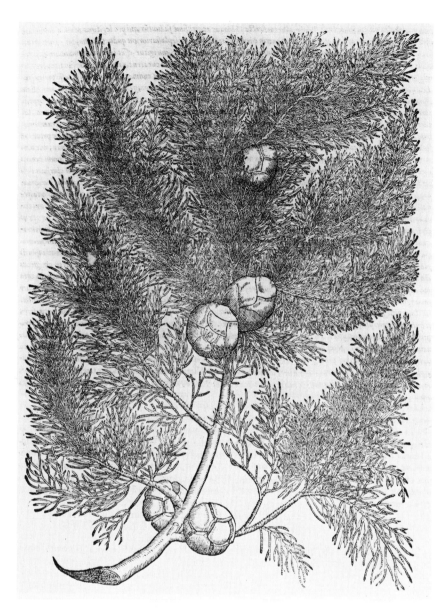

22 Cypress, *Cupressus sempervirens*. Woodcut, from Pierandrea Mattioli, *Commentarii . . . Dioscoridis* (1565). 220 × 160 mm.

12 *left* 'Daughter of the Picts', painted with flowers. Watercolours and bodycolours, by Jacques Le Moyne de Morgues, *c.* 1585. 260 × 185mm.

were derived from Fuchs, Mattioli, Dodoens, L'Écluse and L'Obel. But there were a few original illustrations including the potato (23), and the milkweed, the latter drawn by John White in Raleigh's Virginia. The text was largely an adaptation of Dodoens's final work. But Gerard's book was far from being weakly derivative for it was full of his own acute observations as a gardener and medical man and is written in a simple and vigorous prose which must in no small way have accounted for its popularity. Typical are his comments on the globe artichoke which is 'eaten both rawe with pepper and salt and commonly boiled with broth of fat flesh, with pepper added; and accounted a dainty dish, being pleasant to the taste, and good to preserve bodily lust.' Gerard never loses sight of the utilitarian aim of his book, whether a plant is 'fit for meate or medicine'. Thomas Johnson brought out a much revised edition of Gerard in 1633 which was reprinted in 1636. It was the last herbal to make use of Plantin's blocks, among them copies of Greek originals taken from the Anicia Codex of Dioscorides.

23

The heyday of the herbal was by this time in decline as was that of the woodcut. The tradition persisted for several centuries – as long as there was a popular need for the herbal's characteristic combination of botanical and medical lore. That need almost vanished with the general availability of doctors and the chemist's shop. But how hard the tradition died is exemplified by Agnes Arber, the historian of the herbal, in the last lines of her book. 'The present writer was once told by a man who was born in 1842 that, during his boyhood in Bedfordshire, he was acquainted with a cottager who treated the ailments of her neighbours with the help of a copy of Gerard's *Herball*. If, as is most likely, this was one of Johnson's editions, she must have known certain illustrations copied from Anicia Juliana's manuscript of Dioscorides made soon after AD 500 – figures which were probably derived themselves from the work of Krateuas, belonging to the century before Christ. We thus catch a glimpse of the herbal tradition unbroken through two thousand years, from Krateuas, the Greek, to an old woman poring over her well thumbed picture book in an English village.'

In western Europe, as we have described, interest in plants was revived in the eleventh century AD through the herbal. One important stimulus was the *De Materia Medica* of Dioscorides, which continued to be copied with ever-degenerating illustrations in the Byzantine Empire, and which became known in Italy and Spain through Arab translations and copies; for in spite of its division into three broad camps (Catholic, Orthodox and Muslim), the Mediterranean in the early Middle Ages was a culturally interdependent region.

In the Islamic world, which covered vast areas of Western Asia, North Africa and parts of Europe, there was strong religious discouragement of representational art. Plants were not forbidden to artists as human beings and animals were (at least in theory), but the abstract-patterned nature of mosque decoration led to floral motifs being used very formally and symmetrically. The interest in herbals and medicine which developed in the ninth century AD was therefore important in Islamic countries in keeping alive at least the concept of plant drawing, which it did almost unaided for about four centuries.

The first Arabic translations of Dioscorides were made in Baghdad in the ninth century. No manuscript survives today before the one dated 1083 (University Library, Leiden), which itself claims to copy one dated 990. We can reasonably assume that all translations, like the Greek Byzantine originals, were illustrated. The coloured drawings in the Leiden manuscript are crude, though like the near-contemporary Anglo-Saxon herbal (plate 3) they have vigour and are often quite recognizable as plants. The stylization and symmetry found in later manuscripts as a result of the influence of Islamic design had not yet developed.

This symmetry is, however, very apparent in some pages of the famous manuscript from the library of the Museum of the Topkapı Saray in Istanbul. This is dated 1229, and was probably written and illuminated in Mosul in Northern Iraq. The figure of the lentil for example, shows a plant of almost total symmetry shown sideways on, growing round a dead-straight central stalk cut off at the base of the stem almost like a contemporary stone

وزهر اصغر طيب الريحه وثمر صغار سفعريه وعروق حمر
اوست وغلظ اصبع لنه حلوه مسته اذا خرجت عصارتها
وطبخت بشراب وبسل كل واحدمنهما سواولها في المقدار
ونصف جزو مرفلفل وسله من الكدر كان دواء نافعا
جيد للعين ومن الناس من يسميه ابراقليا
هوبات من المنتاسف كونه كل سنه وله ورق شبيه
بورق الفراسيون الا انه اطول منه مثل ورق النبات
الذي يقال له الاسقاقي او ورق شجره الملوط الا انه
اصغرمنه وهو وحشن وله قضبان مربعه طولها نحومن شبر
او اكثر لتبزريكره الطعم يقبض قضبا سير علها حاشيه

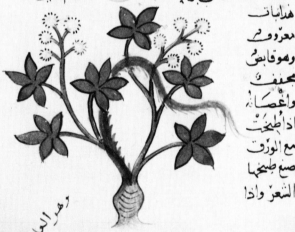

الفلك وله قضبان مربعه طولها نحومن شبر او اكثر ليس
يكره الطعم و٤ تلك الفلك بزراسود وسط
مواضع فيها صغوز وورق هذا النبات اذا تصمد به اللحم الحراحا
ومنع عنها الورم هوبات له
اعضان طولها نحومن ذراع دقاق على قضبان طوال تخرج من

مشرف كثير العدد ماسمرجنسى القضبان وعلى الاغصان
الباده ٤ اعلى موضع من النبات شعب دقاق ٤ اطرافها
رؤوس متديره شبيه ٤ استدارتها بالاكرخشه فيها بزر
شبيه بزر السلق الا انه اشد استداره منه واصل وقوه هذا
النبات وورقه يوافق الجراحات باطن وهو الحليق
هرابات
معروف
وهوقابض
يجيف
واغصانه
اذا طبخت
مع الورق
صبع طبخها
الشعر واذا

carving. Yet astonishingly, this same book contains the most beautiful and lifelike plant drawings to have survived since the great Juliana Anicia Codex of AD 512 (plate 4) which it so much resembles. Plate 4 shows the picture of the vine from the Islamic manuscript, complete with every root and tendril, every leaf different from the last in colour and shape, the shading of the stem giving depth and roundness, the intertwinings of leaves and stems creating an illusion of space. Clearly this was copied from an early Byzantine original, now lost, for it recalls closely the style of the Juliana Anicia Codex of fully seven hundred years earlier, which however does not include a vine to compare it with. Nowhere in Europe or Western Asia was comparable work being done at that date. Only in distant China did there exist a definitely superior ability to depict plants.

Unfortunately, the lost standards of antiquity were not revived by this example. It may well have been the same painter who did both the formal and naturalistic drawings, using different sources to copy from. Such was the nature of the medieval artist, especially the Muslim one who did not wish to presume to impose too obviously his skill on God's creation.

The herbal based on Dioscorides continued up to at least the fifteenth century. Apart from the Topkapı Saray manuscript, it did not produce any great achievements in plant drawing, but it carried the torch, as it were, until a gradual relaxation of Islamic attitudes set in. And there is an attractive side to the way the average later Dioscorides manuscript combines symmetrical patterning with more or less recognizable flowers. A typical example is one from Baghdad dated 1334, where the vivacity of the more recognizable specimens seems to suggest the artist did look personally at the plants from the old Greek work which were known to him (British Library; ill. 24).

There is an unpretentious ease about these little drawings which was taken over in manuscripts of the botanical section of the general compendium of knowledge *The Marvels of Creation* written by Zakāriyā Qazwīnī in the 1270s. This became one of the most copied texts in the Islamic world, and it carried on an ever more natural and light-hearted attitude to plant drawing into the great period of Persian miniature painting in the fifteenth and sixteenth centuries. A Persian manuscript done at Herat in 1503 (British Library) has little flowers and plants, four or six to a page, lightly coloured and drawn in a very relaxed manner. The flowers are by now quite naturalistic, but they are nevertheless no more than a decoration. In other words, they have become part of the general vocabulary of the Persian miniature, which was taking Islamic painting into a new and more expressive age.

Thus, just as in Europe, the herbal did its job and became submerged in a new culture. But in the absence of the woodcut or any other printed medium, it lingered much longer at a fairly low level. Indeed, manuscripts of *The Marvels of Creation* were still being copied in Muslim India and Persia as late as the first half of the nineteenth century AD. Like the English seventeenth-century herbal, still used in the nineteenth (p. 24), these offer a sort of continuity in plant drawing over some two thousand years.

4
Artists of discovery

The European expansion into Africa, America and the East brought back to Europe information about the inhabitants and natural resources of the newly discovered lands. Some of this came by means of illustrations – illuminations on maps, drawings, and more frequently with the spread of the printed book, engravings. Little in the way of illustrations has come down to us from the earliest voyages but it is clear that before the middle of the sixteenth century Spanish and Portuguese expeditions took with them artists to assist in the mapping of the new territories and to record the human and natural life they encountered. There is no doubt that in the thinly inhabited areas of America, for example, the Europeans, always intent on exploiting the economic resources of the areas they appropriated, carefully observed and recorded in words and drawings the local flora and its possibilities for providing food, medicine and other essential or desirable products. Verrazzano in 1524 described the stateliness and beauty of the trees in 'Arcadia' (the eastern shores of Virginia or Maryland) and also notes 'the many vines of natural growth, which, rising, entwine themselves around the trees, as they are accustomed in Cisalpine Gaul; which, if they had the perfect system of agriculture by the agriculturists, without doubt would produce excellent wines We found wild roses and lilies and many sorts of herbs and fragrant flowers different from ours'. Similarly Jacques Cartier, or one of his party, in 1534 described Brion Island, off Newfoundland, as 'covered with fine trees and meadows, fields of wild oats, and of pease in flower, as thick and as fine as ever I saw in Brittany, which might have been sown by husbandmen. There are numerous gooseberry bushes, strawberry vines, Provins roses, as well as parsley and other useful, strongsmelling herbs'. Unfortunately we have only such word pictures of these early discoveries for artists' drawings were at first rare and few have survived.

Ramusio in his *Navigationi et Viaggi*, published in Venice in the 1550s, was the first to make information on the American discoveries generally known and he includes a few engravings of plants, among them cacti (25) and Indian corn or maize (26). Though a most precise study, the latter was not the first picture of maize which suprisingly appears in a woodcut by Hans Burgkmair of a native procession, including Brazilian Indians, but how Burgkmair obtained his study of the plant is not known.

Fernández de Oviedo, author of *Historia General y Natural de las Indias* (1535–57), considered a detailed and systematic account of the natural history of the lands which Spain had conquered essential and this required a wide range of illustrations. He lamented the lack of an artist of the calibre of Leonardo, Mantegna or Michelangelo, whom he had known in Italy, to do justice to his theme. He set about making his own drawings which were crude but practical and included a number of plant figures, which however were never fully published.

The Council of the Indies in Seville required its officials in America to send home detailed reports of the resources of their territories including information about their natural history. These were not illustrated but Francisco Hernández, physician to Philip II of Spain, carried out in Mexico a systematic illustrated record of its Indian and natural life, the first on such a

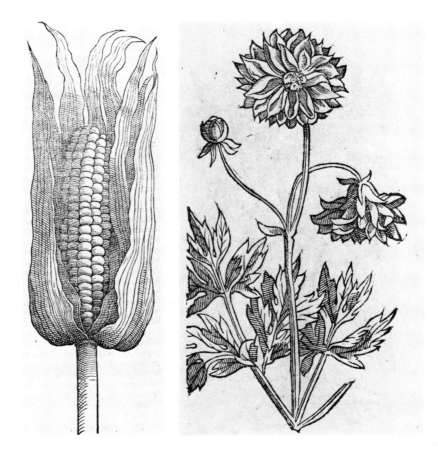

26 *right* Maize, *Zea mays*. Woodcut, from G. B. Ramusio, *Navigationi et Viaggi* (1556). 182 × 58 mm.

27 *far right* 'Cocoxochitl', *Dahlia* sp. Woodcut, from Francisco Hernández, *Thesaurus* (1651). Approx. 120 × 65 mm.

scale to be undertaken in the New World. He gathered together a team of artists and observers in the 1570s who made detailed coloured drawings and compiled notes which were to fill fifteen manuscript volumes, but sadly these were destroyed by fire in the Escorial in 1671. Woodcuts of some of the illustrations appeared in his posthumously published *Thesaurus* (1651) including the earliest portrait of a dahlia with its native name of *Cocoxochitl* (27).

An illustrated record of a similar kind, though not conceivably so extensive or systematic, must have been carried out by Jacques Le Moyne de Morgues in Florida. Le Moyne was commissioned by Laudonnière to accompany the Huguenot expedition of 1564 in order to carry out essential mapping duties and to make a graphic record of 'anything new' they encountered. As a most gifted plant draughtsman he certainly must have made many individual studies of plants during more than a year in Florida. But it is doubtful whether he brought any away with him for the Spaniards overran the colony, nearly all the Frenchmen were massacred, and only a few, among them Le Moyne, escaped. After great privations he returned to France. His miniatures of Florida, engraved by Theodor de Bry in 1591, were to some extent reconstructions and consisted of a map, charts of the coastline explored by the French, and illustrations of Indian life. Echoes of individual plant studies can be found in the melons, grape-vines and cedar trees which in the engravings decorate the shores of Florida, and in Le

28 Rosegentian, *Sabatia stellaris*, by John White. Watercolours and bodycolours, c. 1586–90. 349 × 179 mm. P. & D., 1906–5–9–1 (38).

Moyne's one surviving miniature. This portrays an Indian chief pointing out to Laudonnière a stone column, set up on a previous expedition to mark French sovereignty of the area, which a group of Indians are worshipping. There are baskets of fruit and vegetables in the foreground as well as a bundle of ears of maize and some bottle-gourd containers. Evidence that the miniature is at least partly reconstructed from memory lies in the fact that the fruit and vegetables are mostly European (as are the baskets) and the garlands on the column are stylized but naturalistic inventions rather than actual studies of flowering plants. Ironically, nearly all the original drawings by Le Moyne which have survived are of common French or English garden plants. They are portrayed with such distinction as to make us realise all the more acutely the extent of our loss in the disappearance of his studies of American plants.

A curious miniature by Le Moyne, not entirely unconnected with his American venture, does however survive (collection of Mr and Mrs Paul Mellon). It shows a 'young daughter of the Picts' standing in a landscape. She is naked but painted from head to foot with flowers (plate 12). An engraving of the figure appears in a section on Ancient Britons and Picts in De Bry's *America* pt. 1 (1590), placed there to show that our painted ancestors were once as savage as the painted Indians of Virginia. The book speaks of John White as the designer of the figure but when the original reappeared recently it was realised that the painter of the flowers could be none other than Le Moyne. He presents the figure as he might the goddess Flora, and some of the flowers she sports were, in 1585 (the probable date of the miniature), recent introductions into Europe, including the Marvel of Peru from America.

Le Moyne finally settled in London 'for religion' and was in touch with the younger English artist, John White. White, too, was appointed official artist to the expedition of 1585 to Raleigh's 'Virginia' (parts of the present states of North Carolina and Virginia). With Thomas Harriot he surveyed and mapped the areas explored by the English, and drew and described its Indian life and its flora and fauna. De Bry engraved some of White's charts and Indian scenes in 1590 (*America*, pt. 1) but the portfolio of natural history material which White and Harriot compiled has not survived, though early copies of some of White's birds, fishes and reptiles have come down to us. Among White's original drawings in the British Museum are a few studies of plants: a pineapple, bananas, and a mammee apple which he made in the West Indies on the voyage out; and two, a rosegentian (28) and a milkweed, which he drew on the North American coast. The milkweed appears as a woodcut illustration in Gerard's *Herball* – one of the few not taken by Gerard from some other published source. In White's drawing of the Indian village of Secoton, he depicts maize in different stages of growth and in the variant of the same scene engraved by De Bry he has added crops of sunflowers and tobacco (29).

While artists were discovering and drawing plants in the New World, the frontiers of botanical knowledge were being relentlessly widened in the Old. Conrad Gessner of Zürich (see also p. 129), one of the great encyclopaedists of natural life, was also an active traveller, mountaineer, and pioneer of alpine

29 *right* Crops of sunflower, *Helianthus annuus* and tobacco, *Nicotiana tabacum*. Detail of line-engraving after John White, from Theodor de Bry, *America*, pt. 1 (1590). 70 × 30 mm.

30 *far right* Job's Tears, *Coix lacryma-jobi*. Woodcut, from Charles de L'Écluse, *Rariorum aliquot stirpium per Hispanias . . .* (1576). 135 × 73 mm.

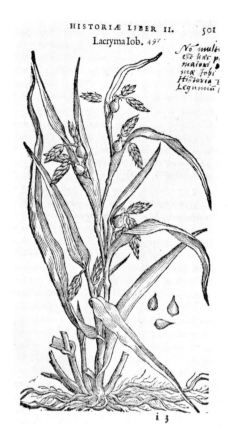

plant-collecting both in his native Switzerland and along the borders of Italy and Austria. Before his death in 1565 he had brought together a large number of plant drawings, some of them his own, but comparatively few of these were published in his great unfinished work, *Historia Plantarum*.

Ten years junior and much longer-lived, Charles de L'Écluse (Clusius) was another outstanding figure who placed himself at the centre of a web of communications with scholars and collectors all over Europe. He was also an immensely active traveller and plant collector in the face of the most daunting misfortunes. Though he apparently had no special gifts as an artist himself he attracted the work of talented plant draughtsmen from all sides who illustrated the new species so aptly described in his books (30). Besides known names such as Pierre van der Borcht, who seems to have made hundreds of drawings of plants for the block cutters, there must have been many anonymous artists some of whom gathered their material on travels of exploration in Europe, America, and Asia.

The seventeenth century witnessed an increase in the activity of explorer-artists both in extent and in depth. Some of this resulted in plant portraits which were not only informative but of high quality artistically. In Brazil, after the Dutch had gained possession of the colony from Portugal, Count Maurits of Nassau-Siegen was appointed its first governor in 1637. He was a man of remarkable gifts and a discerning patron of science and the arts. He laid out botanical and zoological gardens, as well as the new town

of S. Antonio, and employed a group of artists to assist in the most complete survey yet made of any part of the American continent. The two most outstanding of these were Frans Post (*c.* 1612–80) and Albert Eckhout (*c.* 1610–64). Post recorded the colony in a series of landscapes and Eckhout portrayed its Indian inhabitants and some of its zoological and plant life. The landscapes were not merely topographical or topical but contain many details of botanical interest, accurately depicted. A volume of preparatory drawings by Post for his paintings is in the British Museum (31). Eckhout portrayed Brazilian Indians more realistically and, from an ethnographical point of view, more convincingly than any artist before him, but also produced some exceptional paintings of Brazilian flowers, fruit and vegetables (32), made no doubt from studies of individual plants. Not content with these original records Count Maurits saw to it that the results of the natural history survey made by William Pies (Piso) and Georg Marcgrave (the latter a considerable artist as well as astronomer and

31 Wild 'babassu' oil palm, *Scheelea martiana* 'Coqueiro urucuri'. Detail of a drawing by Frans Post. Brush and grey wash. 1640. 280 × 140 mm.

32 Brazilian fruits, including custard apple, pineapple, melon, passion fruit, fig and orange(?). Oil painting by Albert Eckhout, *c.* 1637–44. 915 × 915 mm.

naturalist) were published. They appeared in Johannes de Laet's edition of their *Historiae Rerum Naturalium Brasiliae* in 1648.

Though the Dutch colony in Brazil was short-lived the Dutch maintained a foothold in South America in Surinam (later Dutch, British and French Guiana). Without the advantage of an enlightened patron like Count Maurits, it yet attracted two considerable artists, Dirk Valkenburg (1675–1721) who painted topographical landscapes somewhat in the tradition of Post and at least one study of fruit, and the Swiss-German, Maria Sibylla Merian (1647–1717). Always interested in the painting of insects, Maria Merian, while residing in a Dutch Labadist convent, was fascinated by its collection of South American insects. She decided to make the journey to Surinam and to draw them from nature. She visited the colony in 1698 and stayed two years and has left a large number of paintings and drawings not only of insects but of plants, flowers and fruits over or in which insects fly, crawl or burrow (plate 13). These are not the wild flowers of Surinam but plants of economic value – pineapple, cotton, passion fruit, banana, castor oil plants etc. She was an extremely gifted and highly imaginative draughtsman, able to endow her vegetable world of vivid colours with a sometimes sinister intensity as the invading insects prey upon the ripe fruits or upon birds or upon each other. She painted many of the Surinam subjects in watercolours on vellum and engraved a number of them in *Metamorphosis Insectorum Surinamensium* (1705).

While the voyages of exploration and trade caused the plants of the new lands to be drawn and described for purely economic reasons, the development of botanical science in the seventeeth century initiated a new kind of expedition intent on discovering plants for the sole purpose of increasing botanical knowledge. If the explorer had the gift of drawing he could both portray and describe the new discoveries. More often than not he took with him an artist, just as the scientist Thomas Harriot in the sixteenth century had worked with the artist John White in 'Virginia'. In eastern Europe and the Levant the richness of plant life, hitherto largely undescribed, began to exert an increasing attraction. The great French botanist, J. P. de Tournefort, having assessed the artistic abilities and potential of Claude Aubriet (1665–1742), persuaded him to accompany him on the famous voyage to the Levant in 1700–2. During more than two years Aubriet observed and recorded costume, architecture, antiquities and, in particular, plants on Crete and the Aegean islands, in the area of Constantinople, on the southern shores of the Black Sea, and in Smyrna and other parts of Asia Minor. But few of the plant studies were effectively published until the appearance, long after the artist's death, of R. L. Desfontaines, *Choix des Plantes* (1808), including the portrait of a hellebore (plate 15).

Dutch trade in western Asia as elsewhere opened up new opportunities for interested and enterprising men to discover information about the flora of these previously inaccessible areas. As Hernández in Mexico and Count Maurits in Brazil, the Dutch Governor of Malabar, Van Rheede tot Draakestein, on the coast of southern India and again in the wake of the Portuguese, assembled in 1669 a team of artists and learned Brahmins who drew and described the plants brought from Cochin by native collectors. These records were the basis of Van Rheede's celebrated *Hortus Indicus Malabaricus* (1678–1703; ill. 33). In the same way Paul Hermann (1646–95), a German doctor, reached Ceylon in 1670 where the coast was under Dutch control. There he was encouraged to make a herbarium and a collection of drawings of the flora near Columbo.

A more learned and an even more adventurous explorer than any of these, the German Engelbert Kaempfer, who had already travelled across Russia to Persia, was able to voyage to Ceylon, Bengal and Java as a surgeon with the Dutch East India Company. In 1690 he reached Nagasaki in southern Japan. But the Japanese closely restricted the movements of Europeans and Kaempfer was not allowed to collect plants on the Japanese mainland. The Dutch were in fact confined to a small island in Nagasaki harbour. With persuasion helped by a 'plentiful supply of European liquors' and in return for lessons in astronomy and mathematics, Kaempfer succeeded in obtaining specimens of wild and cultivated Japanese plants. Some of these he drew with skill and care (34). Again the results were not published until long after, in 1712, four years before Kaempfer's death.

But officials of the Dutch East India Company were not only active in Asia, the East Indies and Japan in searching out new plants and cultivating or recording them, they were also doing the same on the southern tip of Africa. As early as 1652, when Van Riebeck founded the colony that later

33 Banana. *Musa x paradisiaca*. Line-engraving, from H. van Rheede tot Draakestein. *Hortus Indicus Malabaricus* (1678–1703). 336 × 225 mm.

34 *right* Tiger lily, *Lilium tigrinum*, by Engelbert Kaempfer. Pen and dark brown ink, *c*. 1690. 311 × 215 mm. Sloane MS 2914, f. 141 *r*.

became Cape Town, then a port of call for ships trading between Holland and the East Indies, the making of a garden there was considered an immediate priority. From the cultivation of the region's rich flora many new plants found their way back to Holland. Some watercolours of plants in the British Museum (Natural History) made in about 1685 (35) are not signed but may be the work of Hendrik Claudius, an artist sent by Andreas Cleijer, head of medical supplies in Batavia, to study medicinal plants at the Cape at this time.

The urge to record more scientifically and systematically the flora of lands now long since discovered found its outlet in a number of single-handed expeditions. These took place mainly in America and the West Indies and were undertaken by men who were often not in the first instance botanists but able to portray convincingly the new plants they found. The physician, Sir Hans Sloane (1660–1753), founder of the British Museum, was in Jamaica in the late 1680s collecting and illustrating plants to such effect that not only did Linnaeus make use of his records published in the *Voyage to the Islands of Madera, Barbados ... and Jamaica* (1707–25) but botanists today still find them of value. A French monk, Charles Plumier (1646–1704), a

few years later was in Haiti and the French part of Hispaniola and left an enormous collection of plant drawings which still survives in Paris. Another French monk, Louis Feuillée (1660–1732), surveyed the coasts of Peru and Chile between 1707 and 1712 and made some of the first records of western South American plants. Some of these he engraved and published in his *Journal* (1714–25; 36). But more appealing to the layman are the designs of the Englishman, Mark Catesby (1679–1749), of flora and fauna which he observed, drew, engraved and published in his *Natural History of Carolina, Florida and the Bahama Islands* (1731–47). In this form

35 Partridge-breast aloe, *Aloe variegata*, by Hendrik Claudius (?). Watercolours, c. 1685. 407 × 268 mm.

36 *right* Oxalis. *Oxalis* sp. Line-engraving, by Louis Feuillée, from his *Journal* (1714–25). 190 × 150 mm.

37 *opposite* Witch hazel, *Hamamelis virginiana* (?). Etching and line-engraving, by Mark Catesby, from his *Natural History of Carolina, Florida and the Bahama Islands* (1731–47). 355 × 260 mm.

they were of immediate use to Linnaeus, among others. Catesby travelled in Carolina, Georgia and Florida (1722–5), collecting and drawing, always, he said, from the living plant freshly gathered, and then visited the Bahamas. As a draughtsman Catesby was a self-taught amateur though when the need arose to get the work engraved he decided, as later did George Stubbs for his *Anatomy of the Horse*, to do it himself. So he took lessons in etching from Joseph Goupy. His book is the successful product of enthusiastic involvement in the close observation of nature and a striking if somewhat naive sense of design (37). The original drawings are in the Royal Library, Windsor.

By the mid-eighteenth century in Europe the remarkable advances in horticulture taking place first in the great gardens at Kew, in Paris and Vienna and those of the wealthier landowners, demanding the intro-

duction of whole ranges of new plants. The Dutchman, Nikolaus Joseph Jacquin (1727–1817), a typical figure of the age, was one of the many scientifically-equipped horticulturists concerned in supplying them. He happened also to be a considerable artist. After finishing his medical studies in Vienna he was put in charge of the imperial gardens at Schönbrunn and was sent to the West Indies and central America to procure living plants and to collect dried ones. When many of the latter were destroyed he made illustrated notes of his own observations. Schönbrunn flourished and became renowned throughout Europe. Jacquin was later appointed professor of botany and chemistry at Vienna University and director of its botanical garden. He became a prolific author of botanical books which he, or a number of artists under his supervision, illustrated. Perhaps the finest of them is concerned with the plants at Schönbrunn, *Plantarum Rariorum Horti Caesarei Schönbrunnensis Descriptiones et Icones* (1797–1804). Curiously perfectionist he produced a second edition of another of his books, *Selectarum Stirpium Americanarum Historia* in 1780, illustrated not with engravings but entirely with original watercolours. Obviously the edition was strictly limited – to twelve copies! But his sensitive ability to make quick but informative, and very beautiful, sketches of plants is best seen in his notes and particularly in the manuscript volume of letters of the 1790s to Jonas Dryander (plate 17), now in the British Museum (Natural History).

Alexander von Humboldt (1769–1859) was the Kaempfer of the eighteenth century but perhaps even more the philosopher-scientist. His travels in South America with the botanist Aimé Bonpland produced detailed studies of botany as well as of geology and zoology and an account of the pre-Columbian civilizations of America with the earliest coloured illustrations of Aztec codices to be published. Humboldt furthermore drew rather well but most of his sketches were redrawn by professionals before they were engraved. The best of the artists associated with his botanical discoveries was François Turpin (1775–1840). Blunt describes him as 'possibly the greatest natural genius of all the French botanical painters of the day'. He was the life-long friend of the botanist Pierre Antoine Poiteau who inspired him to become one of the greatest exponents of his art. More than almost any other plant artist he combined a wonderful delicacy with the utmost precision. He met Humboldt in North America in 1801 and he and Poiteau collaborated in a number of the finest botanical publications of the early nineteenth century including several concerned with Humboldt's South American discoveries. The Fitzwilliam Museum, Cambridge (Broughton Collection) possesses a volume of the finest drawings by both Turpin and Poiteau for Humboldt's *Monographie des Melastomacées* (1816–23; ills. 38, 39), presumably made from dried specimens.

The Age of Enlightenment was never more so than in its patronage of the arts and sciences. When the patron was himself a notable man of science, an enthusiast and an organizer, clearly he must have been particularly effective. Such a patron was Sir Joseph Banks (1743–1820), President of the Royal Society from 1778 until his death. His primary interest was natural history, in particular botany, accompanied by a voracious appetite

13 *opposite* Hog plum, *Spondias mombin* (syn. *S. lutea*). Watercolours and bodycolours, by Maria Sibylla Merian, *c.* 1700. 387 × 278 mm.

14 Mountain knapwood, *Centaurea alpina*. Pen and ink and watercolours, by Conrad Gessner (?). Mid 16th century. From a facsimile of a drawing for his *Historia Plantarum* in the University Library, Erlangen. 317 × 195mm.

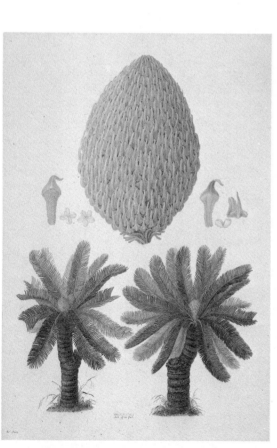

15 *above* Lent hellebore, *Helleborus orientalis*. Watercolours and bodycolours, by Claude Aubriet. Early 18th century. 349 × 226mm.

16 *left Cycas media*. Watercolours, by Ferdinand Bauer, *c*. 1820. 527 × 359mm.

17 Page of a letter from Nikolaus von
Jacquin to Jonas Dryer, 1792. Sketches
in pen and ink and watercolours.
595 × 329mm.

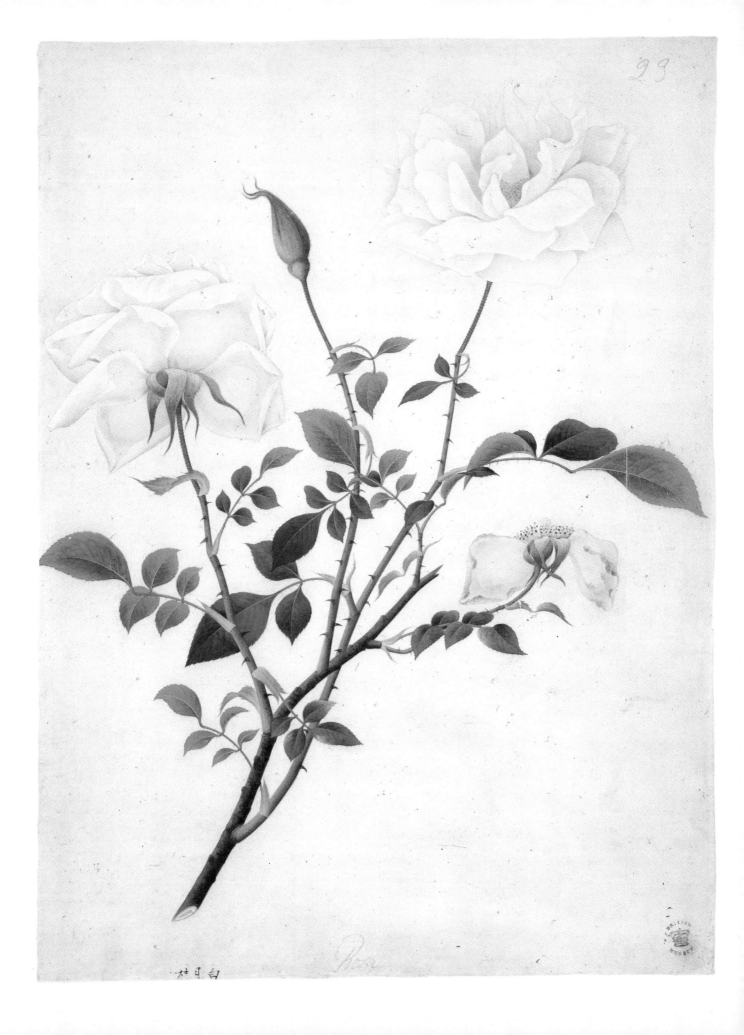

29

白月桂

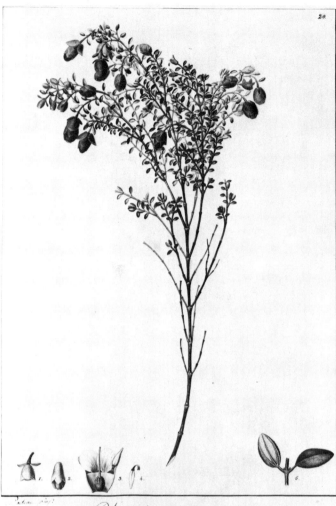

Rhexia Multiflora. *Rhexia Conferta.*

38 *above left Monochaetum multiflorum*, by François
Turpin. Watercolours. For Alexander von Humboldt,
Monographie des Melastomacées (1816–23).
429 × 334 mm.

39 *above right Brachyotum confertum*, by Pierre-
Antoine Poiteau. Watercolours. For Alexander von
Humboldt, *Monographie des Melastomacées*
(1816–23). 430 × 327 mm.

18 *left* Yellow garden rose, *Rosa*. Watercolours on
Chinese paper, by an anonymous Chinese artist, late
18th century. 370 × 280mm.

for discovering, collecting and recording everything new in this field. Before
he was elected President of the Royal Society he had already made a
reputation for the way he used artists in the service of scientific illustration.
The programme which he formulated and carried out on the famous voyage
to the South Pacific with Cook on the *Endeavour* (1768–71) provided the
pattern for all later Pacific voyages. In addition to Cook's primary aims to
chart the new discoveries and to observe the 1769 transit of Venus across
the face of the sun, there were Banks's objectives – to observe and record the
human and natural life of the new lands and their flora, climate and
geology. The shared responsibility of the Royal Society and the Admiralty
for the voyage underlined the importance of these scientific aims. Banks
chose two naturalists, Daniel Carl Solander, who was to take charge of the
recording and classification, and Herman Dietrich Spöring; and two artists,
Alexander Buchan for topographical work and Sydney Parkinson
(1745–71) as the natural history draughtsman. Parkinson had already had

experience in drawing birds and animals for Banks from his Newfoundland and Labrador expedition (1766). Described and classified by Solander, a new plant was then drawn by Parkinson who normally had time to make only an outline sketch with colour notes. Later, often many years later, the finished drawing of the plant was made in England by Frederick Nodder (*fl.* 1777–1800). From his drawing a final engraving was made. It is possible to compare the dried specimen of a plant collected by Solander, preserved in the British Museum (Natural History), with Parkinson's sketch, Nodder's finished drawing, and the engraving (40–3). The method worked and it is surprising how convincing the final plant portrait often was. But because of Buchan's death, Parkinson was required to do the work of two men. The importance of Parkinson's graphic record is considerable even though the drawings of plants in their unfinished form – there are more than six hundred of them – give us only a small idea of the artist's undoubted ability as a plant draughtsman. Banks did not in fact publish the engravings as he intended, and the artist himself died before the end of the voyage.

Though Banks did not accompany Cook on his second voyage to the

Antarctic and the Pacific (1772–5), the *Resolution* and the *Adventure* carried a staff of astronomers, naturalists, and artists on the pattern initiated by Banks. Because of the nature of the voyage when the vessels did not come within sight of land for long periods of time the recording and portraying of plants played a much smaller part than before. William Hodges (1744–97), the professional artist employed, was concerned with seascapes, landscapes and visual phenomena, only occasionally with drawing trees and vegetation. The naturalists were Johann Reinhold Forster and his son Georg, both distinguished men, the latter of whom was also employed in drawing animals and plants, but he showed much less ability than Parkinson in this field.

The Admiralty reduced the staff of specialist assistants on Cook's third voyage (1776–80) which aimed to discover a north-east passage from the Pacific to the Atlantic, appointing a surgeon's mate, William Anderson, as naturalist; his assistant, William Ellis, acted as a natural history draughtsman. But a professional artist was considered essential and the man chosen was John Webber (1752–98). Though his main work was illustrative, he

40–43 Banksia, *Banksia integrifolia*.

40 *far left* Outline drawing, by Sidney Parkinson. Pen and ink and black lead outlines, with colour touches, 1770. 550 × 350 mm.

41 *left* Finished drawing, by Frederick Nodder (?). Watercolours, 1775–80. 540 × 365 mm.

42 *below* Line-engraving, 1775–80. 495 × 318 mm.

43 *below, right* Dried specimen collected from Botany Bay, New South Wales, 1770.

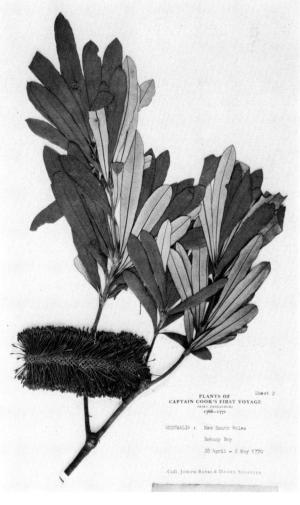

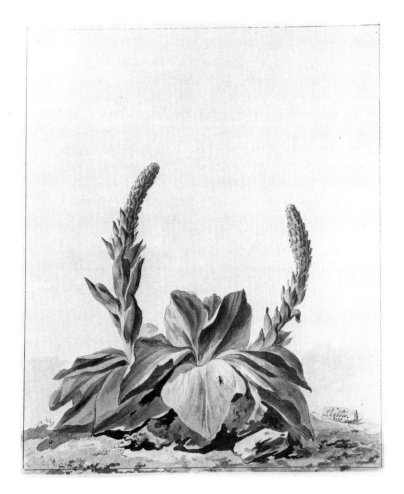

was a close observer of nature and of plants in particular. In his landscapes where trees and plants are found as well as in his rarer plant studies he shows, in the finished drawings, great attention to botanical detail. In others where such finish was not required he displays an easy broad and fluent brushwork revealing his understanding of the plant's essential form and structure (44). In his landscapes where there are also figures, we are immediately aware of his effectiveness with specific trees and plants and by comparison of his ineffectiveness with the human form. But, as Bernard Smith says, 'no voyage undertaken in the days before photography ever returned so well documented with pictorial illustrations'. Many of them, in the main subject or in detail, give a remarkable insight into the kind of vegetation found in nearly every part of the world touched at by the

44 *far left* Kerguelen Island cabbage, *Pringlea antiscorbutica*, by John Webber. Watercolours, 1779. 228 × 190 mm.

45 *left* Clary, *Salvia sclarea*. Coloured etching, by J. Sowerby after Ferdinand Bauer, from J. Sibthorp and J. E. Smith, *Flora Graeca*, vol. 1 (1806), pl. 25. 466 × 283 mm.

Resolution. And much of Webber's work was engraved for the official account of the voyage published in 1784.

Increased botanical activity in Europe, and that produced by the exploration and settlement of the Australian coastline, owed more to Banks's enthusiastic and informed patronage than to any other source during the 1790's and the opening years of the new century. Two of the greatest of all plant draughtsmen, the brothers Francis and Ferdinand Bauer, came to settle and work in England, or with England as a base, largely because of his support. Ferdinand concerns us chiefly as the explorer-artist while Francis, established at Kew in 1790 as draughtsman to the Royal Gardens, at Banks's expense, drew the plants which were brought there from expeditions in Europe, America, the East, and Australasia over the next fifty years. Ferdinand Bauer (1760–1826) met John Sibthorp, Sherardian Professor at Oxford, in Vienna and was persuaded to accompany him on a tour of Greece and the Levant in 1786. Sibthorp had been studying the Juliana Anicia Codex of Dioscorides in Vienna. As with so many other botanists its influence was potent and was the incentive to explore the land of Dioscorides and identify and record its incomparably rich flora, something of which Krateuas had begun to draw nearly two millenia before. The final result was the famous *Flora Graeca* (1806–40) and the incomparable collection of finished drawings which Bauer made from his field sketches now in the library of the Department of Botany at Oxford (45). But the explorer's instinct would not allow him to remain in Oxford, however congenial the work. In 1800 he accepted the invitation of Matthew Flinders, then planning his voyage to Australia. With Bauer on the *Investigator* there sailed Robert Brown the young Scottish botanist who was to become 'perhaps the greatest figure in the whole of British botany', and William Westall the landscape artist. It was an unusually adventurous and hazardous expedition but during the five years of the voyage Bauer worked prodigiously and the partnership with Brown was possibly more productive than any other we know of. After his return to England Bauer began the work of illustrating Brown's descriptions of Australian plants in *Illustrationes Florae Novae Hollandiae* but, unable to find artists to engrave and colour the plates, he decided to execute the work himself. But war conditions had made money scarce and the market for elaborate botanical publications had almost disappeared. Bauer was forced to abandon his efforts and left England to live in his native land near the gardens of Schönbrunn where he completed his drawings of Australian plants (plate 16; ill. 46). His work was enormously influential, a model for later explorer-artists, for example Sir Joseph Dalton Hooker (1817–1911) who expressly stated his admiration for Bauer's style of draughtsmanship which he sought to emulate.

The European powers and America sent a succession of voyages to the Antarctic and the Pacific staffed with scientists and artists on Banksian lines, some even more ambitiously as was Nicolas Baudin's expedition to the Pacific (1800–4) when he took, besides astronomers, zoologists and hydrographers, four artists and five gardeners. Though the zoological results in particular were of unprecedented importance the botanical were

43

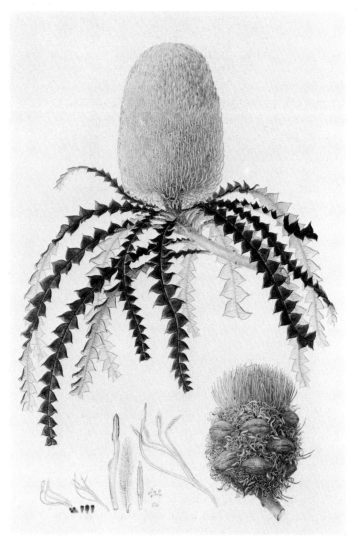

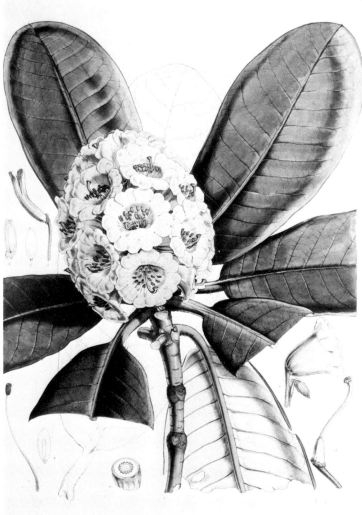

46 *left* Banksia, *Banksia speciosa*, by Ferdinand
Bauer. Watercolours, *c.* 1810–20. 525 × 360 mm.

47 *right* Hodgson's rhododendron, *Rhododendron
hodgsonii*. Coloured lithograph, by W. H. Fitch after
Sir Joseph Hooker. From J. D. Hooker, *The
Rhododendrons of Sikkim-Himalaya* (1849–51).
497 × 364 mm.

somewhat meagre when compared with those of Brown and Bauer. J. D.
Hooker, primarily a botanist but also a self-taught artist of some distinction,
sailed with Sir James Ross on the *Erebus* to the Antarctic (1839–43). As no
professional landscapist was appointed Hooker found himself undertaking
coastal profiles and topographical work which sharpened his artistic
faculties whether in recording marine creatures or icebergs – for there were
few plants to be observed. His artistry stood him in good stead when a few
years later he visited the Himalayas and Australia as a free-lance botanist.
His admirable drawings of rhododendrons in Sikkim were lithographed by
W. H. Fitch for *The Rhododendrons of Sikkim-Himalaya* (1849–51; ill. 47). He
made a detailed study of the flora of Australia and Tasmania, no doubt
stimulated by the earlier work of Brown and Bauer, noting their strikingly
distinctive characteristics. His experience of the vegetation of Europe and
parts of Asia made him question the immutability of species in a way which
closely paralleled the ideas of his friend Charles Darwin. He finally accepted
the truth of the descent and modification of species in his *Flora of Tasmania*

(December, 1859) which appeared only a few weeks after the *Origin of Species*.

The drive to collect and record new plants increased as the nineteenth century advanced but the development of the camera eventually greatly reduced the number of artists in the field. Before this happened in the later years of the century the English, and the French in particular, used their colonial possessions to further botanical knowledge by discovery, scientific description and illustration. But the artist's ability to observe intently and to use his skill to emphasise particular aspects of a plant's physical make-up can often surpass the capacity of the camera. As plant discoveries continue so does the work of recording them, and the artist, whether amateur or professional, is still likely to play a part in portraying them though not necessarily in the old way by means of elaborate and carefully finished drawings. A recent example of the work of a collector who was also an artist is that of Rear-Admiral Furse (1904–78) who travelled in Turkey and Iran in 1960 and a few years later in Afghanistan and Iraq. As a result he made an unprecedented collection of bulbs for the garden of the Royal Horticultural Society at Wisley and drew many species of crocuses, irises, fritillaries and tulips which admirably illustrate the vitality of an old tradition.

East India Company Artists

While some bold European botanical artists were exploring much of the rest of the world for new plants, the officers of the British East India Company were using the native talents of Indian and Chinese painters to do the work for them. As a result, many thousands of very high quality coloured drawings of Asian plants came back to Britain, where most are still to be found in the great London museums and libraries.

Like their Dutch counterparts, the British East India Company were not only worldwide merchants but also in some areas colonisers and Imperial administrators. In much of the Indian subcontinent they were until the reign of Queen Victoria entrusted with actual government. A position of such influence over huge areas of the globe gave them an unquestioning confidence in the virtues of their own European civilization. In the small field of botanical painting this attitude allowed them to impose European standards and ideals on Asian artists with the fascinating results we very often find in good hybrids, whether they be floral, artistic or in a whole way of life.

As we describe in chapter five, the Mughal Emperors encouraged both flower portraits and flowers as decorative borders in miniatures. Splendid results were achieved in the traditional gouache technique (plate 26); but in the mid-eighteenth century when Company officers began to commission Indian artists to produce pictures to record 'exotic' aspects of life there to take back to Britain, they soon became dissatisfied. The opaque gouache seemed to them too garish, too apt to flake from its highly prepared thick paper, and lacking in the clear, precise line they expected from the European tradition. They frequently complained about the lack of perspective, of modelling by light and shade, and of 'taste'.

These objections now seem in their turn naive and a result of cultural confusion, but they had no hesitation in training the many Indian artists who were looking for work as the patronage of the Mughal Empire gradually broke up. These men were rigorously taught to use flexible European paper, to copy exactly from nature in sepia ink or pencil, and to fill in with watercolours of which the brightest pigments could be muted with grey wash to conform to the restraint of current British taste (plate 20).

This process had already occurred a century before in an otherwise isolated enterprise with the publication of *Hortus Indicus Malabaricus* in Holland in 1678–1703 (see p. 33). It is quite clear from the nature of these engravings that most of them were taken from drawings by Indian artists in Malabar. They show all the decorative qualities found in the drawings done for the British by Indian artists a century later, and even the details of technique are similar. In particular, the tendency for them to spring straight out of the edge of the paper and to slant diagonally across it are very characteristic of these hybrids of European and Indian art.

The Indian artists were quick to learn what their British masters wanted, and nowhere were they more successful than in plant drawing. This was readily admitted by late eighteenth-century patrons like Thomas Twining and Michael Symes, who were however critical of other aspects of their performance. But the British were hard taskmasters. One large drawing of *Musa Robusta* now in the library of the Kew Herbarium is inscribed: 'Most abominable leaves for which Master painter shall be duly cut with reference to his months wages'. It was in fact in large, glossy leaves and big, gaudy blossoms that the Indian Company artists most often failed. This may seem surprising in view of the bright, bold approach of native styles, in which powerfully drawn jungle vegetation often plays a major part (63). But we must remember that in the native paintings a tradition of rather effective simplification of form and colour had grown up over several centuries to cope with the artistic problems set by such forms. This did not translate well into the European watercolour idiom, and few of their images of the more garish plants can compare with those, for example, of Maria Merian. A later British civil servant in India put his finger on their true talents when he said:

The native artist is also patient: for weeks and months he will work at his design, painfully elaborating the most minute details; no time is considered too long, no labour too intense to secure perfection in imitation or delicacy in execution. (B. H. Baden Powell, *Handbook of the manufactures and arts of the Punjab*, Lahore 1872, as quoted by Mildred Archer in *Company Drawings in the India Office Library*, London 1972).

We can readily show these virtues in such miracles of delicate and complex draftsmanship as *Ipomaea* (48), a plant too fine to be done in ink or pencil first, but painted direct, mostly in green watercolour, with a very fine brush.

All the Indian botanical drawings illustrated here are from the collection of Major Thomas Hardwicke now in the British Library (Department of Manuscripts), a group of over a thousand done in the heyday of this genre around the year 1800. Hardwicke (1756–1835) was one of the many British who trained artists to do botanical work, and his collection shows both successes and failures. *Merremia* (49) and *Caesalpina decepecala* (plate

48 Cardinal climber, *Ipomaea quamoclit*. Botanical watercolour drawing by an anonymous artist. India, about 1800.

19) must rank among the most beautiful botanical studies ever produced. *Melia* (50) is a quite delightful study, but there is a confusion in the lower leaves which could not have happened to a European artist; having learned that a pale wash can be used to show the leaves which are further from the viewer, and having successfully applied that technique at the top to give an almost romantic impression, he has at the bottom actually drawn the paler leaves over and in front of the bolder twigs and berries. The artist of *Bauhinia* (plate 20) has mastered wash, and produced a masterpiece of delicacy which must have impressed even Hardwicke.

Though the British commentators saw most of the virtues of their Indian

49 *left Merremia dissecta*. Botanical watercolour drawing by an anonymous artist. India, about 1800.

50 *right* Bead tree, *Melia Azedarach*. Botanical watercolour drawing by an anonymous artist. India, about 1800.

artistic employees, they seem to have missed one important point, perhaps because they were not deeply interested in the native traditions they sought to alter. A glance at the reproductions will show a strong element of pattern-making. It was unconsciously encouraged by the need, for botanical reasons, to include details of seeds, stamens and the like, which were fitted in by the best artists with a very apt sense of placing on the page. *Caesalpina decepecala* is an extreme example. Accurate in every detail, it yet uses the natural curves of the stem and the precise coils of the tendrils to fill the whole sheet out into a pattern which could almost be from a carved Mughal panel in marble of the seventeenth century. It is this combination of unconscious native traditions of design with great accuracy that gives the best of these paintings their unique charm. *Merremia* (49) is another example where the leaves are so crisply done as to resemble carving in stone. The design element in native Indian painting is discussed in chapter five.

These Indian paintings usually lack a sense of *natural* movement. *Bauhinia* (51) is a rare exception with its dynamic thrust from bottom right

to top left. To the Chinese an ability to express a feeling of nature's life and movement was their artistic birthright. When the British East India Company set up their Canton offices in the early eighteenth century, Chinese artists had been painting flowers with unequalled skill for at least a thousand years. The British were not colonists in China, so that the situation was altogether rather different from that in India.

Nevertheless, such was the demand for paintings of the exotic flowers of the East and such the enthusiasm of British botanists, that work soon began to be commissioned and sent back to Europe. Among the earlier arrivals must have been those from an album owned by Sir Hans Sloane who died in 1753 (plates 21, 22). On comparing such paintings with their Indian counterparts one is struck by the ease with which the Chinese provided

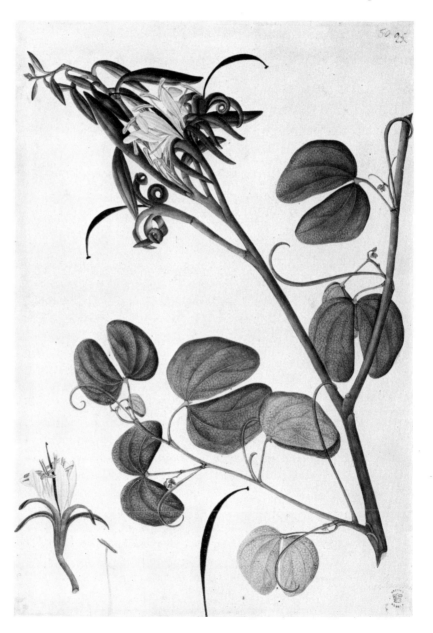

51 *Bauhinia*. Botanical watercolour drawing by an anonymous artist. India, about 1800.

52 *above* Epidendrum. Botanical watercolour drawing by an anonymous artist. China, early 18th century.

opposite
53 Paeony. Botanical watercolour drawing by an anonymous artist. India, about 1800.

54 Hibiscus. Botanical watercolour drawing by an anonymous artist. China, about 1800.

55 Mango bough. Botanical watercolour drawing by an anonymous artist. China, about 1800.

56 Lichee bough. Botanical watercolour drawing by an anonymous artist. China, about 1800.

something acceptable for their European customers with the minimum of alteration to their own techniques. The epidendrum in illustration 52 could almost come from a painting for native taste. Its easy elegance is the result of many centuries of painting the epidendrum (orchid), which was one of the 'noble plants' so admired by scholar-painters (chapter six). Similarly the chrysanthemum (plate 21) would not look out of place in either a European album or a Chinese decorative painting of the period. Yet all are accurate enough to please the botanist.

The secret of this ease lies in the fact that the artists were using techniques they understood. The paintings are on thin, absorbent Chinese paper. Its silky whiteness brings out the subdued brilliance of the water-based pigments, a little extended in their variety, but traditional. The designs are sketched in a light brush line which completely disappears when the colours are applied. Where the Indian artists had to learn, not always with good results, such tricks of the trade as painting the underside of leaves in green pigment lightened with white to give them body, the Chinese had known them from the Sung period. Most striking of all, the Chinese artists had no difficulty in placing their specimens on the page in an easy and natural manner.

Some of the pages in this album were undeniably 'exotic' to Western eyes with their great insects hovering over the flowers (another tradition from the Sung Dynasty). By around 1800, the peak period of demand for Asian botanical drawing, the Company officers had trained some Chinese in the European manner, especially in the East Indies, and the work of all of them is modified somewhat. A later album than that discussed above is in fact from the series collected by Hardwicke. It includes the yellow rose (plate 18) which is among the most delicate of all botanical paintings and which can stand comparison with the finest work of Redouté. But strong native traits remain. The paeony (53) is done with the loving patterning made famous by Yün Shou-ping (1633–90) and there is a preference for the withered or insect-bitten leaf rather than the 'ideal' specimen desired by Western botanists. The delicate white hibiscus blooms (54) are subtly emphasized against the equally white paper by a very quiet grey wash round them. And the modelling of mangoes or lichees (55, 56) is accomplished by a method known in the Sung Dynasty of dotting a dark shade onto a lighter. For these reasons, the Chinese artists were much more successful than the Indians in portraying fruits and brightly coloured flowers.

After the early nineteenth century, these admirable botanical schools began to decline and gave place more and more to flower paintings of the 'souvenir' variety. This was perhaps caused by the increasing numbers of Western tourists in these countries. Typical of what they bought were the clever but usually uninspired little paintings done on sheet mica in India, or in China on the silvery inner bark of a native tree. This latter is one of the many materials wrongly described by Europeans as rice-paper.

53

54

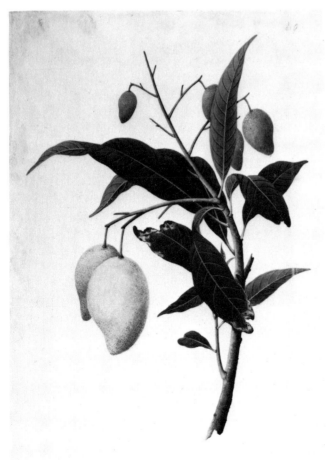

55

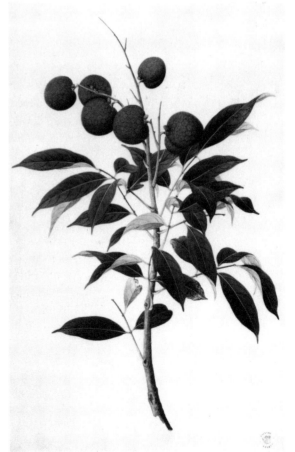

56

5
Flowers for pleasure in India and Islam

The greater part of this book is devoted to Europe, China and Japan. There lies in between an enormous expanse of the Old World, where there were regions of high civilization in which flowers, plants and trees were as much loved and appreciated as anywhere. Yet the portrayal of flowers in the art of these countries, while not negligible, certainly cannot compare in scope, seriousness or variety with that of Europe or East Asia. A quick look at the reasons for this relative deficiency (and it is only relative) will help to explain the nature of painting itself in the wide area from Turkey to S.E. Asia.

The most important reason is probably one of attitude to flowers and plants themselves. In Europe the dominant feeling was of scientific curiosity; in East Asia it was both artistic and philosophical; but in the Asian lands between, it was simply one of pleasure – in scent, in colour, in the coolness and romance of gardens, in the way flowers can delight the heart whether in a plucked nosegay or growing wild in the desert (plate 24). This trait was encouraged over all Western Asia and India by the hedonistic outlook of kings and princes, who in the period we are discussing were overwhelmingly the most important patrons of painting. There was generally lacking that additional large body of ecclesiastical, scholarly and middle-class patronage which existed in Europe, China and Japan and encouraged wider attitudes and varying formats. Further there was virtually no use of printed techniques until the nineteenth century. Chapters eight and nine explain how the presence of such techniques help to widen the scope and understanding of painting and encourage all its forms.

At this point we should glance at the long 'classical' period of Indian culture, which is usually taken from the emergence of the plastic arts under the Emperor Ashoka in the third century BC and continues to the Muslim invasions of the thirteenth and fourteenth centuries AD. A glance at the many styles of architectural ornament and sculpture which existed in different areas over that long period will show a very lively appreciation of flowers and trees and a delight in their natural forms. In particular, the central symbol of Buddhism, the lotus, is very widely found. It is also found in the palm-leaf manuscripts of Buddhist scriptures which must have existed in large numbers but of which only a small proportion survive, none from earlier than the eleventh century AD. Being painted for religious patrons, the lotus always tends to the symbolic and the philosophical rather than the naturalistic. There is a gravity in these palm leaves which is not found in India after the decline of Buddhism. Although it falls largely outside the scope of this book, it is necessary to emphasise that Buddhism alone had a flower as its central symbol, and that this reflects the very deep sense of respect which has always been one side of the reaction to the natural world in India.

Formats are a further vital factor. In Islamic Asia almost entirely, and in India to a very large extent, royal patrons commissioned the illuminated and illustrated manuscript in book form, or the intimate picture-album. Wall-painting was never favoured by the Muslims, and after they invaded Northern India in the thirteenth century, murals, which are particularly associated with Buddhist shrines, disappeared there too. There was almost

no equivalent of the flexible medium-sized formats which artists could adapt to their own aspirations elsewhere – the unmounted drawing and the framed painting in Europe, the hanging scroll and the handscroll in China and Japan. The book form was restrictive not only in its size, which was for practical reasons usually rather small, but also in technique. Throughout the period we are discussing, the fourteenth to nineteenth centuries AD, miniatures and borders were nearly always done in gouache – opaque powdered pigments mixed with egg or gum – on highly prepared paper. This was an inflexible medium, and only painters of the highest skill could handle it adequately. It also lacked the nuances possible in European watercolours or Chinese ink, and it discouraged any emphasis on line, which has elsewhere been a necessary instrument for accurate representation of flowers.

Painting itself, therefore, laboured under severe restrictions, and flowers and plants were a marginal subject – literally marginal in the beautiful floral borders of Persian or Mughal miniatures (57). Yet a further disadvantage was the official Islamic disapproval of copying from nature. Although this was rarely enforced and in any case applied more to the animal kingdom, it did tend to discourage a search for naturalism. Yet in spite of all these apparent problems, anyone who looks at Persian or Mughal miniatures will take away a strong impression of flowers as one of the most memorable and joyous features of those paintings. It is time now to turn to that positive achievement.

Flowers and trees begin to bestrew the landscape backgrounds of Persian miniatures from the fourteenth century onwards (plate 24). The Mongol conquerors from the East brought with them an art both more vigorous and more in touch with the natural world than the formal symmetries of the Arabic Muslim culture which had prevailed all over the Islamic world until then. They also brought the concept of landscape itself, without which flowers cannot appear to grow naturally, and by their contacts with China they brought new insights into how a tree or a flower could be painted. Expressive sinuous individual trees, derived from Chinese Sung court painting via decorative arts like embroidery, lacquer and porcelain, became an important decorative element in Persian painting also. A Persian line-drawing in the Chinese style, of birds, trees and flowers (58) executed about 1400, shows the gnarled, twisting form of tree trunk which was used in Persian miniatures thereafter (59). Affection for individual trees, perhaps natural in the semi-desert lands of Western and Central Asia, is a very marked feature of both Persian painting and its Indian derivatives, and some miniatures with apparently human or animal subjects seem in fact to be tree portraits (60). In the splendid late sixteenth-century version of the *Babur Namah* (Memoirs of the Mughal Emperor Babur) in the British Library, there are in fact many pages of actual tree portraits. This is a side of plant drawing not much followed in Europe, or indeed in China, where the ink paintings of the pine and plum tree derive from a very different attitude (see chapter seven).

Although the individual tree often figures prominently in Persian painting (59), the flowers also make a great impression and seem to

57 Mixed flowers. Border in gold on blue from a Mughal MS. India, about 1630.

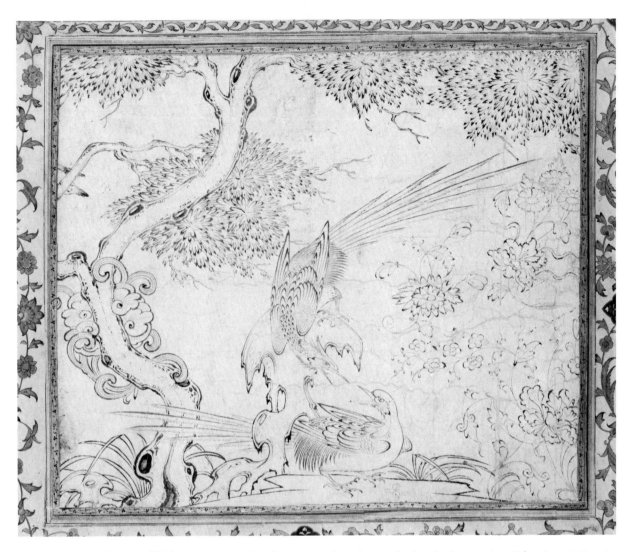

58 Chinoiserie tree, flowers and birds. Anonymous ink drawing. Persia, 14th century.

symbolize the more relaxed attitude that had come into Islamic painting in the fourteenth century (see plate 24). They are usually in fact tiny, for they are painted in proportion in landscapes and garden scenes which are themselves already miniatures. But they stand out brilliantly in the green grass, tawny sand or pink-grey rocks in which they are set, usually under a sunlit blue or golden sky. A beautiful example is illustrated in plate 24 from the foreground of the scene of Sultān Sanjar and the old woman from the *Khamsa* of Nizami in a manuscript painted at Tabriz in 1539–43. The flowers, scattered on the grass, are of many species and most delicately executed. They include an improbable assortment of more or less accurate depictions of favourite blossoms. The effect is of slightly unfocussed delight, a very normal human reaction to flowers. The gold-decorated border of this miniature is another example of a Persian innovation, in which flowers frequently play the most important role. In this marginal position, they always have a tendency to a formal symmetry which makes them unrecognizable and therefore beyond the scope of this book. But the border passed into Mughal painting in India and there for a while, especially under

54

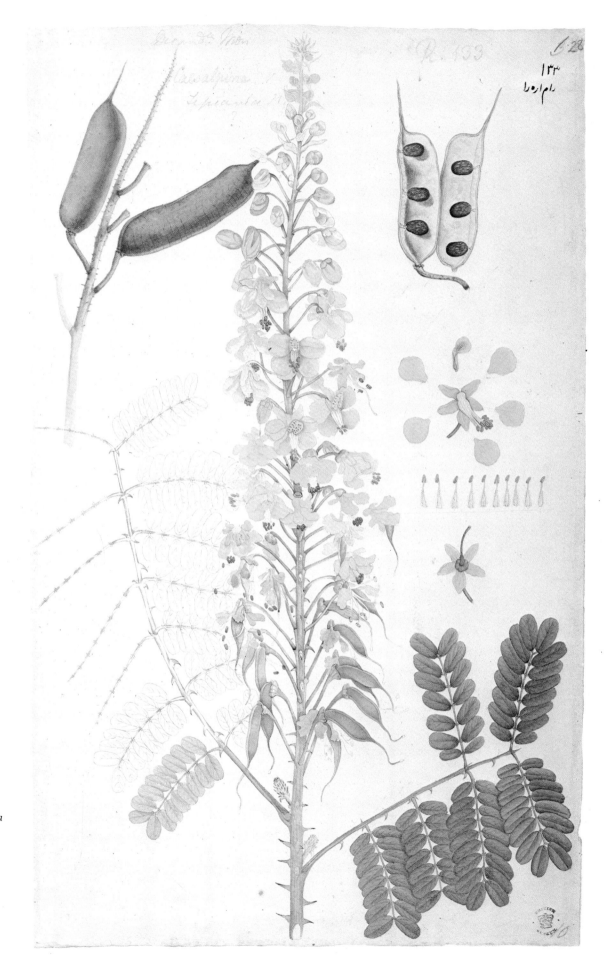

19 Mysore thorn, *Caesalpina decepecala*. Watercolours on European paper, by an anonymous Indian artist, about AD 1800.
440 × 281 mm.

21 Crown daisy, *Chrysanthemum coronarium*. Watercolours on Chinese paper, by an anonymous Chinese artist, early 18th century. 430 × 315 mm.

20 *above Bauhinia*. Watercolours on European paper, by an anonymous Indian artist, about AD 1800. 440 × 320mm.

22 *left* Florist's chrysanthemum, *Chrysanthemum × morifolium*. Watercolours on Chinese paper, by an anonymous Chinese artist, early 18th century. 425 × 320 mm.

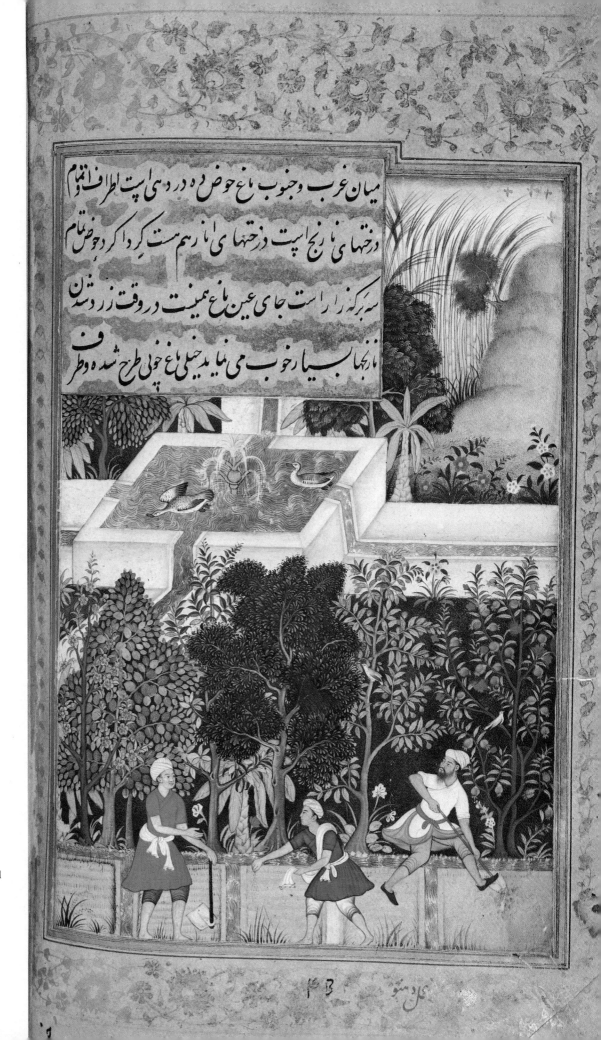

23 Laying out the Gardens of Fidelity at Kabul in 1504. Miniature in gouache on paper by Dhanū, from an illustrated Mughal MS. of the *Babur-nama*. India, about AD 1590.

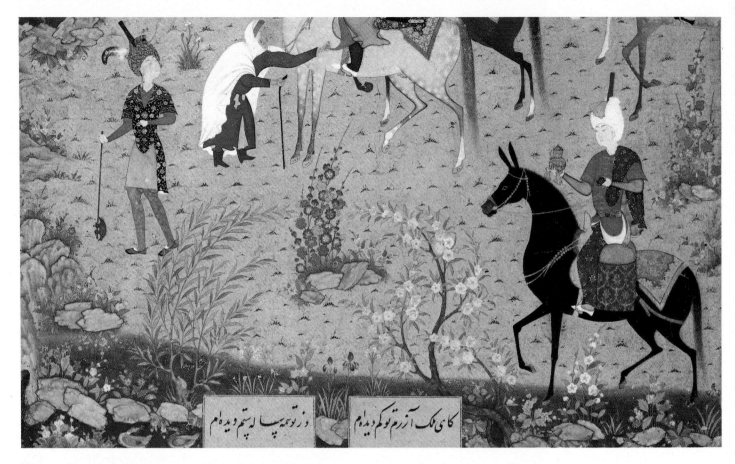

كاى ملك آزرم تو كم پاله ستم ديده ام و زتو تمه پسا لاپه ستم ديده ام

24

25

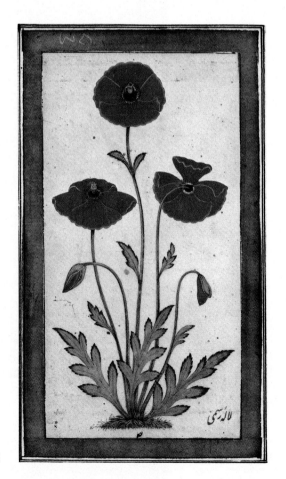

26

59 *left* Rustam killing the White Div. Miniature, perhaps by Aqa Riza, from a MS of the *Shah Namë*. Persia, about 1580.

60 *right* Ascetics under a Banyan tree. Anonymous miniature painting. India, Mughal, 1630–1.

24 Sultān Sanjar and the old woman. Detail of miniature in gouache on paper by an anonymous artist, from an illustrated MS. of the *Khamsa* of Nizami. Persia, dated AD 1539–43.

25 Young woman on a terrace holding a lotus bloom. Miniature in gouache on paper by an anonymous Mughal artist. India, 18th century.

26 Field poppy, *Papaver Rhoeas*. Miniature in gouache on paper by an anonymous Mughal artist. India, about AD 1615.

the Emperor Jahangir (reigned 1605–27), became a lively field for naturalistic or semi-naturalistic plants. In illustration 57 a detail is reproduced from a rich border in gold on blue which surrounds a portrait of Mir Jamla by the artist Shivdas. Here the plants have a sense of natural growth, and one feels the artist had genuine examples at least in mind. A movement to greater expressiveness is found in a border (61) of a portrait of Jahangir himself by the artist Manohar, where the flowers are painted in lively colours and strewn around on a white ground. Both these are in the Victoria and Albert Museum in London. But naturalism may be illusory, especially in Mughal India where artists in spite of their technical skill always tended back to the formal. A miniature in the same collection done by Farrukh Beg in 1615 shows a fantastic, multicoloured tree, and has a border which includes orange narcissi with blue trumpets.

The conquest of Northern India by the Mughal Emperor Babur (reigned 1482–1530), who came from Western Central Asia, took the Persian style, then the most advanced in the region, and transplanted it to a totally different environment – one of aridity alternating with monsoon, steaming heat, dense jungle and tropical vegetation. He also took a passionate interest in plants, recorded in his vivid memoirs known as the *Babur Namah*,

and a near-obsession with creating gardens wherever he went. By the time
of his grandson Akbar (reigned 1556–1605) native artists had added their
denser and hotter colours to the Persian style and transferred it to their own
landscape, thick with trees and gaudy flowers. A famous manuscript in this
new Mughal style illustrates the *Babur Namah*, and includes descriptions
and portraits of many flowering and fruiting trees. One well-known
miniature from it shows the laying-out, at Babur's orders, of the Gardens of
Fidelity in Kabul (plate 23). Babur loved the flowers he encountered on his
journeys of conquest, expecially in Afghanistan and Kashmir. This scene
shows the characteristic dense green tree foliage and brilliant flowers of the
Mughal style.

Gardens were important to the royal patrons of painting in Persia and
India. One needs look no further for the reason than the inhospitable desert
or jungle environments in which they lived. Gardens themselves frequently
provide a subject for painting or at least a setting for a human scene in
which the garden is, as it were, the chief participant. It is never the

individual flowers which are prominent in these miniatures, but rather the formal flowery scene. The chief part of the pleasure seems to have been the sense of an oasis of tamed and subservient nature. There are some splendidly formal Mughal examples, while illustration 62 shows the spread of the idea to the more Indian schools of painting peripheral to the Mughal Empire – in this case Rajasthan to the south-west. The romantic walled garden had meanwhile passed to Europe via the Islamic world. Portraits in both Islamic Western Asia and India frequently showed the subject holding or smelling a single flower. The appreciation of such things was clearly part of the equipment of the civilized man or woman. In plate 25, a young woman both holds a flower and stands against a background of a walled garden.

Under the Mughal Emperors a more scientific attitude to the study of the natural world was added to the enthusiasm which already existed for it in both Persia and India. In the reign of Jahangir, examples of European drawing and engraving began to influence the court painters, and this resulted in a brief period of precise, beautiful and accurately observed plant and tree portraits. The painter Mansur is recorded in Jahangir's *Memoirs* to have painted hundreds of flowers in a day on a visit to Kashmir. In plate 26 an elegant poppy from the 'Clive' album in the Victoria and Albert Museum is illustrated. These miniatures compare very favourably with contemporary European plant drawings, but they retain a decorative quality which is here perfectly balanced with naturalism but which contains the seeds of later degeneration into the merely pretty. Some miniatures of the time actually copy European originals, for example a martagon lily from the same album, which is taken directly from Vallet's *Le Jardin du Roy*. This brief period, in which lively and recognizable plants (as well as living creatures) appeared in miniatures, in architectural decoration, carpets, textiles and other applied arts, is in some respects akin to the naturalistic bias of the Chinese Sung Dynasty described in chapter one. Like that imperial culture, it changed into a more diffuse and decorative style, but much more quickly than in China, because the Mughal court was at base always an alien imposition using a foreign language (Persian). The native tendencies of the large populations under the imperial sway were always there even in the early maturity of Mughal painting. A most striking example is the rich jungle setting of a scene from the epic *Hamzanama* (63). This is one of a set of unusually large illustrations on fabric done at the behest of Akbar during the years 1567–82. The trees and flowers have naturalistic details such as the moulded shading of the trunks, but the overall impression is of mysterious, dark forces, partly to be loved, partly feared, partly accepted.

This mixture of love and apprehension is very different from the analytical Mughal outlook and from the European attitudes which influenced them even further in that direction. It existed already in the early sixteenth-century miniatures of Rajasthan, and it continued to exist all over the peninsula. One can quote a mysterious, flower-laden night scene from the Punjab Hills (about 1770; ill. 64); the vigorous, though polished array of trees and flowers in Kotan hunting scenes of the eighteenth century (65); the joyous profusion of distorted yet somehow living flowers in a saci bark manuscript from Assam (about 1836–7) showing Krishna dancing with

61 Mixed flowers. Painted border from a Mughal MS. India, about 1630.

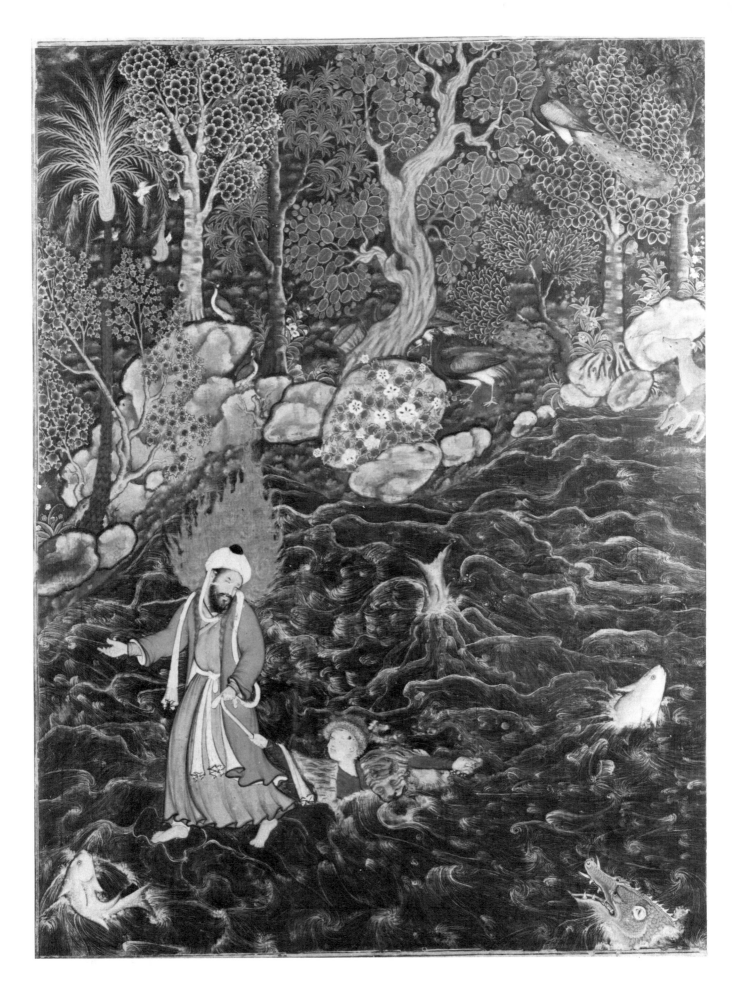

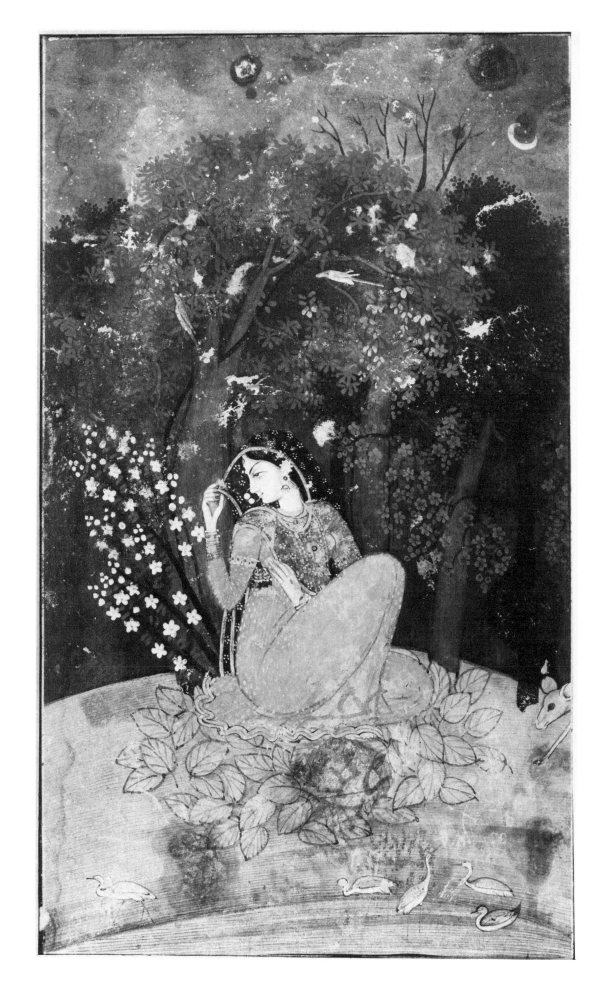

63 *left* Khidr-Ilyas rescuing
Prince Nur al-Dahr.
Anonymous painting in
gouache on fabric from the
Hainza-Namë of Akbar. India,
Mughal, 1567–82.

64 *right* Rhada waiting for
Krishna. Anonymous painted
miniature. India, Garwhal,
about 1770.

65 *top* Hunting boar. Anonymous painted miniature. India, Kotah, about 1775.

66 *bottom* Krishna dancing with the cowherds in the groves of Gokula. Anonymous painting on saci bark. India, Assam, about 1836–7.

the cowherds in the groves of Gokula (British Library, ill. 66) and in the more austere but still exuberant idiom of an Orissan palm-leaf manuscript of the seventeenth century showing the milkmaids walking in the groves of Brindaban (British Library). This last is incised in the leaf and then partly coloured in. It represents a continuity with the Indian classical tradition of palm-leaf painting which also survived in Nepal.

Although Mughal flower portraiture quickly turned into decorative motif after Jahangir, there were two areas in the Islamic world where semi-botanical flower portraits were painted up to the nineteenth century – Ottoman Turkey, and Qajar Persia. In the case of the Turks, there seems to

have been a genuine interest in accurate detail and in botany itself as well as a more traditional love of flowers. European travellers encouraged these tendencies by obtaining albums of native species, which themselves had a considerable influence on seventeenth-century European horticulture (the tulip was the most famous import). These Turkish drawings show considerable European influence. In Qajar Persia in the eighteenth and early nineteenth centuries, the impetus came also from European sources. The very crisp iris by Muhammad Rizā (67) is a pleasant example of this hybrid style. In both Turkey and Persia, the sudden influx in the nineteenth century of European engraving and lithographic techniques obliterated native painting.

67 Iris, by Muhammad Rizā. From an album of sketches and portraits. Persia, about 1830.

6
A world of colour – floral painting in China and Japan

In chapter one we described briefly the ideas and attitudes which produced a brilliant school of naturalistic flower painting in China at a time when European art still had several centuries to develop before reaching a similar level of success. The Sung achievement was realized with certain materials, techniques and formats which were to be very little modified in later centuries in China and Japan, and it will help at this point to describe them, for they immediately explain many of the differences between European and Far Eastern painting which are obvious even to the most casual viewer.

A comparison of the splendid later Sung handscroll (5, plate 27) with any of the European drawings or watercolours illustrated in this book may bring out the most essential difference. The European flower study convinces us of its reality because of its faithfulness to the detail of the original and its clear analysis of the plant's structure. This appreciation may not develop until we have looked hard for a minute or two, and part of our admiration may lie in the long scrutiny we feel the artist himself must have given to his subject. But it is very often a *specimen*, a cut or uprooted example of the flower, that the European artist has drawn. The Chinese painting, however, gives an immediate feeling of life, growth and movement. This movement can be felt in even the most decorative paintings and prints of China and Japan in all periods after the Sung Dynasty. A quick look at the examples illustrated in this book will confirm that impression. Life is present even in the cut flowers of Ch'en Hung-shou (plate 32), a painting which is otherwise an extreme instance of elegant artificiality.

This feeling of life comes from the sense of movement in the ink line, which is the basis of most Far Eastern painting. It is implied even in those styles which they themselves described as 'boneless' or 'without line'. Why was this so? The answer is provided by the brush itself, which was the instrument of all painting, from the grandest and most finished academy work down to the slightest sketch, and which was used for both the ink under-painting and the colour work of the former as well as for the complete execution of the latter. This brush was put in the hands of every child who began to write, for there were no pens or pencils, only the infinitely flexible and versatile brush, which he must master as early as possible to be an educated person. The intimate connection between calligraphy and painting is explored more closely in chapter seven, which describes a type of art which does not exist at all in other parts of Europe and Asia.

The brush developed in China to use with ink on silk or paper. When colour was used it had to be more or less of the light consistency and texture of the ink in use for writing and outline. Both the suppleness of the brush and the surface made that inevitable. The colours were therefore, like the ink, water-soluble, sometimes slightly stiffened with gum, and the traditional mineral pigments did not radically change over the centuries discussed here. It was a characteristic of these pigments that they could not be mixed to produce an infinite variety of shades in the way that Western oil colours or watercolours could. Only the mixing of shell-white with pigments was widely practised to alter the strength of the tones. This resulted in a fresh but soft clarity in the use of colours which justifies the term 'a world of colour' in spite of the narrow range of the tones used.

68 Tiger lilies, by Tsubaki Chinzan
(1801–54). From a painted handscroll.
Japan, mid-19th century.

The formats used also imposed their restrictions on colour, for the
traditional insistence in China and Japan on lightness, portability and
space-saving storage led to standard types of painted surface which would
not take heavy pigment without damage. The small single leaf was often
mounted into a folding album, the surface of which would be rubbed by the
page above if the colour were too thick. Chinzan's paeony is an example of
this type (plate 28). It could even be made into a half-size album, each leaf
itself folded down the middle, as in the Bunchō hibiscus in plate 36. With a
central fold, no sort of built-up painted surface could be used at all, for it
would inevitably crack. The folding screen which became so popular in
Japan in the sixteenth century offered wider and stouter surfaces, but they
would rub each other when folded. Further, they had for practical reasons
to be very light, so a broad surface capable of taking a thick oil or egg-based
pigment was not usually possible. The most important forms for painting, as
for calligraphy, were handscrolls and hanging scrolls. A handscroll was
unrolled a section at a time on a table for intimate viewing. Hanging scrolls
were unrolled and hung for viewing for a short time. The tensions on the
rolled surface made only the lightest and most flexible materials practical,
and of course the pigments had to have a similar flexibility if they were not
to crack at every point. So strong were these traditions that oil painting,
with its undeniably greater ability to produce an illusion of reality, never
seriously caught on in East Asia until the later nineteenth century, and
such earlier artists as tried it tended to imitate oils in their own materials.
The Japanese Shiba Kōkan (1747–1818) was notably good at that, and in
China the Jesuit Castiglione (1688–1766) perceptively adapted Chinese
techniques, formats and materials to the expression of European ideas of
light and shade, perspective and modelling.

None of these restrictions in fact deflected artists from trying to make
their pictures of flowers and plants as alive as possible. One way, as we have
seen, was through movement of line. This vitality extended to areas of pure

69 Gourd, by Kyōho. Painted album-leaf. Japan, mid-19th century.

colour in line or wash, as for example in the extremely convincing movement in Tsubaki Chinzan's glorious handscroll of about 1850 loosely based on the style of the Chinese master Ch'en Shun (1483–1544; 68). Another was to wash one colour over another which was still wet, so that they shone through and modified each other. This was not the same as mixing colours, for both remained clearly visible. The masters of the Japanese Maruyama-Shijō School in the early nineteenth century were particularly adroit at that technique, none more so than Kyōho (69). In such combinations, one element was often pure ink, which gave the possibility of producing a light-and-shade effect.

More central to the concept of skilled brushwork, however, was the loading of a wide brush with different strengths of the same pigment, some thinned with water to the palest wash, and then to produce a whole modelled and shaded petal or even a whole plant in one breathtaking stroke. Again the Maruyama-Shijō masters were unequalled at this technique. A particularly fine example is a group of roots and funguses (70), by Yamazaki Toretsu (1786–1837).

Finally, artists could superimpose a darker shade of a colour over a paler wash to produce a rounded form. This was very useful for the depiction of fruits, and is seen in full maturity in the Sung lichees in the handscroll illustrated in plate 27. The use of pink over white is equally effective in the

64

lotus flowers in plate 1. Indeed, the white obtained from ground sea-shells was to prove one of the most useful pigments in both China and Japan, because it could be laid on flat but not too thick. It could form a base to give greater depth to a pigment laid over it, or details could be painted onto it without loss of clarity, and, as we have seen, it could be mixed with other colours. It was naturally much used for white paeonies and chrysanthemums, and in its 'piled' form it played a prominent part in such Japanese decorated screens as the fine pair by Watanabe Shikō (1683–1755) in the Ashmolean Museum, Oxford and the anonymous eighteenth-century doors (plate 31).

Thus the Chinese or Japanese artist with different means and different traditions was able to produce as impressive results in flower painting as any European. In the Sung Dynasty there was indeed a great achievement, especially when we consider how very few works from that period can have survived. Why, then, was this high level not maintained or improved on as it was in Europe from the Renaissance onwards? The answer is quite a simple one. Painting of the natural world cannot survive for long without direct observation by the artist of his subject. In China, after the Sung Dynasty was destroyed by the invading Mongols in the late thirteenth century, the habit of precise observation was lost among the courtly painters who specialized in birds and flowers. Without that enthusiasm for

70 Edible root and fungi, by Yamazaki Tōretsu (1786–1837). Painted album-leaf. Japan, about 1830.

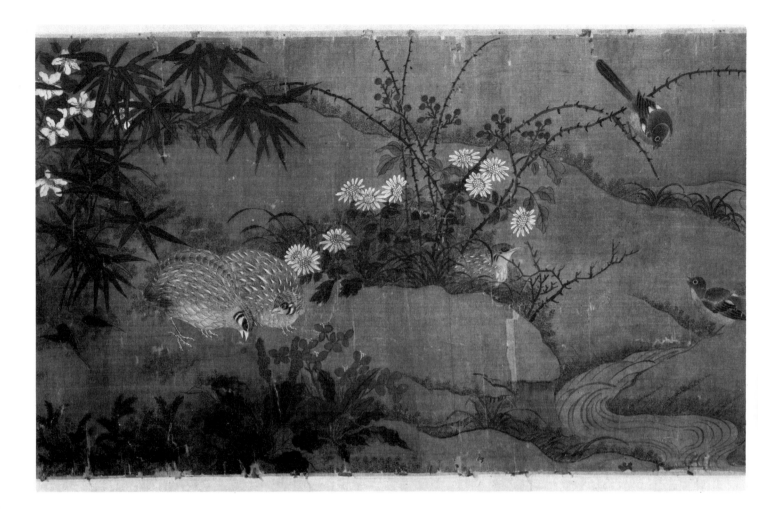

71 Quail and autumn plants. From a painted handscroll by an anonymous artist. China, 17th century.

the original plants which in Europe came with the scientific revolution of the Renaissance, painters declined into what we describe as the decorative, or into mere repetition of the works of Sung masters.

Before passing to a broad look at floral art in China after the Sung, we must mention two important points. One is that the term 'decorative' need not at all be a derogatory one. If the artist has other sources of vitality, then his work will be vigorous. This is true of the screen painting of Japan which we shall discuss later. The other is that in China direct observation of nature in a rather restricted field did live on in the 'gentleman-scholar' ink painters.

The Mongol Dynasty called Yüan (1280–1368) destroyed the old idea of an Imperial Academy. Under the native Ming Dynasty (1368–1644) artists were again officially appointed, but never under the strictly organized control of ideals and standards that had existed under the aesthete Sung Emperors. Painters in the 'bird-and-flower' tradition continued to work for the court, but now with very little feeling of direct contact with nature. Their works are often, however, of great beauty and craftsmanship, deliciously executed concoctions for a leisured clientele with often more than a hint of the European 'Chinoiserie' taste of the eighteenth century. Such a piece is the pretty sixteenth-century handscroll on silk in which

delicately outlined, static insects improbably hover over a series of more or less accurate plant portraits (plate 29). There is no European equivalent to this sort of painting, even in the Dutch flower pieces of the seventeenth century. But it continued right through into the nineteenth century, maintaining basic standards of skill if not of inspiration, a tribute to the extraordinary stability of Chinese civilization before the present century.

The extremely refined line, the artificiality and delicate colouring of later Chinese courtly flower painting had its counterpart in Japan, where the revived Tosa school led by Tosa Mitsuoki (1617–91) painted even more restrained confections for the quiet classical taste of the Imperial family. The Tosa painters specialized in delicate pictures of quail and millet, quail and chrysanthemums and other set subjects usually done in ink outline with rather quiet colours on silk. They seem to be harking back to surviving works of the Sung Dynasty, even to the antique look of the artificially darkened silk. A similar quest for a vague feeling of antiquity is seen in some Chinese courtly works of the same period, and paintings from the two countries show a clear resemblance (71, 72). But the best Tosa works,

72 Quail, rock and autumn plants. Detail from a painted hanging scroll by Tosa Mitsusuke (1675–1710). Japan, about 1700.

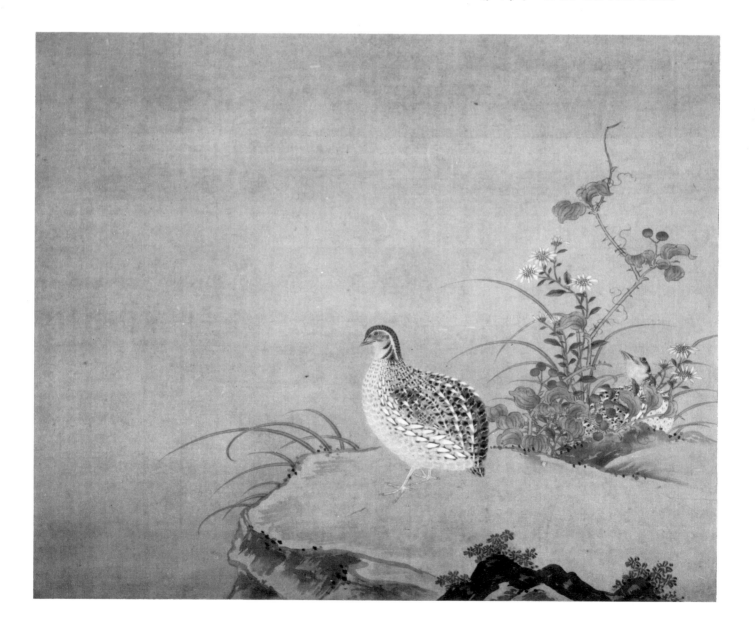

especially the super-refined chrysanthemums of Mitsuoki, are triumphs of a very highly cultivated and restrained court taste which is not quite the same as the more extravert Chinese counterpart. Yet even the Tosas could not compete with the Chinese artist Ch'en Hung-shou (1599–1652), a man famous for the complex antique flavour of his paintings. His superb large hanging scroll on silk (plate 32) dated to 1635, depicts two groups of flowers and foliage, one in a glass vessel, one in a white porcelain vase, with an inscription in Ch'en's easy-flowing calligraphy recording the rather obscure occasion which led to their being cut and painted. These flowers and leaves are recorded in minute and convincing detail. The crab-apple bough shows every corrugation through the glass vessel. The colours of autumn glow quietly against the buff-coloured silk background. Yet this is not like a Sung portrait of flowers. Rather it is a painting about painting an arrangement of flowers, a sort of activity so removed from reality as to be almost exclusive to the scholar-artists of China.

It is important to record here the fact that in Japan painters did not much concern themselves either with flower arrangement or with the depiction of the native garden or with the miniature trees known as *bonsai*. To the Japanese, these were already improvements on nature which required great artistry, and to record them further in painting appeared unnecessary and unenlightening. The subtle and colourful world of flower arrangements therefore forms no part of this book, though imaginary groupings of flowers like those of Yamamoto Baiitsu (1783–1856) were much painted.

Apart from the repetitive court traditions, the Chinese artists who achieved success in coloured flower paintings were mostly orthodox academics or 'individualists' like Ch'en Shun (1483–1544), Ch'en Hung-shou (1599–1652), Yün Shou-ping (1633–90) and Kao Feng-han (1683–1743). They have in common that none of them was simply primarily a colourist. This is true even of Yün Shou-ping, celebrated for his brilliantly colourful paeonies in the 'boneless' style which formed only part of his work. The large number of coarse later copies of his paintings in China and Japan has vulgarized his reputation down to the level of lesser decorative artists like Shen Chüan who so impressed the Japanese when he visited Nagasaki from 1731–33. The Japanese artist Chinzan's blue paeony (plate 28) comes nearer to the delicacy of Yün's original work.

Ch'en Shun was noted as a landscapist and a scholar, but his flowers in colour without outline were celebrated in Japan, where they had a profound influence on 'scholar-painters' such as Baiitsu and Chinzan, although these artists may never have seen a genuine work by him. His coloured style can be guessed at from the crisp washes of a purely ink handscroll of chrysanthemums and other flowers (73) and also from Chinzan's splendid recreation of a coloured floral scroll now lost (68). But Chinzan's work is very Japanese in its painstaking technique and in the somewhat irrational patterns it makes of its floral subjects. Ch'en's original, like the ink handscroll illustrated, was surely more rational.

Kao Feng-han (1683–1743) achieves an impression of brilliant colour without actually using more than a few dashes of red in his beautiful fan painting of bamboo and winter flowers in the snow. It is a wonderful piece of

73 Mixed flowers and bamboo, by Ch'en Shun (1483–1544). From an ink-painted handscroll. China, early 16th century.

illusionism – the black foliage of winter done in ink against the white paper representing snow. In such subtleties did the scholar or independent-minded artist try to show his superiority over the professional at court (plate 35).

Such snobberies were not important in Japan in spite of the feudal structure and the existence of artists who called themselves 'scholar-painters'. Even the courtly Tosa artists would turn their hand to a private commission of a gaudy folding screen or even an erotic handscroll. The craftsmanship of the artist and his inherent sense of design gave him enough status in a society with a very deep appreciation of professional skill. Out of this situation there grew in the sixteenth and seventeenth centuries two related schools of painters who used flowers in art in a way that had never been seen before.

The vehicle for this outburst of floral painting (though it was by no means restricted to flowers) was the paper screen. This formed an essential part of the Japanese house. The paper was stretched over a light wooden frame. One large frame could be used as a sliding door, and in a big house a set of such doors would form what was in fact a sliding wall. It was realized as early as the ninth century AD, when the Japanese first dispensed with chairs and high tables and sat on the floor, that these panels, singly or in groups, provided a large surface for painting otherwise absent in their small-scale culture. In the same way, large portable folding screens of six or eight leaves, made to keep out the draughts in the bigger houses, could be used for paintings, sometimes in pairs. We know that from at least the thirteenth century screens were painted with brightly coloured flowers, but none survive from earlier than the mid-sixteenth century when there was a great outburst of decorative work of a quite new kind.

This outburst came from the rich, confident world of the merchants and townsmen of the cities of Kyōto and Ōsaka. The new, non-aristocratic military rulers set the tone at their resplendent castles – Oda Nobunaga (1534–82) at Azuchi and Toyotomi Hideyoshi (1536–98) at Momoyama.

These men wanted big, exciting effects, and these were supplied on large-scale painted screens. It was the Kanō school, originally ink painters, which provided the solid, thick ink line apparently necessary to make pictures stand out against the brilliant gold- and silver-leaf decorated backgrounds of their surfaces. Their commonest subjects were flowers, most of them red or white chrysanthemums, poppies or paeonies, chosen for the simple clarity of their colours and the richness of their foliage. These were frequently set against a foil of spreading trees such as bamboo or maples; or a screen might consist only of trees whose boughs would be stretched over all the panels to unite the composition.

Illustrated in plate 31 is a detail of a painted door from a set of four by an anonymous Kanō artist which form a continuous scene of flowers, trees and ducks in the water in the four seasons, datable probably to the early eighteenth century. This example is on paper sprinkled with patterns of gold dust and gold and silver leaf, a technique inherited from the decorated covers of medieval handscrolls. Some of these applications of gold represent, rather loosely, bands of mist which unite different parts of the design and smooth over its illogicalities. The white paeonies at the bottom left (the whole is about two metres high) are designed to stand out brilliantly at a distance. They are outlined, both leaves and blossoms, in thick ink and the flowers are filled in with shell-white which is laid on quite densely. This thick paint does not survive very well because it cracks with exposure to the air and flakes with rubbing, but neither the artists nor their customers seem to have expected doors and screens to last long. The leaves are done in the traditional powdery malachite green and edged in yellow, both to indicate late summer and to provide a striking colour contrast. In spite of their boldness, these flowers are full of movement, and so are the snow-laden trees above them (the seasons being a little irrationally mixed) and the bamboos to their right. Screens of this sort took decoration to the level of high art with a confidence that no other culture has achieved.

A striking technical feature of some of these screens was the attempt to produce a three-dimensional effect by applying the slightly raised shapes of blossoms in a form of *gesso* (built-up plaster) and then painting over them. The clearly ribbed structure of the double chrysanthemum was the favourite for this process, and the *gesso* base gave the red, yellow or white pigments painted over it a quality of glowing brilliance.

This decorative style began in the Momoyama Period (1568–1614) and continued right through to the nineteenth century. It was mostly the work of the Kanō artists, official painters to the government, who were not otherwise very successful as flower artists. Their emphasis on a rather heavy ink line worked against the delicate forms of flowers and leaves, and it was only in the bold screen format that they contributed something unique to the world's floral art.

The artists of the Rimpa tradition, beginning in the early seventeenth century, with Tawaraya Sōtatsu, extended the coloured screen style to even more spectacular heights (plates 33, 34), and some of their works, like Kōrin's (1658–1716) plum boughs across a swirling stream (now in the Atami Museum) have become world famous and are illustrated in every

27 *opposite* Common gardenia, *Gardenia jasminoides*, and Lichi, *Litchi Chinensis*, with birds. From a handscroll in ink and colours on silk attributed to the Emperor Hui Tsung (reigned AD 1101–1126). China, 13th century. Height 260mm.

28 *opposite* Tree paeony, *Paeonia suffruticosa*, and Japanese crab apple, *Malus halliana*. Album painting in ink and colours on silk by Tsubaki Chinzan. Japan, AD 1854. 240 × 315mm.

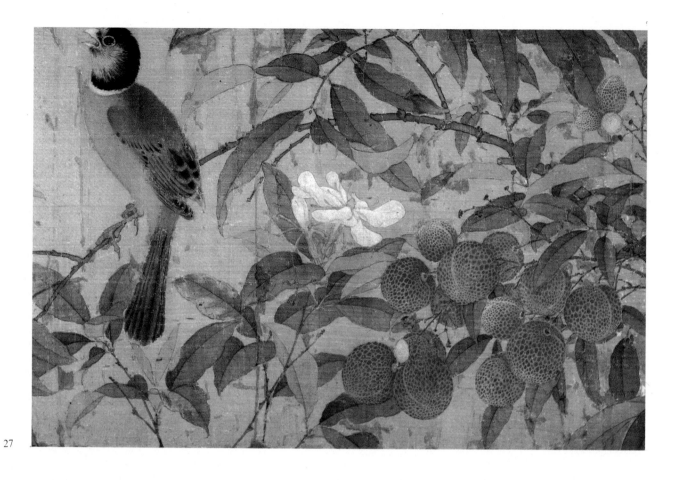

27

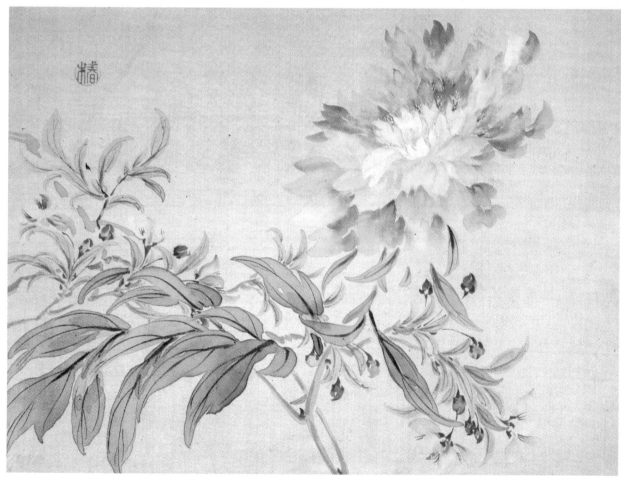

28

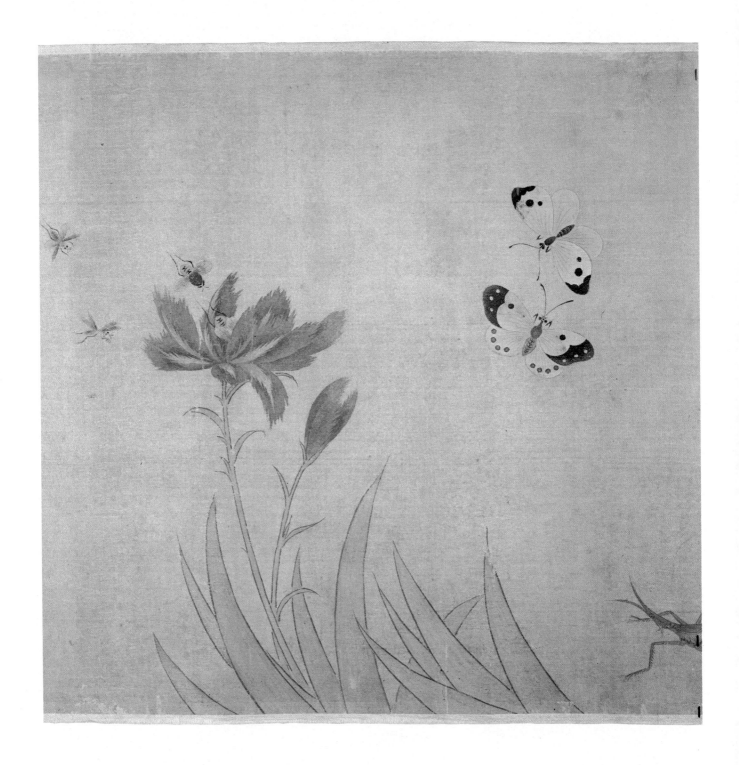

29 Iris with butterflies and insects. From a handscroll in ink and colours on
silk by an anonymous artist. China, 16th century. Height 255mm.

book on Japanese art. The word Rimpa means 'school of Kōrin', the greatest master of the style. The Rimpa manner was one of extremely bold design, using forms from the natural world which were either naturalistic or distorted according to the needs of the composition. The boldness was accentuated by their almost invariable use in screens of a plain gold- or silver-leaf background; it was made up of sections of leaf about ten centimetres square which overlapped to make a muted chequered pattern much admired in Japan for its 'natural' appearance.

On this gold or silver ground the Rimpa artists painted direct. Their colours therefore had a particular brilliance which is characteristic. Nakamura Hōchū's varied flowers (plates 33, 34) glow with an extraordinary vivid clarity, which brings out the brilliant details of the flowers; they are often done with great simplicity but are entirely believable in spite of the artificiality of their gold setting. Hōchū worked about 1795–1817.

The gold was used to further effect, however, for in many cases it was allowed to shine through a rather thin wash of pigment to give the feeling that sunlight was playing gently over the whole scene. In Hōchū's screens much of the foliage which dominates the composition is done in this way. Its liveliness contrasts with the heavy, matt green of the paeonies in the Kanō painted door described earlier.

The basic gold could be used even more elaborately in the technique called *tarashikomi* which is almost a Rimpa trademark. It made a virtue of the inability to blend pigments mentioned at the beginning of this chapter by exploiting the effect when drops of the pigment were allowed to drip from the brush into or immediately next to a different colour which was still wet. If done with enough skill, the dripped colour would push the other out to the edges of the wet patch it had made in a restricted 'marbled' effect. This was frequently done with black ink and green pigment and when done lightly over gold could produce a triple colour combination of elegance and subtlety. Hōchū has done this in many of the leafy parts of his screens. The technique became even more skilled when done in a very narrow section such as a plant tendril. In his fresh young bracken shoots Hōchū has successfully run a dark green onto a paler green while still leaving the edges clear, a remarkable blending of decoration and the natural effect of light on a stem.

In the yet more splendid screens of flowers of the four seasons attributed to the earlier master Watanabe Shikō (1683–1755) in the Ashmolean Museum, Oxford, the gold is used to give a wonderfully autumnal glow to the creepers cascading down on the left of the screen representing autumn and winter. In the same screen chrysanthemums are done in raised work, standing out in striking contrast to the more sensitive brushwork of other parts of the painting. Such unlikely but telling combinations of technique are typical of the practical attitude of Japanese artists and especially those of the Rimpa school. If something worked visually, then they would use it.

Hōchū took the tendency of his school to simplify natural shapes to very exaggerated limits. His book of woodblock designs adapted from the work of Ōgata Kōrin (1658–1716) has a graphic strength which looks entirely twentieth century to a Western viewer (74). This reduction to simple shapes

74 Plum bough. From the woodblock-printed book *Kōrin Gafu* by Nakamura Hōchū (worked about 1797–1818). Japan, 1826 (second edition).

is beautifully illustrated in the poppies which stand out as the strongest part of his floral screens (plate 34). One of the poppies consists of nothing more than four red petal-like shapes which nevertheless vibrate with life. The combinations of red and white in these flowers make a pattern which satisfies the eye on its own abstract terms, and yet it breathes the freshness of real poppies and the open air.

Both the Shikō and the Hōchū screens demonstrate Rimpa painting at its artificial best. Both are elaborate compositions of flowers which grow straight out of their gold backgrounds without so much as a hint of real earth or even a convention of clouds or mist to explain the impossibility of their all growing together. Both use a variety of means to add to the decorative impact, yet each flower or plant is freshly portrayed and we feel that these artists knew their flowers. In Shikō's case we have sketchbooks from nature to prove it. Indeed, the designs are so carefully planned that any detail taken from them will stand on its own as well as forming an essential part of the composition.

Shikō was an important figure in another respect, for in the extremely naturalistic details of some of his flowers he was the predecessor of the Maruyama-Shijō School. This was at rather a late stage in Japanese artistic history to produce a whole new school of what in the West would be called nature artists who combined unpretentiously but with some success the Chinese ideals of observation of nature and vivid, free calligraphic brushwork with a more native subtlety of colour and poetic sentiment.

The Maruyama-Shijō artists are included in this chapter because they were basically concerned with realizing nature's colours, and not, like most of the scholar painters, with symbolizing them in ink and a few conventional shades. On the whole they did this with a skill in line and wash which in its way equalled the dexterity of any 'learned' artist. Yet they were not scholars or even calligraphers. Few of their paintings have long inscriptions, their signatures are undistinguished, and literary allusions are rare. Only in their more formal works did they paint the old conventional plants – the pine, the bamboo, the paeony. They preferred the everyday natural or cultivated trees of Japan – the flowering cherry (plate 30), the wisteria, the maple, the willow, the wild rose, the persimmon, charlock (75), the water lily, and even vegetables and mushrooms (70). In landscape, animals, birds and insects, too, they depicted their native scene.

Ink may sometimes play a major part in the works of Maruyama-Shijō artists, but it only seems to emphasize the fresh colour of the blooms themselves. This is strikingly seen in a long handscroll of spring flowers by Matsumura Keibun (1779–1843) from which we illustrate cherry blossom (plate 30). The sheer sense of movement in the boughs and the crisp freshness of the red-brown leaves makes us quite forget the lack of the actual colours of nature. In contrast, many paintings of this school dispense almost entirely with ink and use delicate pigments in place of it. This was the first time in the Far East that paintings were consistently done with no ink either in outline or wash, though there are of course isolated cases. A typical example is the hanging scroll of charlock by Yokoyama Seiki (1792–1869) which is done almost entirely in green and yellow. In a black-and-white photograph it could paradoxically be mistaken for an ink painting, so deep were the roots of brushmanship (75).

The brush style of the Maruyama-Shijō artists was well suited to nature painting, for it came from the haiga tradition. Haiga were the little sketches illustrating the seventeen-syllable verses called *haiku* and accompanying them when they were calligraphically written out in handscrolls or on hanging scrolls. Haiku and their haiga were invented in the seventeenth century, and were a very native form of art. Every haiku had to refer to the season of the year, and it was very often inspired by a plant, as in this verse by the poet-painter Goshun:

Although without name
There are places of beauty –
Mountain-cherry blooms!

Goshun (1752–1811) was the co-founder of the School (it was he who lived in Shijō Street in Kyōto and this gave half the name to the School). His verse

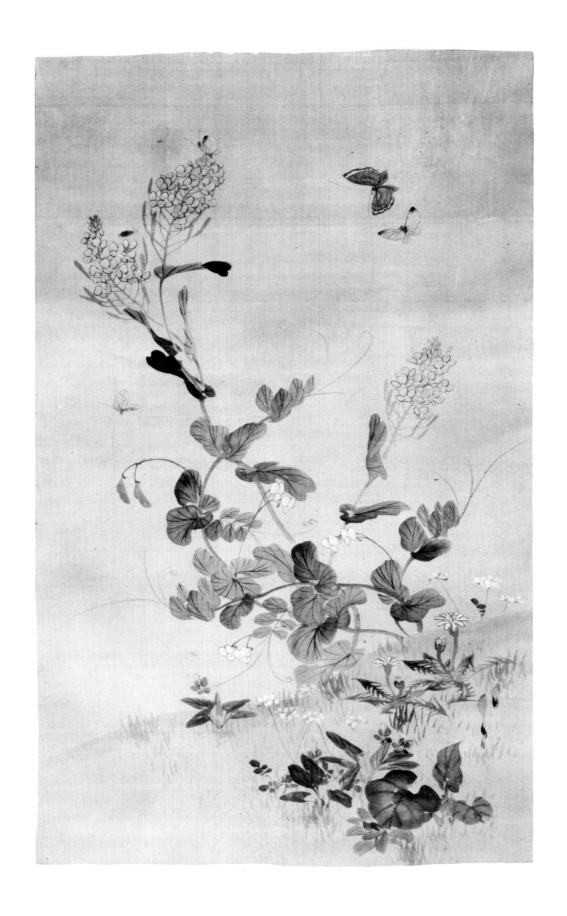

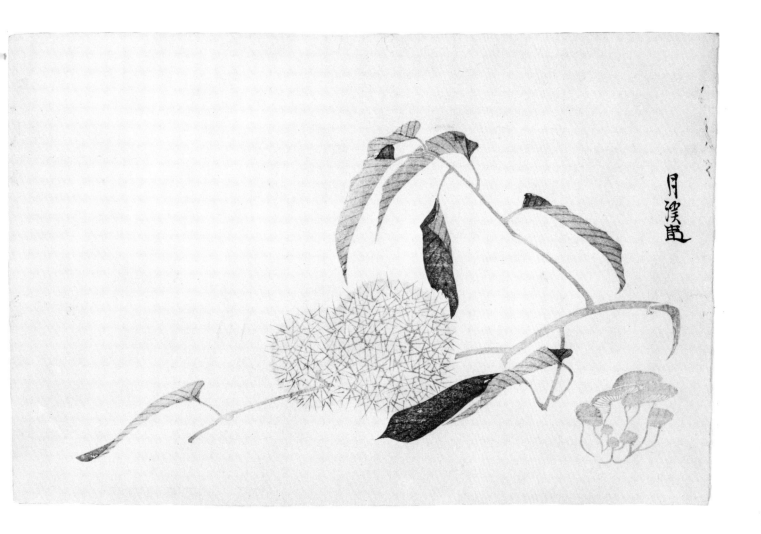

75 *left* Charlock. Painted hanging-scroll by Yokoyama Seiki (1793–1865). Japan, mid-19th century.

76 *above* Chestnuts, by Matsumara Goshun (1756–1811). From an untitled woodblock-printed album. Japan, 1793.

could almost describe a typical Maruyama-Shijō sketch of a wild cherry tree in a gorge. It was this native strain of sensitive observation of nature, finally finding a suitable outlet in painting, that makes works of this sort so fresh even today. One of the earliest works in the Maruyama-Shijō style is Goshun's print of chestnuts from a woodblock book of 1793 (76).

Maruyama Ōkyo (1733–95) was the other founder of this movement. A very versatile artist who unified a number of styles into a powerful new one, he gave the sanction of his considerable prestige to actually sketching from nature. This was an idea that had come partly from texts about Sung Chinese art and partly from contemporary Europe, but it was a startling innovation in eighteenth century Japan. Before Ōkyo it had been practised by only a few great individualists like Shikō and Itō Jakuchū (1713–1800) whose grand series of paintings of animal and vegetable creation now in the Japanese Imperial Collection are too exaggerated to have influenced others. The breath of the real natural world, flowing into art, made it live anew. Artists like Kyōho (fl. mid-19th century) did album leaves which are as intimate, lively and affectionate as any floral art done at any period (69).

The Rimpa and Maruyama-Shijō painters represented two sources of

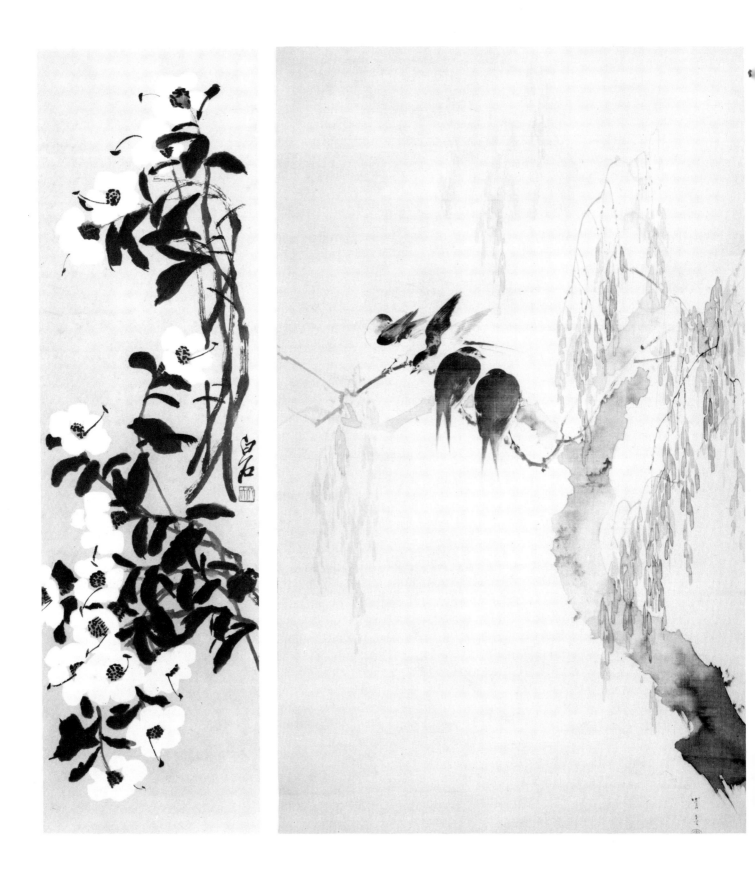

77 left Willow. Detail from a painted hanging scroll by Watanabe Seitei (1851–1918). Japan, about 1900.

78 far left Tea-flowers. Painted hanging scroll by Ch'i Pai-shih (1863–1957).

perennial vigour in Japanese painting. It is not surprising therefore that they should have come together to form the basic *Nihonga* ('Japanese pictures') style which after 1880 survived and still survives against the pressures of Western art. The super-delicate willow tree by Watanabe Seitei (1851–1918) in illustration 77 combines a feeling of misty reality with the use of the most precise *tarashikomi* in green, black and gold on the leaves which drop like tears. Flowers, both subtle and brilliantly coloured, have up to the present day remained at the centre of the *Nihonga* style, which remains alive and vigorous.

A better-known style has been the bird-and-flower painting of China in the last century and a quarter, which has become quite widely circulated in the world through the works of artists such as Ch'i Pai-shih (1863–1957). In the mid nineteenth century traditional Chinese society, which had been dominated by the educated mandarin class, began slowly to collapse, and the centres of vitality shifted to the Treaty Ports where Europeans co-existed with a newly flourishing merchant class in the determined pursuit of money. In this vigorous society there was less market or admiration for the austere ink paintings of the scholar class and for the by now over-refined and lifeless confections of the court painters. The discipline of the brush, however, was far too deeply rooted to give way to Western methods, and a new, lively compromise style developed. It began in mid nineteenth-century Shanghai with the work of the artists known as the 'Four Jens', who combined strong, non-outline ink work with bright colour of the 'boneless' type. This was the final compromise in East Asian painting of colour and ink, the temporary end of an artistic battle which had fluctuated for a thousand years but which now settled down to a truly equal partnership. The solution was helped by the development of a wider range of wash-colours and coloured inks, which could live with black ink on an equal footing.

In illustration 78 Ch'i Pai-shih's hanging scroll of a tea-plant is both strong and balanced. The powerful lines of the ink are set off by and enhanced by the brilliant white of the flowers. Here black and white are used as unashamed colours, not as the subtle outcome of brush, ink and white paper. This style, liberated perhaps by the new-found freedom of later nineteenth century Western painting to use colour and space, has used flowers with great success up to the present day. It has also, following an age-old process, influenced Japanese artists like the celebrated Tomioka Tessai (1836–1924) and Takayama Chōyō (born 1888) to reinfuse their own art with a true partnership of ink and colour (79).

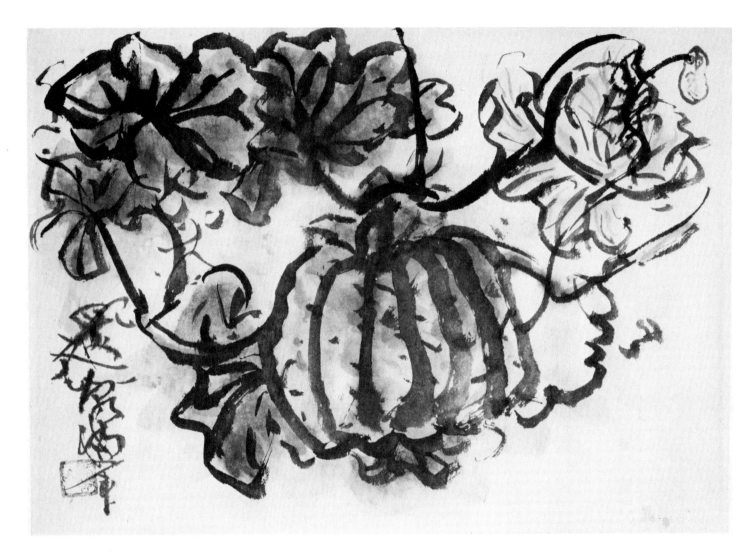

79 Gourds. Sheet painting by Takayama Chōyō
(b. 1886). Japan, 1977.

30 Japanese mountain cherry, *Prunus yamasakura*.
From a handscroll in ink and light colours on paper
by Matsumura Keibun (AD 1779–1843). Japan,
early 19th century. Height 280 mm.

31 Tree paeony, *Paeonia suffruticosa*. Detail from a
sliding door painted in ink and colours with gold by
an anonymous Kanō School artist. Japan, early 18th
century. Height of whole door approx. 1650 mm.

32 Florist's chrysanthemum,
Chrysanthemum × morifolium, and Joseph's Coat,
Amaranthus tricolor. Detail from a hanging scroll in
ink and colours on silk by Ch'en Hung-shou
(AD 1599–1652). China, AD 1635. 1750 × 980 mm.

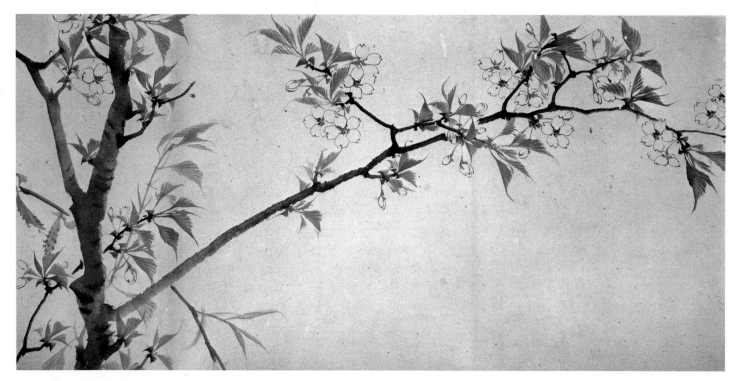

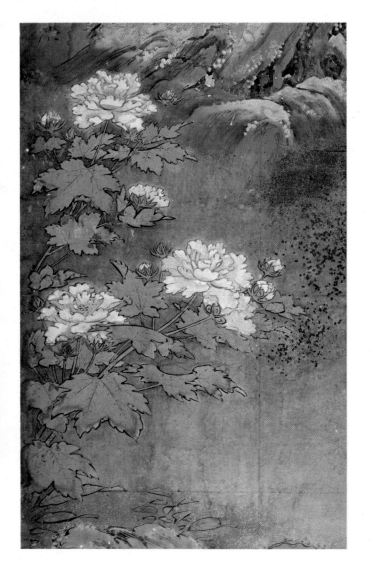

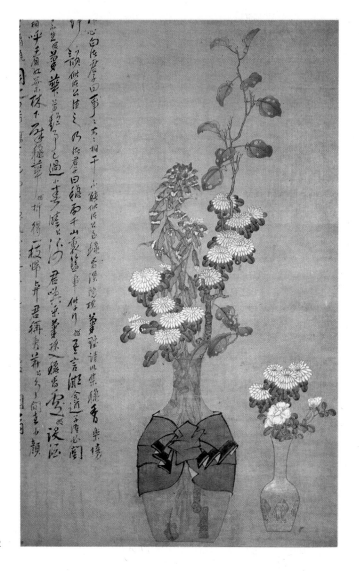

33, 34 Flowers of the seasons. Pair of sixfold screens in ink and colours on gold paper by Nakamura
Hōchū (worked about AD 1797–1818). Japan, about 1800. Height of screens 905mm.

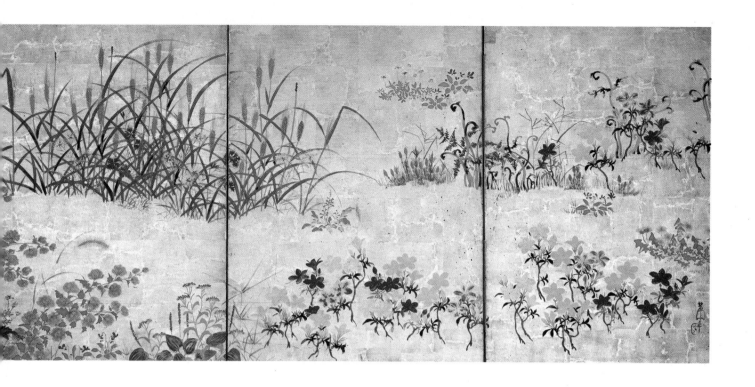

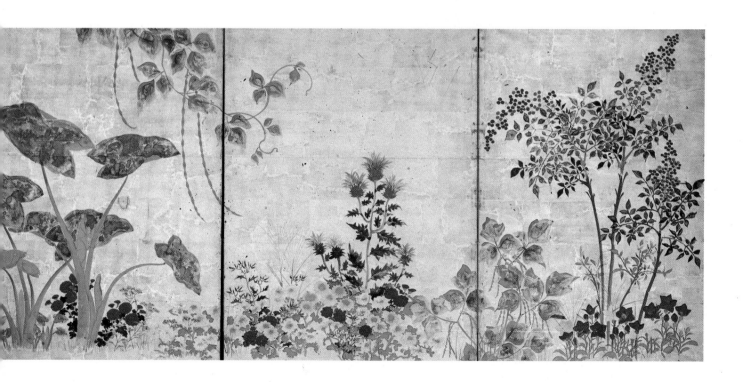

35 *above* Bamboo and winter blooms in the snow. Fan painting in ink and touches of colour on paper by Kao Feng-han (AD 1683–1743). China, 1722. Width 550 mm.

36 *left Hibiscus.* Album painting in ink and pink pigment by Tani Bunchō (AD 1763–1840). Japan, 1796. 280×250 mm.

7
Ink painting in China and Japan

The type of painting described in this chapter has no equivalent outside the countries of East Asia. Painting in black ink without colour may seem an unlikely way of depicting flowers and plants, but in those countries it was one of the most prestigious forms of all art, and certain flowers, plants and trees equalled the status of landscape as the most important subjects for it.

Elsewhere in Asia and Europe, and indeed in the schools of Chinese and Japanese art described in chapter six, painting has nearly always meant colour. Pen-and-wash drawings in Europe, especially the landscapes of Rembrandt and Claude, achieved a high level of skill, but few would base their assessment of those artists on such works rather than on their oil paintings. In floral art the search for colour has been the rule. In Europe line drawings have on the whole been strictly scientific, and monochrome woodblocks, etchings and engravings were often hand-tinted until adequate colour processes were developed. This would seem only natural. Who would actually prefer black ink to colours in depicting flowers?

To explain why the Chinese not only did so but went even further to promote ink-painting to a higher level of art it is necessary first to examine another art which they placed still higher – that of calligraphy. The many thousands of characters in written Chinese have for at least two thousand years united a whole civilisation across time and space. An educated man could as easily read an inscription from a distant area where a different dialect was spoken as he could read one done a thousand years before. The character always retained its basic meaning or idea. Consequently, the written word was venerated as the highest expression of a civilization, as well as the factor which united it.

From about the second century AD, characters were written with a brush in ink on silk or paper, though the latter did not become common until the thirteenth century. A good hand became the essential attribute of a scholar, and under the Chinese system of government all official appointments below the Emperor went to scholars. The extensive training in writing which every educated child would have to go through involved over many centuries the same characters, the same sorts of brushes and ink and the same methods. The order in which the strokes of a character are written is absolutely fixed; therefore every Chinese who knew it could follow every stroke of every piece of calligraphy he saw and live through it with its original writer. He could also appreciate the texture of the ink, the power and flexibility of the line, and the sense of spacing and balance which was crucial to the art.

The calligrapher had to make sure in the squarer forms of writing that each character filled the same area of implied space; a very simple character, like the single horizontal stroke meaning 'one', could be written so that it seemed to fill the space around it as much as a character with over twenty strokes. In the more running hands, especially in 'grass script', these relations were not so exactly maintained, but a careful balance had to be kept so that the 'weight' of a series of characters did not exceed the sum of its individual parts.

The ink artist, who might often be a celebrated calligrapher as well, was faced with very much the same problems when painting bamboo. This was

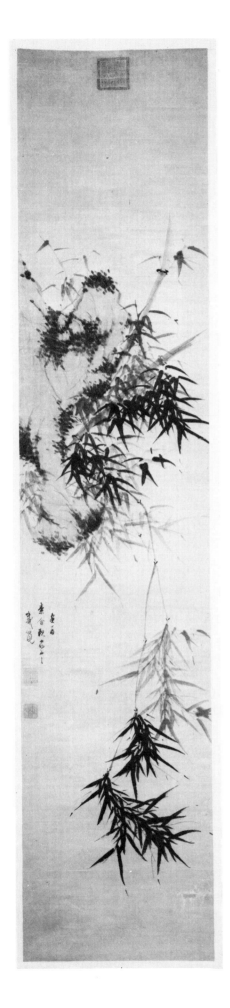

the most 'calligraphic' of plants, and the comparison was not merely fanciful. The strokes used for the bamboo leaves strongly resembled certain strokes used in characters, and they had to be varied within the limits of recognition in the same way.

A fine example is the long hanging scroll by Tai Ming-yüeh (flourished mid-seventeenth century), where the comparison with calligraphy is very close, for his bamboo, growing from a rocky outcrop, moves vertically downwards in the direction that an inscription should run (80). Its flowing movement recalls the connected, running characters of grass script, and the whole plant seems to fill the space allotted in just the way a good piece of calligraphy should do. Although a little darkened with age, it was originally a pure white satin against which the gradations of ink would have stood out without ambiguity, for in ink painting of this sort there was no room for error; a mistake could not be erased or painted over. The great brushman gloried in the scrutiny which hosts of other scholars and connoisseurs might give to his work, for in its strength of line his own elevated character could be appreciated by them.

The tones of the ink itself are a triumph in this painting. Chinese ink (mistakenly called Indian ink by even the celebrated historian of Chinese painting Osvald Sirén) was made from the soot of various woods, especially pine, mixed with a little animal gum and moulded into an ink stick. The stick was rubbed down, when needed, on an inkstone which sloped into a well where it was mixed with the water. The skills of rubbing down, dilution, and loading the brush were acquired over half a lifetime or more, and the connoisseurship of inks and stones was an important part of the painter's equipment. The same expertise was brought to the making and appreciation of paper and silk, and most of all to the brush which by the Six Dynasties Period (AD 221–589) had already become the most flexible and sensitive graphic instrument ever devised.

In the Tai Ming-yüeh bamboos the darker leaves shine with a lustre which is quite astonishing in the medium of black monochrome. The lighter leaves, seemingly lost in thick mist, are of a pale silvery grey which it is hard to believe comes from the same ink, stone and brush. The viewer feels that for all its wonderful accomplishment this painting, like grass script, was dashed off in a very short time as the artist reached his highest point of excitement.

China's most celebrated bamboo painters endorsed this attitude. Su Shih (1036–1101), deploring like every Chinese painter worth the name the lost glories of past masters, quotes his friend Wên T'ung (another single-minded painter of bamboo) as saying:

Painters of today draw joint after joint and pile up leaf on leaf. How can that become a bamboo? When you are going to paint a bamboo, you must first realize the thing completely in your mind. Then grasp the brush, fix your attention so that you can see clearly what you wish to paint, start quickly, move the brush, follow straight what you see before you, as the buzzard swoops when the hare jumps out. If you hesitate one moment, it is gone. (Trans. Sirén, *The Chinese on the Art of Painting*, 1936).

The ink-painters, then, saw themselves as combining the abstract virtues of the calligrapher with the naturalism of the scientific observer. They

80 Bamboo and rocks. Ink-painted hanging scroll by
Tai Ming-yüeh (flourished mid-17th century).
China, mid-17th century.

separated themselves from the colourists of the courtly tradition, yet the best of them devoted themselves to the study of the plants they painted with great dedication. None was more devoted than Li K'an (1245–1320), author of *An Essay on Bamboo (Painting)* and a passionate student of this great family of plants, which he cultivated, painted, wrote about and travelled widely to study. It is interesting to note that he painted bamboo not only in ink but also in outline filled with green wash. In the latter the green is often the only colour amid the black ink. One may call this type of tinting, which was always to be found from the Sung Dynasty onwards, 'symbolic colouring' for it did not seriously attempt to copy nature's colours. Paradoxically, the result was often more austere than in pure ink work.

The liking of non-professional artists for bamboo was due not only to the calligraphic opportunities it provided, but also to the noble properties of the plant itself. Fast-growing, sturdy yet elegant, remaining green in winter, it came to symbolize the scholar himself. The perpetually changing patterns of the leaves as they moved in the wind offered infinite material for the supple ink line of the well-handled brush. It is indeed astonishing how over a period of more than one thousand years hundreds of artists managed to capture in ink moods and movements of bamboo which seemed to have escaped previous generations. Thus Hsü Wei (1521–93) made them like explosions of ink, Cheng Hsieh (1693–1765) preferred them bending but not breaking before a gale, and Wu Chên (1280–1354) saw in them a sturdy force.

The Japanese, on the whole, have been much less successful as bamboo painters than the Chinese, and it may well be that their less solid calligraphic traditions have something to do with this. The misty, moonlit bamboo of Tachihara Kyoshō (1785–1840) in illustration 81 is much more typical of the greater Japanese success with a softer and more feminine mode of brushwork. The comparison with the native *hiragana* syllabary springs at once to mind and the effect aimed at is emotional and tactile rather than intellectual. Only Bunchō (see p. 84) among Japanese artists approached the intellectual force of the best Chinese ink-painters. Strangely enough, this Chinese ideal was more often attained in woodblock prints, for example in Kawamura Bumpō's *Bumpō Gafu* of 1807 (82).

We have dwelt upon bamboo as the most important plant subject for ink painting. It goes back at least as far as the T'ang Dynasty; and the Sung Emperor Hui T'sung (reigned 1101–26) already had 148 bamboo paintings in ink in his collection. But until the Yüan Dynasty (1279–1368) it was part of a wider definition of painting, in which it was generally accepted that painters of plants or of landscape were engaged in the great Chinese philosophical process of trying to understand nature and how human beings integrate into it. In the Yüan Dynasty a great change occurred. Attention shifted definitively from nature herself to the painter and his brushstrokes: and those strokes were without any doubt at all thought of as in ink. The early Ch'ing painter and theorist Tung Ch'i-ch'ang (1555–1636) was to put it in its most extreme form:

… painting is no equal to mountains and water for the wonder of scenery; but mountains and water are no equal to painting for the sheer marvels of brush and ink. (Trans. Wai-kam Ho, quoted in Sherman E. Lee, *The Colours of Ink,* 1974.)

81 Bamboo in the moonlight. Ink-painted hanging scroll by Tachihara Kyoshō (1781–1840). Japan, about 1830.

82 Bamboo. From the woodblock-printed book *Bumpō Gafu* by Kawamura Bumpō (1779–1821). Japan, 1807.

It is thought that the Yüan Dynasty saw this change because scholar-painters loyal to the Sung refused to work for the alien Mongol overlords and thus, retiring to the mountains or lonely huts, developed an unworldly way of life, true to their principles, devoted to the scholar's accomplishments of music, poetry, calligraphy and painting. This theory, like most in art, is a simplification. Perhaps the most influential artist in establishing this movement was Chao Meng-fu (1254–1322) who actually took high office under the Mongols.

The effect of this almost abstract view of nature painting was strangely enough to draw a wider range of plants into the subjects for ink painting so that a greater variety of calligraphic brush-strokes could be developed. In particular we see from that date many paintings of the 'three friends of winter'. The three friends were bamboo, plus plum-blossom and pine. They were so called because they withstood winter, just as the scholar should withstand adversity, and showed continued vitality in it – the bamboo by its flexibility, the pine by its strength, and the plum tree by putting out its delicate blossoms in the late snows. All three were sometimes painted together, a tradition which continued as late as the nineteenth century. All three were favourites for that most typical of Far Eastern art forms, the long handscroll.

Bamboo was the plant closest to pure calligraphy. Clump after clump of bamboos, following each other in a profusion of brush-strokes, became a natural subject for the long handscroll which was already the only practical vehicle for extended calligraphy. A handscroll might be as long as twenty

metres or even more, but would be unrolled only a little at a time for the contemplation of the scholar. Not the least of its delights was the sense of expectancy as each new section was revealed; the whole produced in a good example a sense of development, variety and overall shape and unity which is similar in some ways to the effect of a great musical structure heard for the first time. Illustration 83 is a section from a joint bamboo handscroll by two Ch'ing Dynasty artists Tai Chao and Chu Sheng. It is interesting to note that this scroll includes sparrows, and that they are partly coloured, so that there is just a little of the feeling of the bird-and-flower works of the Sung Dynasty. It was apparently never felt entirely wrong to include colour, even among scholar-artists, if it seemed to improve the painting.

Plum blossom, the second of the three friends, was not quite as ancient a painting subject as bamboo, but it had many artistic devotees from the Sung Dynasty onwards and it offered opportunities for more startling ink-work and greater contrasts than bamboo. Artists never tired of the poetry of the pale blossoms springing from the gnarled bare black boughs, nor of the textural contrasts they offered in ink.

Plum blossom, like bamboo, had treatises written about it. The Sung Dynasty eleventh-century Taoist devotee Hua Kuang was the best known and also the supposed pioneer in painting plum blossom in ink. In his *Mei P'u* (Book of the Plum) he combines artistic, philosophical and horticultural information in a way wholly characteristic of the complete man of his time. The complexities of the symbolism seen by the Chinese in this visually varied plant help to explain the endless fascination it exerted on artists.

Like bamboo, it seems in certain hands to have required a whole long

83 Bamboo. From a painted handscroll by Tai Chao (worked 1662–1722) and Chu Sheng. China, late 17th to early 18th century.

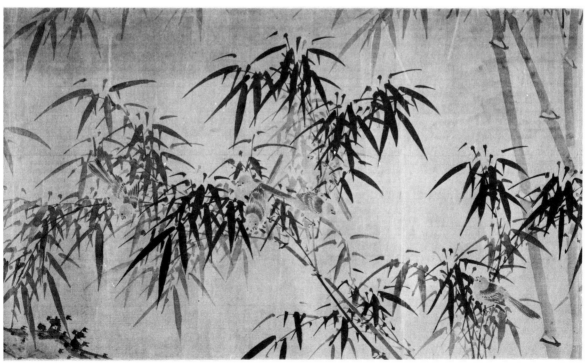

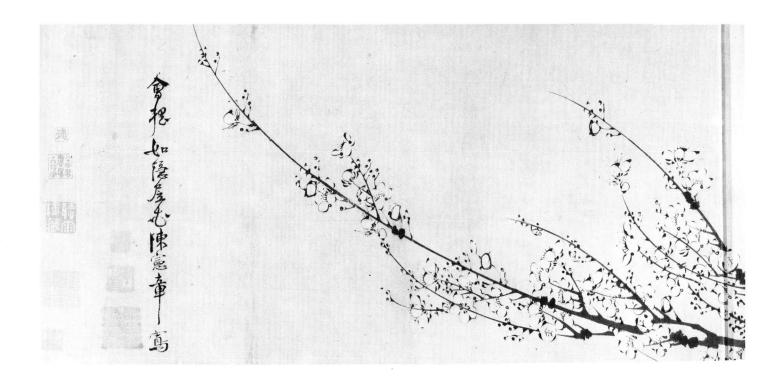

84 Plum-blossom in the moonlight. From an ink-painted handscroll by Ch'en Lu (worked mid-15th century) China, about 1440.

handscroll to explore all their possibilities. One of the finest examples known is that by Ch'en Lu (about 1440) in the Museum of East Asian Art in Berlin. It depicts a seemingly endless succession of plum boughs in the moonlight, done rather surprisingly with a pale blue wash background which exactly reproduces the feeling of an icy, moonlit night. This is yet another example of 'symbolic colour' which seems in its way more effective than a more naturalistic approach (84).

Plum blossom came to be even more symbolic than the bamboo of the romantic idea of the scholar, for it had been associated from as early as the T'ang Dynasty with poetry and learning, and the scholar-painters revered everything associated with antiquity. The aged appearance of the plum boughs themselves seemed to reinforce this feeling. The long deep fissures in the bark typically became associated with a certain sort of brushwork. This was the 'flying white', where a usually biggish brush was fairly lightly inked and then wielded so that white streaks appeared between and among the individual hairs or groups of hairs of the brush-stroke. A very dynamic example can be seen in a plum handscroll of the Japanese artist Tani Bunchō (85).

Bunchō's work, done about 1820, demonstrates the extraordinary vitality of this form of painting in East Asia. Like the plum blossom itself, it seemed over many centuries able to renew itself in the spring promise of every competent new ink artist. Bunchō, like Ch'en Lu (84) adopts a device imposed by the handscroll format. He paints only boughs as if seen from a level slightly above them, omitting the lower trunks altogether. The boughs run into each other against a sky-like blank of white paper (in Ch'en Lu's work the sky is more firmly stated in pale blue). It is implied that we are

looking at the tops of a grove of plum blossom. Bunchō's scroll, however, shows very strongly Japanese characteristics in spite of its virtuosity in ink brush-work, in which Bunchō was unequalled among his countrymen. The work lacks the intellectual concentration which exists in most of the best Chinese ink paintings. Instead, it sees the plum boughs and their blossoms as a dynamic pattern in ink. The petals are done not delicately, but in as forceful an ink as the branches and in a rather exaggerated size which is not quite the relationship in nature. The signature itself, triumphantly bold, is seen as part of the design. It aims at a satisfying shape rather than at calligraphic force, and has been compared by the Japanese to flying birds. The big, square seal of the artist is also a calculated part of the effect. It should be mentioned here that however austere the ink painter, his own cinnabar seal and the added seals of later connoisseurs were never considered out of place. The red, otherwise little used except in court painting, was simply not 'seen' (86).

This patterning is very basic to one side of Japanese art. It is taken to extreme lengths in the Rimpa School. Illustration 74 shows a very stylized example from a later edition of the 1802 woodblock book *Kōrin Gafu* which reinterprets the work of Ogata Kōrin (1658–1716).

It should not be assumed, though, that Japanese painting is ever simple to sum up. There is a completely different side even to their attitude to plum

85 Plum-bough. From an ink-painted handscroll by Tani Bunchō (1763–1840). Japan, about 1820.

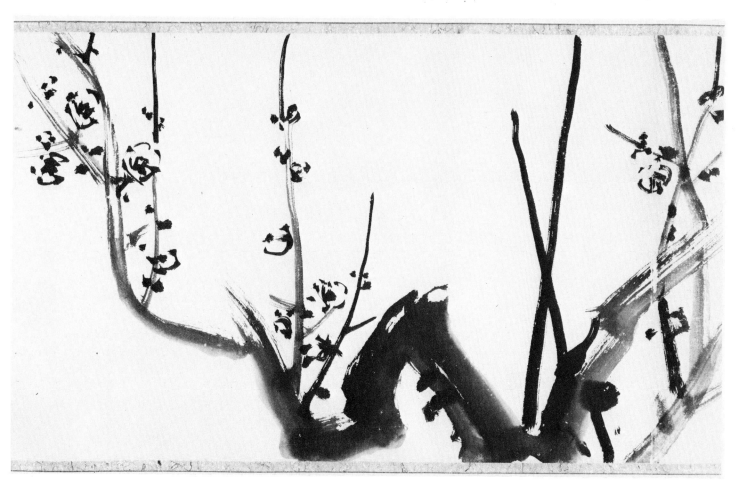

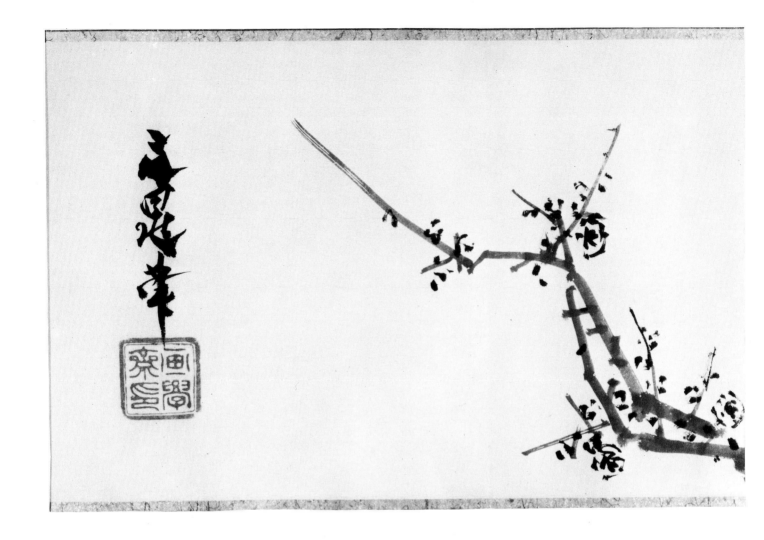

86 Plum-bough, with the artist's signature and seal. End of an ink-painted handscroll by Tani Bunchō (1763–1840). Japan, about 1820.

37 *right* Double nasturtium, *Tropaeolum majus* 'Flore pleno', with *Coronilla glauca* (right) and *Teucrium latifolium*. Colour mezzotint after Jacob van Huysum, from *Catalogus Plantarum* (1730).

blossom. In the Maruyama-Shijō School, for example, the poetry, delicacy, and romance of the trees flowering in early spring is brought out in fine washes and strokes of white, pink and deep rose. The effect aimed at is impressionistic and atmospheric, certainly not forceful or calligraphic. But these methods tend towards the use of trees as a landscape element rather than as individuals, and are beyond the scope of this book.

It is interesting that Bunchō adds to parts of his scroll a light purply-brown pigment which is almost unnoticeable except under close scrutiny. This is not quite what we have called 'symbolic colour' for that is always used very openly, whereas here the artist seems to be trying to conceal his use of it. It certainly adds life and vibrancy to the line, but it points up a slight lack of confidence in the ability of the artist to express in pure black ink everything he wants to say.

By contrast there was in China from the T'ang Dynasty onwards a central belief among scholar-painters that only ink was necessary for the great master of the brush to put on paper or silk whatever he wished to communicate. The classic statement was made by the art historian Chang

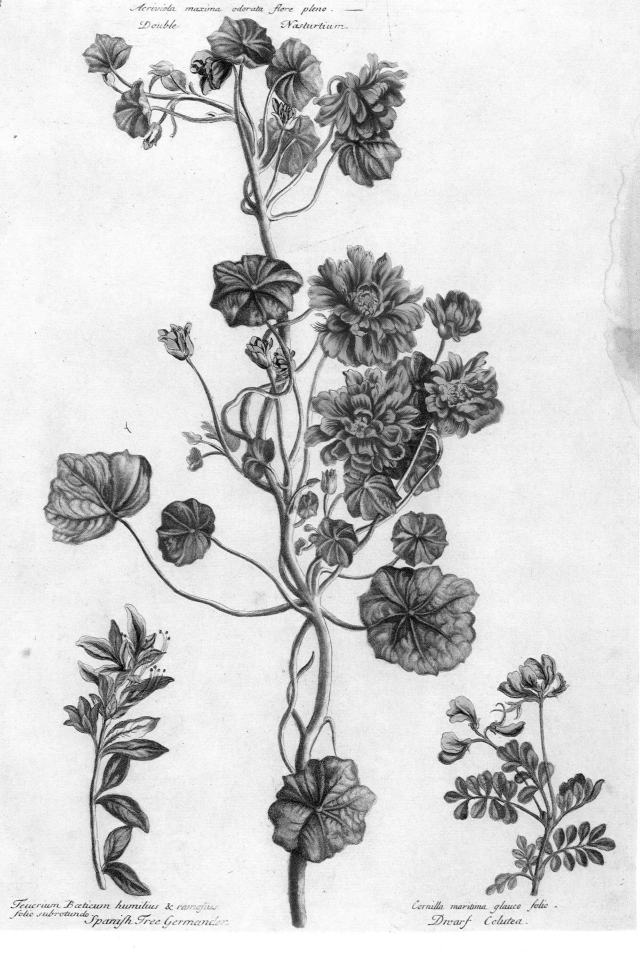

3

Acriviola maxima odorata flore pleno.
Double Nasturtium.

Teucrium Bæticum humilius & ramosius
folio subrotundo Spanish Tree Germander.

Cornilla maritima glauco folio.
Dwarf Colutea.

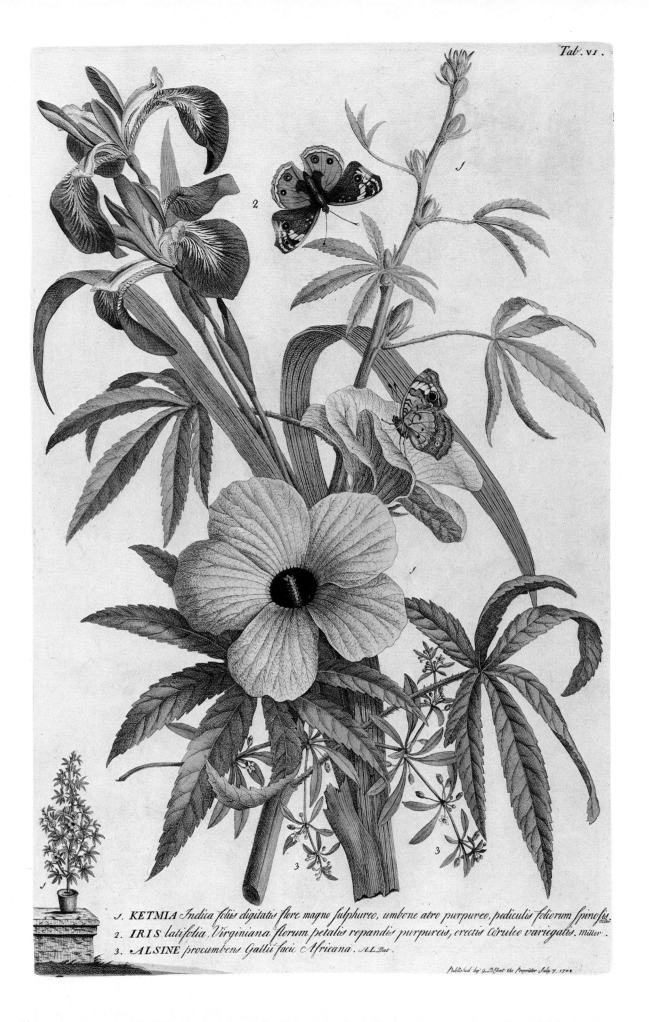

Tab. VI.

1. KETMIA *Indica foliis digitatis flore magno sulphureo, umbone atro purpureo, pediculis foliorum spinosis.*

2. IRIS *latifolia Virginiana florum petalis repandis purpureis, erectis cœruleo variegatis.* miller.

3. ALSINE *procumbens Gallii facie Africana.* A. L. Dat.

Published by G. D. Ehret the Proprietor July 7. 1748.

Yen-yüan in 847, when he said that the aim of the painter should be to express all the traditional 'five colours' by the use of ink alone. That was accepted by most ink painters of later periods. Wu Chên (1280–1354), a celebrated painter of both bamboo and plum blossom, said: 'I have read Ch'ên Chien-ch'ai's poem about ink plum-blossoms which says: "The thought (or spirit) is enough, why seek for coloured resemblance?".' (Translated Sirén.)

Such reverence for ink is felt perhaps most strongly of all in paintings of the third of the three friends, the pine tree. This had always been associated with ink landscape, where it could form (often together with cypress) either a landscape element or a prominent place in the foreground. The latter began to appear increasingly in the Yüan Dynasty, when the ideals of the scholar-painter grew in strength and began to be rather rigidly codified. The pine was the most impressive of the plants and trees symbolizing that class of men. Powerful, unmovable, complex, it could to their minds be rendered most adequately in pure ink.

It was of course very old pine trees which embodied these qualities most strongly, and it inspired in a Ming disciple of the painter Shen Chou (1427–1509), founder of the so-called Wu School, an astonishing handscroll which strains that form to its natural limits and beyond. Handscrolls of plum, as already described, could easily adapt to the limitlessly long horizontal shape by concentrating on the upper, lateral boughs of a group of specimens, and this technique was used also for groups of pines or in a famous example of seven junipers by Shen Chou's pupil Wen Cheng-ming (1470–1559). Shen Chou's follower, however, takes a different and even bolder course. In a painted length of many metres, he portrays only *one* old pine tree (87).

In assessing how the artist managed to achieve this startling feat, we must remember that a scroll of this sort would be unrolled only a little at a time, rarely showing more than a comfortable amount to hold between the hands. The impact of the unnatural horizontal movement of the tree would therefore be lessened. The artist does not actually move continuously along the branches and the trunk; nor would the horizontal sections match up if they were placed on top of each other. Rather, they merge semi-logically into each other. The viewer, unrolling a little at a time, naturally moves more quickly across the less striking transitional parts and halts at the more central ones, by which time he is completely adjusted. It is a splendid proof that art imposes its own illusions, even in a format which seems at first sight absolutely unnatural. In addition, the artist uses to the maximum the natural twists of a gnarled old pine to give the feeling of movement sloping upwards. Nevertheless, it is difficult to realize as metre after metre unrolls that this is one tree, shown from its topmost twigs and needles to the furthest wanderings of its roots among the rocks. Modern photography allows us to examine all of it at once, or at least substantial parts, and it is surprising that the close organization and logic of the tree stands out just as powerfully when seen as a whole.

Shen Chou was a great calligrapher, and the second half of this handscroll consists of an extended inscription, after his style, about the pine.

38 *left* 1. *Hibiscus cannabinus*. 2. *Iris versicolor*. 3. *Mollugo verticillata*. Coloured etching and engraving by Georg Ehret after his own drawing. 421 × 274 mm. Plate VI of Ehret, *Plantae et Papiliones Rariores* (1748[–59]).

87 Pine-boughs. From an ink-painted handscroll after Shen Chou (1425–1507). China, date uncertain.

His calligraphy is powerful, rather square, full of inherent energy and carefully avoiding a superficial charm. The painting is a pictorial equivalent; just as the artist produces endless visual variety within the constraints of the characters, which never stray beyond strict spatial limits, so he makes the two basic brush elements of his pine into a series of relationships of extraordinary skill. These elements are the longer strokes of the trunk and branches and the groups of short strokes representing the cluster of needles. To the scholar-painter, this is not only a portrait of a pine, it is also a portrait of its artist and of a whole class of men.

If this is a pine-scroll which is really about a man, Yu Ch'iu (active late sixteenth century) has painted a scroll about a man which is really about pines (88). It shows the scholar Ko Chih-Ch'uan on his journey to find the traditional refuge of his class in a hut in the mountains. As we unroll, we see his servants loaded with his possessions, among which books and writing equipment are much in evidence; then we see Ko Chih-Ch'uan himself on his donkey, and finally the hut. All are surrounded by vegetation, representing the world of nature to which he retires. Pine-trees and bamboo naturally play the major part.

The figures are relatively unimportant, overshadowed in each case by a great pine tree painted in loving detail with a very dry brush. The tree which

leads us up to the scholar himself is a splendid example of the horizontal movement aimed at by many painters in ink. The dry delicacy of the brush-strokes compared with the wetter, stronger ones of Shen Chou's strokes show something of the range possible within such an apparently limited form as pine trees in black ink. It would be difficult to find in European art such intense contemplation of a single tree as appears in these two scrolls.

It is interesting to notice that the Japanese were less successful with the pine tree than with any other plant in ink, although the pine was always important in their art and figured prominently in coloured painting as a strongly decorative feature. The explanation again lies partly in the link with calligraphy. Japanese calligraphy was rarely the equal of Chinese in the strong, square styles of writing characters; similarly in this strongest of subjects they found themselves at a disadvantage.

During the Ming Dynasty (1368–1644) the scholar-artists achieved, at least in their own minds, a complete dominance over Chinese painting. Their self-made symbols chosen from nature now extended to the *Four Noble Plants*; these consisted of the bamboo and plum, to which were now added the orchid and the chrysanthemum. The orchid usually depicted was a modest wild plant which tended to grow hidden among grass. Its finely scented flower was a pale green. It symbolized the quiet, retiring life of the scholar, but its real attraction lay in its perfection and simplicity of form. Less varied, purer in shape than other favoured plants, it brought out most of all the subtleties of brushwork which one scholar could recognize in another. It is significant that the orchid was the plant which the Japanese most successfully painted in ink. Its delicate, curving lines have much in common with the best Japanese calligraphy, especially with the liquid, cursive *hiragana* syllabary which is unique to Japan.

Consequently, the orchid can be illustrated adequately from Japanese

88 Pine-tree in winter. From an ink-painted handscroll by Yu Chiu (active late 16th century). China, late 16th century.

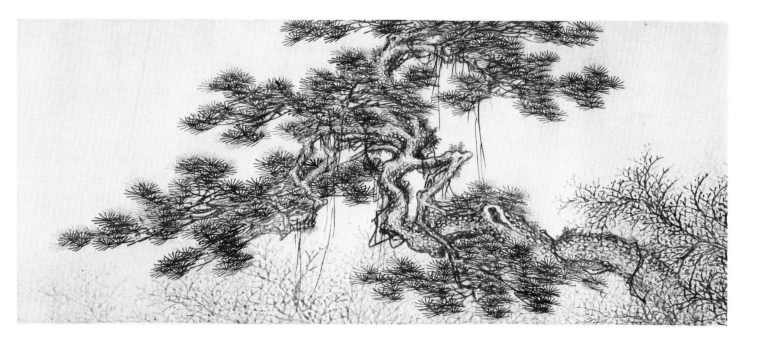

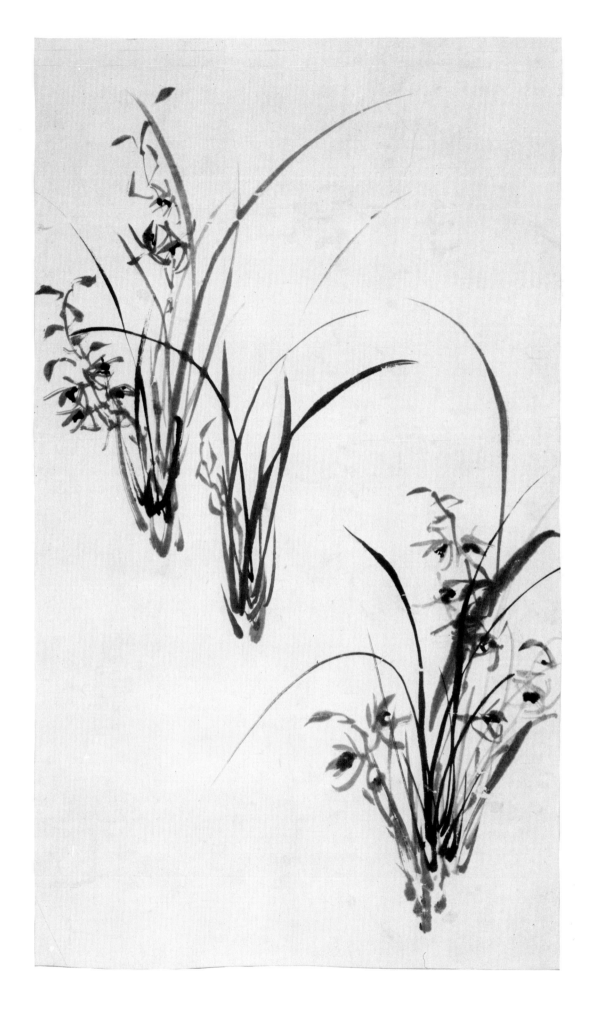

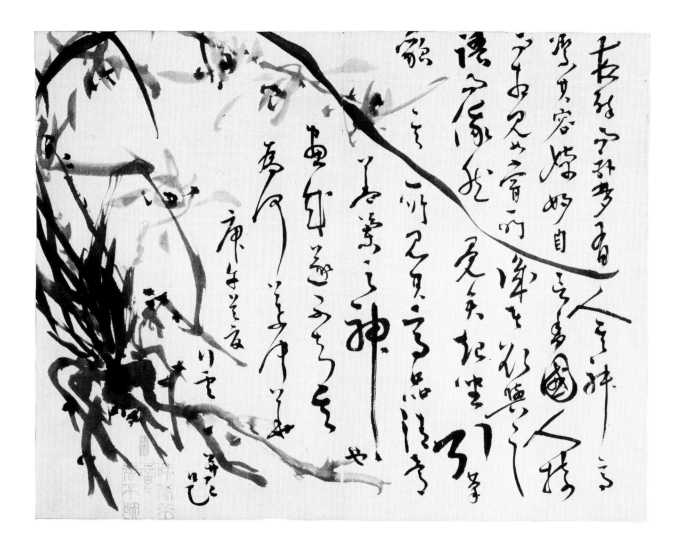

89 *left* Epidendrum. Detail from an ink-painted handscroll by Chō Gessen (1721–1809). Japan, late 18th century.

90 *above* Epidendrum (and calligraphy). Album leaf in ink by Kōun (worked later 19th century). Japan, 1870.

examples. A hanging scroll by the Buddhist priest Chō Gessen (1721–1809) of three clumps of the plants shows the intense, contemplative seriousness with which they were treated (89). Gessen inherited a tradition from the fifteenth century when the priest Bompō, a pioneer in Japanese ink painting, chose the orchid as his favourite subject. The intimate link with calligraphy is neatly illustrated in an album leaf of about 1871 by Kōun (90), where the orchid is almost literally entwined with the writing, and is done in a style which exactly mirrors it. Orchids in ink were also very beautifully realized in wooblock books designed to instruct budding artists such as *Ransai Gafu* (1778; 91).

The fourth of the noble plants was the chrysanthemum which was a symbol of the scholar in retirement. It was widely cultivated in China, Korea and Japan. It appeared less often in pure ink than the others. The difficulty of suggesting the colours which are such a prominent feature of the flower led even scholar painters to allow colour into their chrysanthemums on many occasions. As we have seen (plate 32) the antiquarian Ch'en Hung-shou much admired the flowers, but he did them in a mixture of colour and ink.

91

91 Chrysanthemum. Album leaf in ink by Tani Bunchō (1763–1840). Japan, 1817.

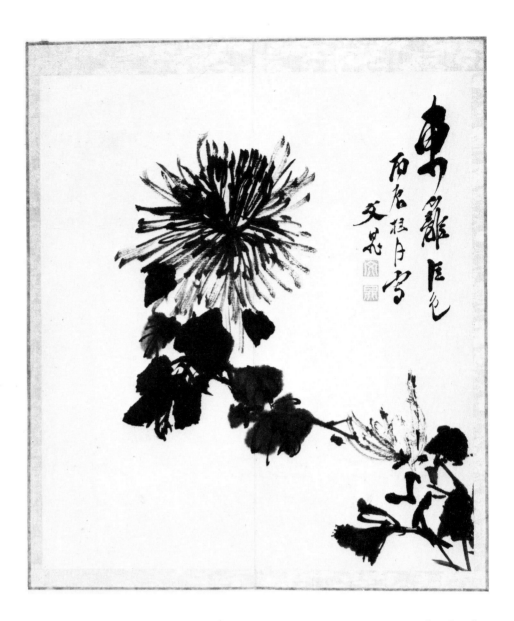

The leaves themselves with their wider areas were not so strongly related to calligraphy, and artists often found it helpful to introduce a rather artificial sense of movement. Ch'en Shun (1483–1544) did it by strewing his plants sideways as if freshly cut (73). The most calligraphic strokes were found in the ray-like petals of some varieties. When these were sharply brushed in, the result was vigorous and alive, as in Bunchō's album leaf (91).

Without doubt the majority of ink paintings of plant life in East Asia were of the five subjects so far described. But there were of course many others, of which the narcissus was perhaps the most admired by the gentleman-scholar of China for its purity of form and colour, its flowing line, and its restraint. Chao Meng-chien (1199–?1267) painted a long handscroll of many narcissi growing together which was always one of the most celebrated of all Chinese paintings. It was later divided into two, and one section is now in the Metropolitan Museum of Art in New York (92). It is an

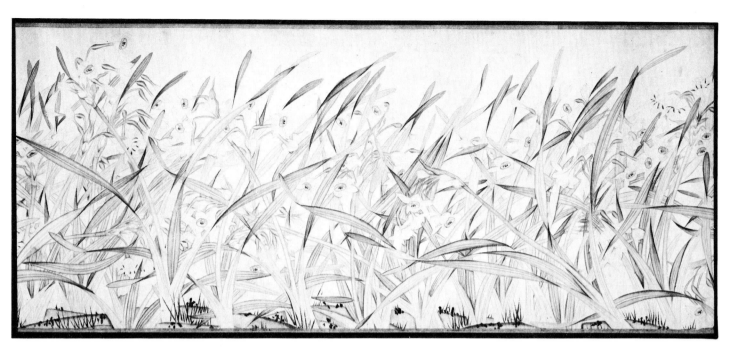

92 Narcissi. From an ink-painted handscroll by Chao Meng-chien (1199–?1267). China, mid-13th century.

astonishing exercise in variety within a very limited form, though its warm appreciation of the character of the narcissus prevents it from being only a disguised essay in calligraphy.

Plants of the more broad-leafed type were less popular as subjects for pure ink-painting. There were clearly technical difficulties in representing very broad areas in pure ink while maintaining variety and subtlety. The lotus with its huge leaves was one that was particularly intractable. Kao Feng-han (1683–1743) solved the problem by using thick outline and implying that it was continued over the spaces he left (93). Others like the paeony, hibiscus and magnolia were considered good enough for the scholar if done in a sufficiently different technique from the professional decorative paintings in which they also appeared.

It was the Japanese who eventually seemed most at home with these plants. Since the sixteenth century the painters of the official Kanō School had in their screen paintings practised a tradition of using large areas of light ink wash combined with heavy, wet ink, mostly in misty landscapes. From the seventeenth century the Rimpa artists had practised the *tarashikomi* (see chapter 6) technique in ink as well as colour. These tendencies had given them a special, almost physical feeling for ink as pigment rather than as a calligraphic tool. With greater knowledge of Chinese painting during the eighteenth century, this began to show in ink painting of a very tactile, almost sensuous type. It can be seen in the luscious tones of the grape-vine of Tenryū Dōjin (1718–1810), who specialized in vines (94) and in the magnolias of Matsumura Keibun (1779–1843; ill. 95). It shows even more in Tani Bunchō's hibiscus (plate 36) where he has added a simple red colour to the liquid blacks of his ink to make an effect of sumptuous luxuriance which combines the virtues of pure ink and colour.

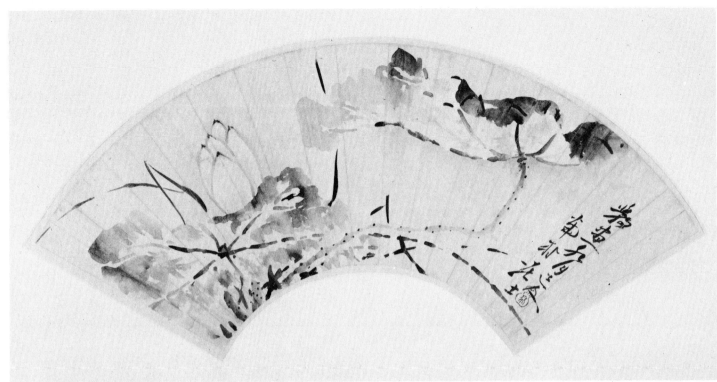

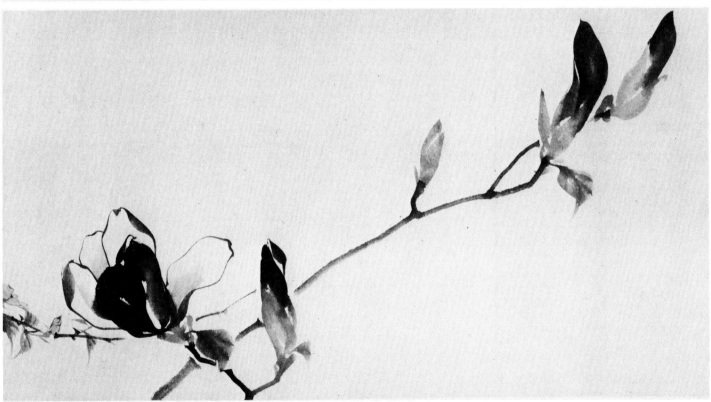

93 *top* Lotus. Ink-painted fan by Kao Feng-han (1683–1743). China, about 1730.

95 *bottom* Magnolia. From a painted handscroll by Matsumura Keibun (1779–1843). Japan, early 19th century.

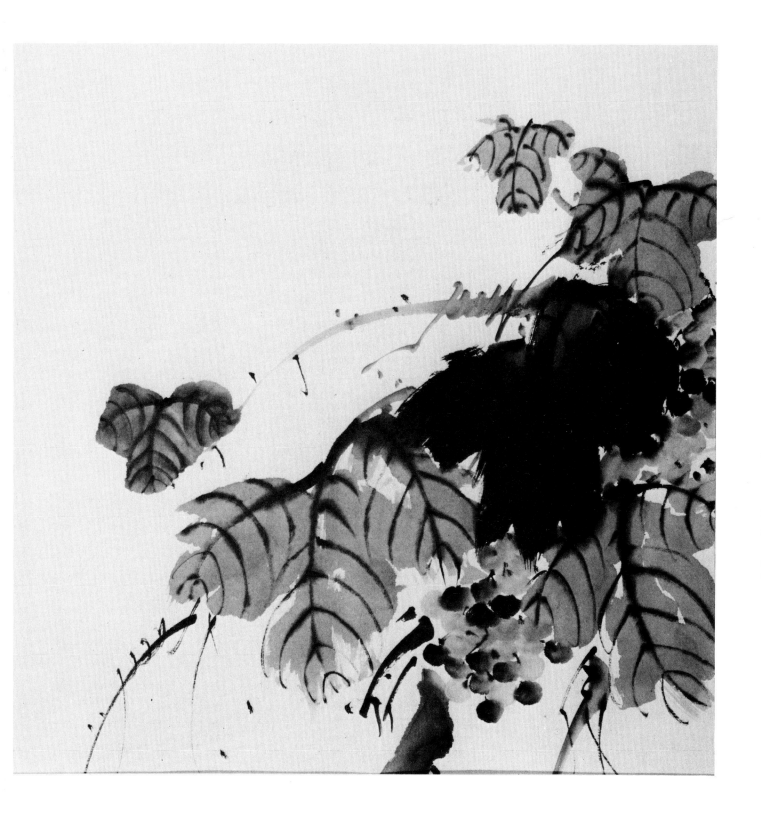

94 Grape-vine. Detail from an ink-painted hanging
scroll by Tenryū Dōjin (1718–1810). Japan, about
1800.

8
Woodblock prints in East Asia

Woodblock printing was invented in China at least seven hundred years before it appeared in Europe in the fourteenth century AD. Paper, which made it possible as an art form, was produced in China even earlier. Yet apart from related techniques, like stone rubbing and stencil, no sustained attempt was made in the countries of East Asia to investigate other forms of printing for illustration until the late nineteenth century. The history of pictorial prints was thus one of ever-greater refinement of the one basic medium of woodblock. During all that period, as discussed earlier, there was also only one serious way of painting – in ink and water-based colours applied on silk or paper with the same brush that was used for writing. When print artists came to design more advanced works, which they did increasingly from the sixteenth century, they therefore had a real understanding of both traditional painting and printing methods. It is not surprising that their productions, especially in Japan, became more closely integrated with the artistic scene than they were in Europe, and the woodblock medium was fully able to cope with the demands of reproducing accurately the finest nuances of the artist's line. This was very different from the European situation (see chapter nine). Because of this close link with what artists actually painted, flowers, plants, trees and fruits formed a very common theme for print-makers, for as we have already seen, the vegetable kingdom was one of the major sources of inspiration for the artists themselves. Many of the landmarks of printing – for example *The Ten Bamboo Studio Albums* or *The Mustard-Seed Garden Manual* in China, and *Ransai Gafu* in Japan – are partly or wholly concerned with depicting flowers. We can therefore follow the history of woodblock printing in those countries through sheet prints and books on floral subjects.

There is a further comparison with painting in the relationship of Chinese and Japanese prints. China invented and took to apparent perfection woodblock printing in both colour and monochrome; Japan copied, developed and refined the technique beyond the dreams of the Chinese pioneers, but at the same time changed the spirit of the originals. We shall see that this was partly the result of the successful commercial development of the print in Japan, and partly due to the strongly decorative tendencies of all Japanese art.

One other very important point should be borne in mind which is a great contrast to what happened in Europe. In China, Japan and indeed Korea, outline prints were for many centuries often tinted by hand until an adequate form of colour printing was worked out. After that, the black and white print tended to occupy a secondary place except where it was aiming to reproduce the subtleties of pure ink-painting. But in Europe, even with the coming of adequate forms of colour printing, such as colour engraving and lithograph, hand-tinting continued right up to the twentieth century. It was not, it seems, until good photographic reproduction in colour came in that the European public or the artists themselves could accept the print medium as an adequate substitute for hand-applied pigments. This was due partly to the very scientific, botanical attitude to floral art of both the artists and the public in Europe. In East Asia, the primary motive was aesthetic, and prints of flowers could be accepted as an art-form in their own right.

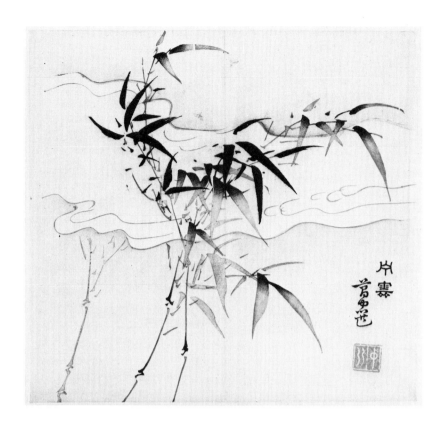

96 Bamboo against clouds. Woodblock-printed leaf after Ko Chung-hsüan from the *Ten Bamboo Studio Albums*. China, 1622–33.

The Ten Bamboo Studio Albums (Shih chu chai shu hua p'u), published between 1622 and 1633, are the greatest landmark in Chinese full-colour art printing (96). Until then, prints had been illustrations to texts, usually in a simple black outline, which made no attempt to reproduce original brushwork and which were apparently done after the designs of comparatively inferior artists. This had gone on for perhaps eight hundred years; the frontispiece depicting the Buddha Paradise in the printed scroll of the *Diamond Sūtra* dated 868 (now in the British Library) is highly developed in simple line technique and must have had a long line of predecessors. Yet it is strange that the enormous skill which went into cutting the blocks for the texts was so long in being transferred to the purely pictorial.

The reason may lie in the very perfection of the process for its limited purpose. It should be remembered that the woodblock process seems to have developed first in China as a means of printing texts rather than pictures. By AD 600 there were about 20,000 Chinese characters in existence, many of them consisting of 20 or more separate strokes. Before that time there had been a slow development of at least 1500 years in writing these characters, and many different styles were practised, including some which were very hard to read except to the learned – the distorted, square seal-script at one extreme, the cursive, flowing grass-script at the other. Compared with the twenty-one Latin letters in contemporary Europe and the very limited number of writing styles, there was obviously among the non-scholars a problem in communication which a plain, standard printed form of the characters must have done much to alleviate.

The use of personal seals (known from very much earlier times in Western Asia) must have provided the idea of cutting away a surface to leave the line in high relief. Artists' seals continue to the present day to be pressed on paintings in East Asia, and many examples can be seen in the illustrations of this book. A standard of clarity was perhaps set up in the reverse-printed ink-rubbings from ancient inscriptions and designs incised in stone (3). Although we do not know in detail how it happened, by the eighth century it had become usual to cut a whole sheet of a text onto one block. Moveable type, though used occasionally in later periods in China and Korea, was simply too complicated to manage with the many thousands of characters. In fertile, well-organized China there were always large numbers of people available to be trained in crafts, and it was clearly no problem to find the many cutters needed to produce a printed book quickly.

These cutters did not aim at subtlety, but they had to work quickly to produce a clear, neat result. Over a millennium a huge reserve of experience and skill was built up, but without inspiration. The main patrons were the Buddhist temples, eager to disseminate their voluminous scriptures with the maximum efficiency. The technique was almost all available, but what was lacking was the customer with the resources and the taste to elicit an art-form from this great potential.

The Ten Bamboo Studio Albums were the result of just such a demand. During the sixteenth century, the security of the mid-Ming Dynasty gave rise to a prosperous, cultured middle-class society, particularly in the more artistically-inclined areas around Nanking on the Yangtze River. This public was quite different from that of the gentleman-scholars. Just as was to happen in Japan a century later, fine printing grew up to satisfy the aspirations of a class excluded from official avenues of advancement. For such men, colour-printing began to develop, at first in fine letter-papers printed in several colours and in erotic books. The latter were a source of progress, because their purchasers were prepared to pay a lot for them, and money above all was needed for the complicated business of fine multi-block colour printing.

Using a different block for each colour must have been thought of almost as early as printing itself, and there are in China and Japan isolated, simple examples as far back as the eighth century AD. But for the reasons discussed above, the art had to wait until the later sixteenth century for its Eastern fulfilment. That was actually later than early sixteenth century European woodblocks in two and three colours; the use of coloured woodblocks, however, did not continue long in Europe.

The main technical problems in colour-printing as an art-form were overcome in *The Ten Bamboo Studio Albums*, and it is interesting to look at how it was done. In illustration 96 we see bamboos waving against passing clouds, a charming and decorative concept which had much influence in Japan. The sky each side of the band of clouds is printed in a very fine pale blue wash. For the delicate imprint of wood on paper, high quality, translucent watercolours and inks had to be found with a very fine granular structure. These turned out to be the clear but simple colours used by

97 Lichees. Woodblock-printed leaf after Kao Yu from the *Ten Bamboo Studio Albums*. China, 1622–33.

painters of the non-professional schools. The papers themselves had to be very fine and of a very clear and white colour. Again they were found among the papers already used by painters. The bamboo itself is printed in ink, and it is aiming to reproduce as closely as possible the exact brush-strokes of the original artist Ko Chung-hsüan. The cutting of the block had therefore to be done with the greatest sensitivity and understanding; furthermore, the inking of the block had to be graded to reproduce the variations from dark to light on individual leaves, and this and the actual printing was perhaps the most crucial operation in creating a really high-quality product. The complexities of the bamboo, one can see on close scrutiny, had to be realized in more than one ink printing.

Correct registration of the different blocks was of course essential, and we can see its importance more clearly in the sheet of lichees in illustration 97. Here the purplish fruits are depicted by printing them with a blue block which includes the minute semi-circular shapes representing the pitted surface of the skin, while over the upper half of each is imposed a pale red wash which gives an illusion of purple. The effect is clear, attractive and even lifelike, but it would fail completely if the red were not perfectly aligned with the blue.

The secret of how this was done in China was discovered only this century. It was first described by Jan Tschichold from eye-witness accounts in twentieth-century Peking, where the traditions had apparently survived from the seventeenth century. The sheets of paper, all cut to precisely the same size, were gripped in a vice fixed onto the working table, which held

them in the shape of a book. One leaf was turned at a time onto the cut block, which was fixed to one side, and after a few pulls to adjust the positioning of the block the whole sheaf was run through. Each sheet was rubbed face downwards onto the inked block with an instrument like a small, heavy brush. There was no press in the European sense. Each successive colour block could be impressed exactly on the whole sheaf in the same way. During the process, each inked sheet was allowed to hang through a slit in the centre of the table, thus neatly getting it out of the way without disturbing the exact alignment of the sheaf, on which the whole operation depended.

By such simple but precise means did the Chinese printers reproduce very closely the work of their artists. For we must remember that *The Ten Bamboo Studio Albums* was produced both as a manual for the amateur painter and a picture-book for the connoisseur. It included instructions on brushwork and materials, and it tried to provide for the budding artists of the Nanking middle classes accurate accounts of real painting. For this reason, there is little ink outline, for when the scholar artists painted in colour it was usually in the 'boneless' style in direct, simple colours. This gave a clear, fresh spontaneity to the prints, and especially to those of flowers, fruits and bamboo which form the bulk of the eight albums. The bamboo naturally predominates, both as the prime symbol of the scholar class, whom the public wished to emulate, and because of the title. The dwelling in Nanking of Hu Chêng-yen, the publisher of the work, was known as the Ten Bamboo Studio from the ten bamboo plants which grew outside it.

In illustration 96, the carefully graded inking of the blocks on the bamboo leaves can be seen. In the lichees in illustration 97 the bough of the tree is even more subtly done, with a light overprinting of black ink in parts on the basic pale brown. This quite successfully imitates the artist's skill in running one wash onto another. The reaction of the early purchasers of the *Ten Bamboo Studio Albums* may have been that these prints were as good as paintings. We can see better, after three-and-a-half centuries, that they are no such thing. Close as they are to painting, they have that indefinable clarity, that simple freshness of colour, that sharp-edged crispness which make the woodblock print a different and yet satisfying medium. Above all, they raise design to the highest virtue. A painting may speak to us without good design through the eloquence of its brushwork. A print without a strong sense of design is nothing.

This was obviously soon realized. There are a group of Chinese sheet prints which were brought back from Japan by Engelbert Kaempfer in 1692 and have been in the British Museum since 1753 (plate 42) where they have been preserved in pristine condition. Their range of colour, still aglow after three centuries, is far wider than that of Chinese paintings even of the decorative schools, and some are of a more brilliant hue than was used by any painter. Yet there is a clean simplicity, in spite of the rather complex designs, which is entirely the province of the graphic art. Most of these beautiful prints are of birds, flowers, and fruits. The latter offer wonderful opportunities for the printer to show his skill in the graded colouring of the block, and they stand out brightly against the pure white paper.

98 Chrysanthemum, pink and rocks. Woodblock-printed leaf from the *Mustard Seed Garden Manual*. China, 1700.

The prestige of the *Ten Bamboo Studio* ensured that a few sets of the albums survived. The Kaempfer prints, preserved by sheer chance in Europe, must have been just one group of many of flowers and birds which have failed to survive, for the Chinese publishers seem to have been able to produce only small editions to the standards they set themselves. One other famous printed work lasted better both because it was in book form and because it went through many editions. This was the *Mustard Seed Garden Painting Manual (Chieh tzû yüan hua chuan)* published in parts from 1677 to 1701, with a late fourth part in 1818. Like its great predecessor, it aimed to teach painting as well as to provide beautiful reproductions of paintings and a great many of these were of flowers and plants, both in colour (98) and in monochrome, the latter concentrating on the 'four noble plants'.

The early editions of this work see the end of the great period of the Chinese woodblock. Circumstances did not seem to favour its continuation at its former high level. But the woodblock print was to find a new home across the sea in Japan and there to reach new peaks of achievement. Like China, Japan had produced prints in black outline for a thousand years, and had known how to print colours for as long. Similarly, economics had prevented the development of full colour printing, even though since the mid-seventeenth century a successful literary publishing industry of great vigour had grown up in the major cities of Edo (modern Tokyo), Kyōto and Ōsaka. Two main influences in Japan changed this situation rather suddenly over the quarter century 1740–65. One was the economic climb of the urban middle classes; by 1765 enough of them wanted colour prints to make them profitable. The other was the example of *The Mustard Seed Garden*. Its increasing influence can be felt from around 1740. Rather

strangely, this famous manual, designed to teach the Chinese how to paint, became better known because it taught the Japanese how to print.

The statement above is of course a simplification. There were a few books and albums privately printed in colour for connoisseurs during the second quarter of the eighteenth century. One, *Chichi no On* (1730) has an elegant roundel of water-flowers in three colours plus ink, very much in the style of the *Ten Bamboo Studio Albums*. But it was *The Mustard Seed Garden* which, apparently quite widely distributed in Japan after the ban on foreign books (except Christian ones) was lifted in 1720, made more Japanese want colour and monochrome printing in its advanced technique, and set off a wave of interest in Chinese-style painting which had hitherto been virtually confined to the port of Nagasaki.

Again, registration was the problem, and some pioneers got round it by using stencils. Since the whole design could be cut into the stencil, different colours could be used on different parts of it with no loss of registration. Ōoka Shumboku's *Minchō Seidō Gaen* (1746), of which only the surviving early copy seems to be the British Museum's, uses this technique in combination with a line block to reproduce designs by Chinese artists, including some from *The Mustard Seed Garden*. The effect, at least in floral designs, is charming and thoroughly decorative, but bears little resemblance to the Ming paintings it claims to copy. Sekkōsai's *Saishiki Gasen* (1767) uses stencil in a more refined way in a design which is so boldly original that it could only be Japanese (99). The colours are yellow and pink in the page of the book illustrated. Elsewhere in it, the publisher has used a background of stippled ink which has been carefully blown onto the paper with a pipe. Such productions could obviously not be for a wide public.

The first Japanese edition (1748) of *The Mustard Seed Garden* is notably badly registered, especially where there is colour and black outline, but a brave attempt is made to use the full range of colours of the original. Some of the simpler designs, however, are more effective. The example in illustration 100 has a plain white gardenia without outline, slanting easily across the double page. This was a sort of pattern which appealed very much to the Japanese liking for off-centre placing, oblique movement and use of space. Designs of this general type appear again and again in Japanese woodblock books during the next century – for example, the sunflower by Kihō from *Kihō Gafu* (1824; 101). The Japanese edition of the *Mustard Seed Garden*, though done on a Chinese-style paper, was sewn up in the Japanese manner. It was not an album, but a book with the inevitable central division down the centre of each opening. The Japanese had a preference for designs which could be carried across the double page in a convincing movement, and flowers and plants were naturally good candidates. In Mori Ransai's *Ransai Gafu* of 1778 the orchids (102) have such a splendid sweep that one almost forgets the central division. In printed albums there was not the same problem, and designs of a much more delicate nature were possible because they had an almost uninterrupted surface . Sometimes, however, as in plate 44 from Utamaro's *Ehon Mushi Erabi* of 1788, the two halves of a book-opening were designed to stand on their own as well as to fit together.

40 *Rhododendron wightii.* Coloured lithograph by W. H. Fitch after Joseph Hooker, from J. D. Hooker, *The Rhododendrons of Sikkim-Himalaya* (1849–51). 497 × 364mm.

39 Common Solomon's Seal. *Polygonatum multiflorum.* Stipple-engraving printed in colour by Degouy, after Pierre-Joseph Redouté, from *Les Liliacées* (1802–16). 520 × 328 mm.

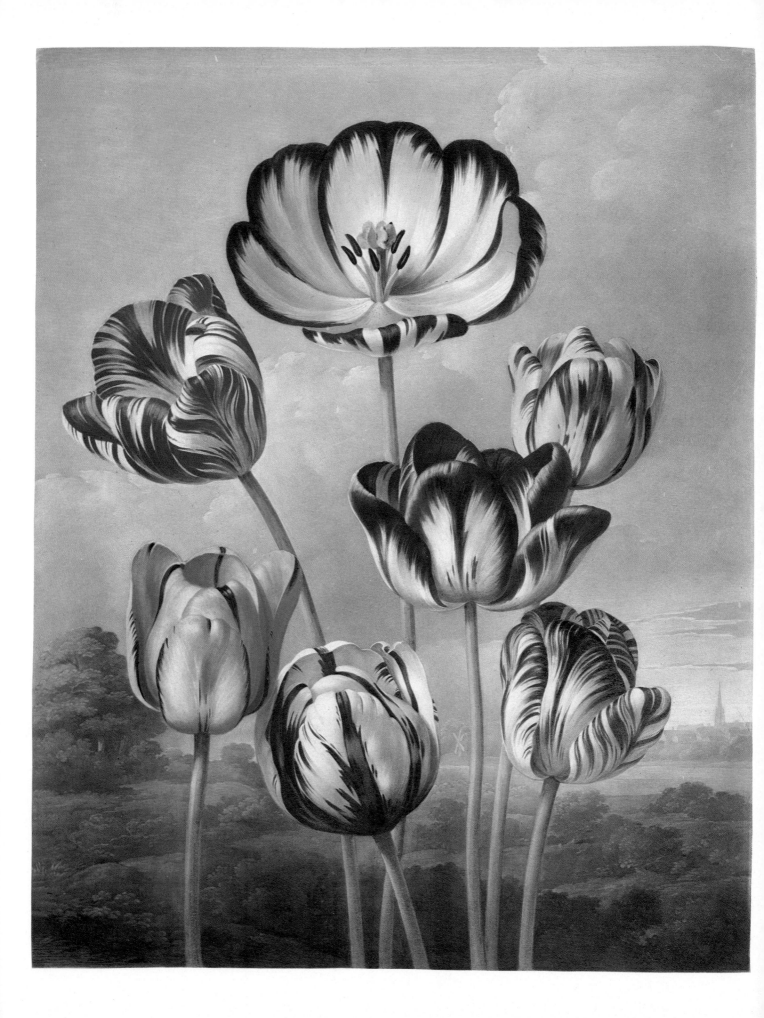

41 *left* Broken Tulips, *Tulipa × gesneriana* cultivas. Colour mezzotint, finished by hand, by Richard Earlom after Philip Reinagle, from R. J. Thornton, *Temple of Flora* (1799–1807). 482 × 348 mm.

42 *right* Peach bough with cicada. Woodblock print. China, about AD 1680. 290 × 370mm.

43 Yellow mallow? Opening from the woodblock-printed book *Suiseki Gafu* (second series) by Satō Suiseki (worked AD 1806–40). Japan, 1820. 214 × 310mm.

99 Plum-blossom. From the stencil-printed book *Saishiki Gaen* by Sekkōsai. Japan, 1767.

100 Gardenia. From a Japanese edition of the woodblock-printed *Mustard Seed Garden Manual*, 1753.

44 *left* Balloon flower, *Platycodon grandiflorus* and Gampi, *Lychnis coronata*. Opening from the woodblock-printed book *Ehon Mushi Erabi* by Kitagawa Utamaro (AD 1753–1806). Japan, 1787. Printed area 215 × 160mm.

疾風生巢揚画
敖菴崇蘭惟汝
翻香萋晴擬見
君室
竺湖外史

Masterpieces of printing of this type show that the registration problem had been solved by Utamaro's time. It was done by the general adoption of the device called the *kentō*, a thoroughly Japanese solution in its extreme simplicity and effectiveness. The *kentō* consisted of two raised marks on the outline printing block. One was a right-angle in one corner; the other a short line at the far end of one of the sides subtended by the angle. The same marks, in exactly the same position, were cut in each colour block. As long as each sheet was cut to exactly the same size, it only had to be carefully aligned with the *kentō* to ensure perfect registration. This device had been known in Japan since at least the early seventeenth century, but it did not come into general use until the decade 1760–70 when multi-colour printing suddenly developed into a major industry.

The commercial success of colour printing was based on the Ukiyoe school prints, which concentrated on the actors, entertainers, prostitutes and the fashionable world of the great cities. These were mostly single-sheet prints, and as they aimed to be up-to-date they avoided conservative subjects like flowers. These can be found in the more refined books and albums of various schools produced in small editions for a more discriminating clientele. The only *Ukiyoe* artist who produced many fine sheet prints of floral subjects was Hokusai (1760–1849), that versatile and prolific designer who could turn his hand to almost any form of painting or graphics. His two series known as the 'large flowers' and the 'small flowers' are quite unlike any other floral prints produced in Japan in their unexpected designs and unusual colour combinations, sometimes elegant, sometimes quirky or compelling (103).

The first Japanese books printed in a wide range of colours with real confidence, good registration and a thoroughly native feel for design were Ryusui's *Yama no Sachi* (1765) and Sō Shiseki's *Sō Shiseki Gafu* of the same year. They both happen to be mainly of flowers and plants, and they also, perhaps not by chance, represent the two main lines of East Asian painting; *Yama no Sachi* is printed in colour with outline, *Sō Shiseki Gafu* in pure ink or colour without outline – the so-called 'boneless' style. The latter, based strongly on Chinese models, is nevertheless very Japanese in the way it begins to adapt and improve woodblock techniques. In the monochrome plate of grapes in illustration 104 parts of the block are 'lowered', that is, very slightly cut or rubbed down so that only a light impression is made, resembling the 'dry-brush' classic painting method.

From this period rapid improvements in method and materials made possible a golden age of woodblock printing in Japan. It lasted for some sixty or seventy years before a decline in standards set in. Cherry-wood blocks, hard but very sensitive, replaced the old Catalpa-wood blocks; the *kentō* came into general use; a wide range of pigments and dyes were developed, many of them, like *nurasaki*, the purple used in *Ehon Mushi Erabi* (plate 44), too delicate and fugitive for most painting; and special new papers replaced the thin, white Chinese types. These papers were thicker, more absorbent, yet gave a very firm surface in an off-white which the Japanese found more sensitive to their subtle colouration. Extreme delicacy of colour, without a hint of insipidity, plus an inspired sense of design are the glory of the prints

101 *left* Sunflower. From the woodblock-printed book *Kihō Gafu* by Kawamura Kihō (1778–1852). Japan, 1824.

102 *left* Epidendrum. From the woodblock-printed book *Ransai Gafu* by Mori Ransai (?1740–1801). Japan, 1778.

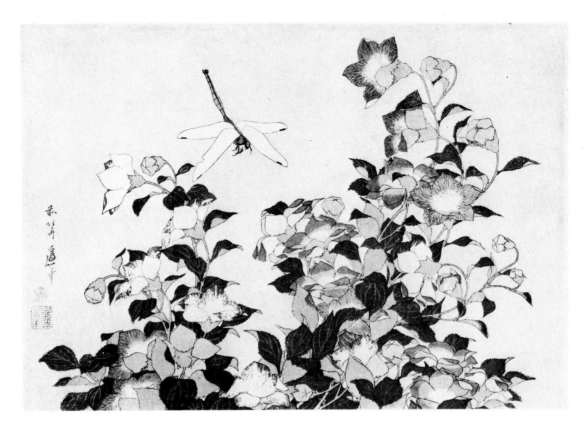

103 *top left* Balloon-flowers, *Platycodon grandiflorus*. Woodblock print by Katsushika Hokusai (1760–1849). Japan, about 1830.

104 *above* Grape-vine. From the woodblock-printed book *Sō Shiseki Gafu* by Sō Shiseki (1712–86). Japan, 1765.

105 *bottom left* Narcissi. From the woodblock-printed book *Shazanrō Ehon* by Tani Bunchō (1763–1840). Japan, 1816.

of this period. They are still there as late as Suiseki's brilliant poppy in *Suiseki Gafu* (1820), a book which is even by world standards one of the masterpieces of graphic art (plate 43). Hokusai's flower prints are the only ones which survived unharmed the introduction of the powerful Prussian Blue imported from Europe in the 1820s, which he himself promoted.

It is possible in this short survey only to hint at the diversity of style and technique of the Japanese prints in this period, even in the relatively narrow area of flowers, plants and trees. Artists of every school designed for books and albums, and some for single sheets; others re-interpreted for the woodblock medium the works of great masters of the past and present. We shall conclude this chapter with a look at a few highlights, followed by a glance at the so far neglected productions of the later nineteenth century.

The Rimpa School had seen its greatest days by the heyday of the woodblock print, but it proved a natural style for the medium because of its startling simplifications of form. Nakamura Hōchū in *Kōrin Gafu* (1802) adapted the original designs of the master Ogata Kōrin (1658–1716) and made them even more surprising. The plum bough in illustration 74 (from the edition of 1826) would not look out of place in an exhibition of early twentieth-century European lithographs.

The ability of the cutters and printers to produce results of either great boldness or extreme delicacy encouraged artists of quite different traditions to entrust their designs to them or to reinterpret for them the works of earlier masters. Thus the reticently expressed yet forceful line of Kawamura Bumpō (1779–1821) is conveyed in the beautiful bamboo from *Bumpō Gafu* (1807) by the combination of careful, light inking, sharp cutting of the block and the very soft paper (82); the incisive ink-work of Tani Bunchō (1763–1840) is crisply cut, and boldly inked in the dashing narcissi (105) from *Shazanrō Ehon* (1816); and the suggestive brush and colour work of Shioji Yoshiaki in *Kakudō Gafu* (1835) is beautifully conveyed in his camellia in the snow, where the white of the paper itself is used to suggest the snow, left in reserve against a background of pale grey (106). Finally, the complexities of Tenryū Dōjin's monochrome brushwork is powerfully realised in the *Budō Gafu* of 1797 (107).

These all use the full double book or album page. In the folding album *Taigadō Gafu* (1804) some designs are even carried over more than one opening, a most unusual procedure. In this remarkable book, borrowing the designs of the great artist Ike no Taiga (1723–76), the deceptive simplicity of Taiga's work is suggested by printing large areas of a single colour with black overprinting, a reference to his use of ink over colour wash. Yet the dramatic points of view made acceptable by the book medium create something quite different in feeling from Taiga's own painted work. The splendid trees in illustration 108 are extreme examples.

There was always room in Japanese printing for the unusual, the bold, the thoroughly original, for there was always a buying public to appreciate them. One work devoted to plants was *Soken Sekitatsu* (about 1768) by the great eccentric Itō Jakuchū. This book goes back to the roots of printing in the Far East by imitating the early Chinese stone-rubbings (3), in which the designs appeared in reserve in white on a mottled ink background

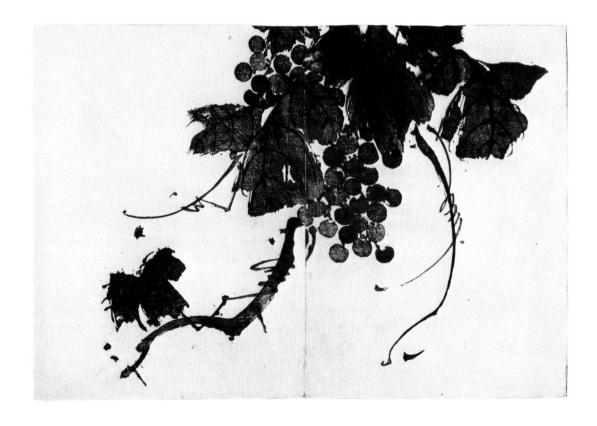

106 *top left* Camellias in snow. From the woodblock-printed album *Kakudō Gafu* by Shioji Yoshiaki. Japan, 1835.

107 *bottom left* Grape-vine. From the woodblock-printed album *Budō Gafu* Tenryū Dōjin (1718–1810). Japan, 1797.

108 *above* Deciduous trees. From the woodblock-printed album *Taigadō Gafu* after Ikeno Taiga (1723–76). Japan, 1804.

resembling lithograph (not unnaturally, since they were actually taken from stone). In Jakuchū's work, splendidly vigorous designs of plants are paired with calligraphy (109). Most of the plants have ragged leaves to help the design and to give a greater sense of naturalness. Yet this is even more of a connoisseur's book than it first seems, for it has not in fact been *printed* at all. The white reserves have a slight edge and a crinkled surface as in a rubbing. This was done by first pressing very thin paper into the depressions made by reversed patterns cut in the blocks. Then the resulting raised surface was inked over, leaving the designs in white. Finally the paper was removed and pasted into the album. This was in effect a stone-rubbing done in wood, the surface prepared to reproduce a stony grain.

The customers for printing of such rarified appeal were often the amateur poets who patronised privately produced books of verse. Thus the beautiful plates in an untitled book of verse published in 1793, mostly of flowers, were almost the public manifesto of the Maruyama-Shijō School (see chapter six). The Hibiscus by Yūjo from that book is one of the most refined flower-prints ever produced, yet the artist and his dates are almost unknown, so high were the artistic standards of the time (110).

千瓣開幽睡春風
得意雲由來宰相
名山中羞

109 *top left* Tree paeony (with calligraphy). From the reverse-printed album *Soken Sekitatsu* by Itō Jakuchū (1716–1800). Japan, about 1768.

110 *bottom left* Hibiscus, by Yūjo (fl. 1789–1804) from an untitled woodblock-printed album, Japan, 1793.

111 *above* Aspidistra, *Liriope* and others. From the woodblock-printed book *Sōmoku Kinryōshū* by Mizuno Chūkyō. Japan, 1829.

Strangely, the botanical or herbal interests never produced great artistic work in China or Japan as they did in Europe or the Islamic world. In both countries printed herbals and botanical works were rather simple affairs in black outline of no distinction. The Japanese, especially, seemed unhappy unless producing the most effective possible design on a page. The one exception to the unexciting quality of botanical books is *Sōmoku Kinryōshū* (1829) by Mizuno Chūkyō (111). Here the use of shading in European flower engravings has been distorted and turned into brilliantly irrational patterning in black and white. The nineteenth century did, however, see very pretty books of garden varieties of flowers, which are not unlike the seedsmen's catalogues of seventeenth-century Holland in their high quality. Examples include *Henyū Hinzatsu Zukō* (1815) devoted to the morning glory *(convolvulus)* and the extravagant *Keika Hyakukiku* (Keika's One Hundred Chrysanthemums) of 1893 (112).

The latter is an example of the revival of standards in Japanese woodblock printing in the late nineteenth century after a period of decline caused by imported Western dyes and the cultural confusion of the shock of Westernisation. Some of the most technically perfect woodblock books were produced at this time, of which *Keinen Kachō Gafu* (1892) by Imao Keinen (1845–1924) is the most sumptuous, with four volumes of brilliantly

三國師

112 Florist's chrysanthemums. From the woodblock-printed book *Keika Hyakukiku* by Imao Keika. Japan, 1893.

detailed studies of birds and flowers. A comparison of details from this work with details from some of Keinen's paintings shows that by this time Japanese block cutters were able virtually to produce facsimiles of an artist's painted work. It is not surprising that artists soon rebelled against this rather deadening skill. In the early twentieth century began the *Sōsaku Hanga* movement where artists cut and printed their own blocks. Such printing was no longer popular in the old sense, and it has now become part of an international graphic scene in which flowers and plants play a less important part.

9
Printing techniques in Europe

The woodcut was the universal medium of printed illustration in the West even before the invention of moveable type in Germany in the 1450s and was widely used for more than a century and a half afterwards. The method of printing from the woodblock is essentially the same as printing from type and so was ideally suited to book production since both text and illustration could be printed in the same press. The technique is simple and direct in that what is drawn on the woodblock stands in relief when the rest of the surface is cut away and when inked will produce an impression on paper under only light pressure. Though the process could demand great skill of the woodcutter, who was seldom the inventor of the design, he was rarely required to interpret the artist's intentions but only to cut away the unwanted surface of the block.

The illustration of plants in early printed books was modest in quantity and usually mediocre in quality. It was largely confined to the herbal which simply republished illustrations which had become ever less useful as they were recopied. It is hardly surprising that the herbal at first failed to attract original and talented artists. In the hands of a master such as Dürer and the cutters available to him the woodblock was capable of producing impressions of great boldness and beauty. Unfortunately Dürer designed no woodcut illustrations of plants but the remarkable plant studies of his younger contemporary, Hans Weiditz, were used to illustrate the *Herbarum Vivae Eicones* (1530) of Otto Brunfels. Brunfels employed woodcutters of great skill to produce his strikingly original illustrations, for the most part far more original than the text. For example, the portrait of the pasque flower (113) captures not only the plant's habit, both sinuous and wilting, but also its essential hairiness. The problem of designing the cuts for the printed page was not always successfully solved in Brunfels's herbal; there is often some distortion with a consequent loss of realism. But in Leonhart Fuchs's *De Historia Stirpium* (1542) the figures are given more space on the page and there is often a gain in boldness with a crisper and more elegant line. For instance, the picture of the asparagus very well expresses the delicate quality of the plant's feathery foliage in a fine, clear line; yet the design remains essentially strong. We know the names of the original artist of the plant studies, Albrecht Meyer, of the artist who translated the designs to the woodblock, Heinrich Füllmaurer, and of Veit Rudolf Speckle, the cutter. Unfortunately, no original plant drawings by Meyer are known but his essential contribution to the art of plant illustration, and that of the craftsmen who interpreted him was immediately recognised and many of the cuts were copied or adapted by later illustrators.

It can be said that the figures of plants in Brunfels and Fuchs mark the apogee of woodcut plant illustration in the West. The general level of plant illustration was as a result considerably raised even if the woodcut never produced anything of quite such quality again. The later sixteenth century was the age of the first great herbalists, Dodoens, L'Écluse and L'Obel who, to meet a growing demand for accurate information, compiled a number of new and original books based largely on their own collections and observations. The infant science of botany at this early stage used a very inadequate language of plant description so that the rôle of the illustrator

113 Pasque flower, *Pulsatilla vulgaris*. Woodcut, after Hans Weiditz, from Otto Brunfels, *Herbarum Vivae Eicones* (1530). 150 × 110 mm.

114 Hoary plantain, *Plantago media*. Woodcut, from Pierandrea Mattioli, *Commentarii . . . Dioscoridis* (1565). 230 × 137 mm.

PLANTAGO MEDIA.

cx uino

was at least as important as that of the author of the text. This was realised by the publisher of these new herbals, Christophe Plantin of Antwerp, who commissioned and purchased literally thousands of worked blocks many of them cut after the drawings of Pierre van der Borcht (1545–1608). This talented artist seems to have been supplied by L'Écluse with great quantities of living and pressed plants and to have produced many hundreds of drawings for the woodblock. Though these were not always cut with the greatest skill the standard of the illustrations is consistently high. They are not so bold or large or so freely designed as the best in Fuchs but succeed generally in suggesting, if not fully stating, the smaller details of plant construction. There were also some excellent woodcuts published in later editions of the *Commentarii* (first edn. 1544) on Dioscorides by Pierandrea Mattioli, as for example the plantain (114).

But the taste and demands of the reading public were changing. On the one hand the quest for medicinal remedies to be found in plants was becoming more urgent, on the other horticultural progress increased the general desire to collect printed portraits of favourite garden flowers, that is to say flower books or florilegia which could reveal those refinements of the inflorescence or foliage which the cultivator might miss in the living plant.

115 Stinking hellebore, *Helleborus foetidus*. Line-engraving, from Basil Besler, *Hortus Eystettensis* (1613). 483 × 401 mm.

The demand was for greater accuracy, more detail and greater refinement – qualities which the woodcut, even if designed and cut by a master, could hardly supply. So engraving and its allied technique etching, already in use in other fields of illustration for more than a century past, began to be employed for the illustration of plants.

It is impossible to imagine the hellebore (115) from Basil Besler's *Hortus Eystettensis* (1613), one of the earliest of florilegia, being printed from the woodblock, for it is so pre-eminently characteristic of copperplate engraving. The engraving provides above all precision as well as a more effective means of indicating shade so enhancing the illusion of the three-dimensional image. Printing from an engraved or etched plate, normally of copper, in contrast to printing from the woodblock, is an *intaglio* process. The engraver works by cutting out the lines of the artist's design, not leaving them in relief, on the surface of the plate by means of the burin

Μαλιναθάλλη *Malinathalla*

INTER

116 Nut sedge, *Cyperus esculentus*. Etching, by
Fabio Colonna from his *Phytobasanos* (1592).
133 × 84 mm.

which can excise, when required, the very finest lines. When the plate is
inked and the surface wiped clean the ink remains in the engraved lines.
Under heavier pressure than that required for the woodblock, the paper is
forced into the ink lines and takes up the impression of the design. As a
result the printed area stands up slightly but noticeably in relief above the
unmarked paper which gives the design added strength and 'brilliance'.

To compare an engraving in Besler with an etching from one of the
earliest books of plants illustrated in that medium (116) by Fabio Colonna,
Phytobasanos (1592), is to bring out the essential difference between these
two techniques of *intaglio* printing. The etched line is the nearest thing to

the drawn line for it is the result of drawing relatively effortlessly with the etching needle onto the plate (the pushing of the burin by the engraver requires some effort and considerable control), the point of the needle piercing the wax coating which is used to protect the plate when it is immersed in citric acid – the next stage of the process. The acid can bite into the plate only where the needle has removed the wax, that is to say into the lines of the design. When the protective coating is removed the plate is then printed in the same way as the engraved plate.

The plates in *Phytobasanos* show the essential character of etching. Here Colonna seems both to have designed the plates and etched them so that the line is as sensitive and free as would have been that of the original drawing. In one of the earliest florilegia, and certainly one of the finest, *Le Jardin du très Chrestien Henry IV* (1608), it seems likely again that Pierre Vallet designed and executed the plates in which the techniques of both engraving and etching are found though etching much predominates and many plates are entirely etched. Vallet (b. *c.*1575) was the first of a long line of French artists who found employment at the French court and whose talents were devoted to the illustration of plants grown in the Jardin Royal des Plantes. His alleged purpose was to produce for the embroiderer a pattern-book of floral designs which by this time were in fashion for court wear. His innate sense of design does not however distort the drawing which is entirely naturalistic and instinctively correct botanically. Though the finest figures are predominantly linear he is able with the etching-needle to suggest textures and shades of colour (117) – a technique which later French engravers were to develop so remarkably. The woodcuts of the earlier herbals had sometimes been coloured before sale but more often had been issued plain for their owners to colour if they wished. By the earlier seventeenth century etching and engraving were developing into tonal techniques and the addition of colour seemed the less necessary. The first experiments in colour printing in fact still lay some distance in the future. Vallet's plates were so successful that they were copied directly or indirectly and incorporated in other famous flower-books such as Johann Theodor de Bry's *Florilegium Novum* (1611).

The advances of horticulture and botany produced two related but distinct needs: for illustrations of an even wider range of cultivated plants shown as characteristically and as naturalistically as possible; and for more informative and scientific plant figures. Draughtsmen and engravers were ready and able to supply both needs. The *Hortus Floridus* (1614) of Crispin de Passe the Younger met the demand for plates of garden plants with such immediate success that the original Latin text was quickly followed by a fresh edition in Dutch and English and over the next half century and more de Passe's plates were copied or modified in many other English and European works. They are entirely engraved and show all the best characteristics of the medium: a strong, clear line allowing great scope for design and dramatic presentation. The engravings, except for those in the first section, the 'Altera Pars', which are generally much inferior, have great vigour and they are worked very broadly. The plants, arranged in their seasons, are shown growing from the ground and are amusingly

117 Mourning iris, *Iris susiana* with snake's-head iris, *Hermodactylus tuberosus* (*Iris tuberosa*). Line-engraving and etching, by Pierre Vallet from his *Jardin du Très Chrestien Henry IV* (1608). 305 × 170 mm.

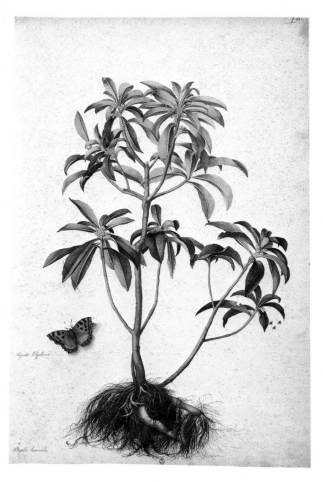

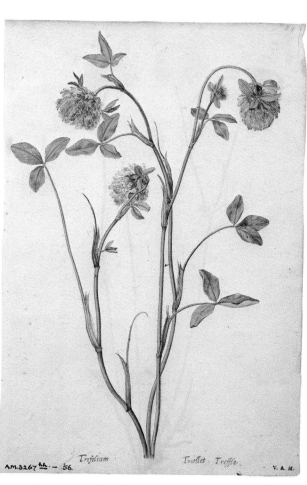

45 Spurge laurel, *Daphne laureola*. Watercolours and bodycolours, by Giacomo Ligozzi, *c.* 1570. 669×459mm.

46 *left* Red clover, *Trifolium pratense*. Watercolours and bodycolours, by Jacques Le Moyne de Morgues, *c.* 1560. 274×187 mm.

47 *above* Crown Imperial, *Fritillaria imperialis*. Watercolours and bodycolours, by Pieter van Kouwenhoorn, *c.* 1630. 452×320 mm.

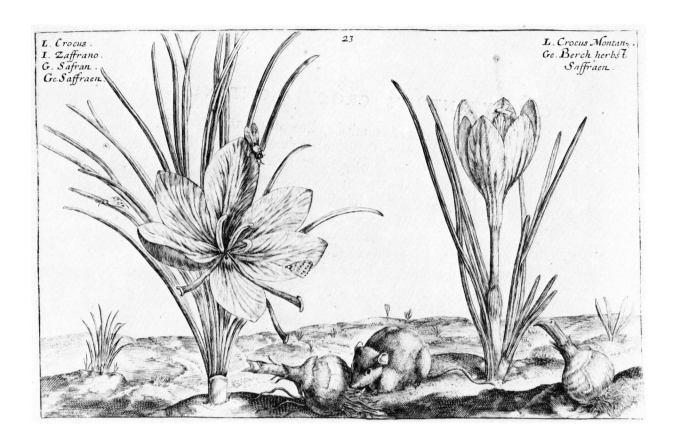

L. Crocus.
I. Zaffrano.
G. Safran.
Ge.Saffraen.

L. Crocus Montan,.
Ge.Berch herbst
Saffraen.

118 *above* Crocuses, *Crocus 'sativus'* and *Crocus 'montanus'*. Line-engraving, by Crispin de Passe, from his *Hortus Floridus* (1614). 133 × 216 mm.

48 *left* Cabbage rose, *Rosa centifolia*. Watercolours, by Jan van Huysum (?). 223 × 175mm.

embellished with insects, snails and other small creatures often with a touch of fantasy (118).

In complete contrast are the plates made at the behest of the newly-formed Académie Royale des Sciences in Paris to illustrate a history of plants. Nicolas Robert (1614–85) was placed in charge of the illustrations of this ambitious work. The choice could hardly have been better for like Ehret a century later Robert instinctively reacted to the refined beauties of plants with the most refined and beautiful drawings. But he also had both the eye and the mind to analyse the finer details of a plant's structure and the artistic flair to express them on paper. In addition he was an etcher of considerable talent as he had already shown in his *Diverses Fleurs* (1660; 119). With Abraham Bosse he set about the immense task of making the plates. A preview of the work was published in Dodart's *Mémoires pour servir à l'Histoire des Plantes* (1675), illustrated with thirty-nine figures nearly all after Robert's designs and many of them etched, occasionally strengthened with engraved lines, by Robert himself. Dodart in the text mentioned his intention of using etching as his printing medium because of its freedom and ability to encompass detail and tone; he would not attempt to introduce actual colour. The work continued long after Robert's death and the numerous plates were published in two volumes in 1701 but without text. The final three magnificent volumes complete with text did not appear until 1788. Unquestionably they represent the best of seventeenth-century printmaking in its application to plant illustration. Robert was the key

119 Madonna lily, *Lilium candidum*. Etching, by Nicolas Robert, from his *Diverses Fleurs* (1675). 200 × 136 mm.

Lilium album

figure in this great illustrative enterprise but the Académie was fortunate enough to employ after his death an even finer etcher, Louis de Châtillon (1639–1734), whose work is wonderfully sensitive (120). Certainly nothing more remarkable than the plates in this work was engraved in the eighteenth century in spite of the tonal refinements later obtained with the copper plate.

It was inevitable that sooner or later attempts to print in colour would be made when exactitude was not possible in the verbal descriptions of plant colours. The earliest attempts to print figures of plants in colour from a single plate is found in John Martyn's *Historia Plantarum Rariorum* (1728–36) and *Catalogus Plantarum* (1730; plate 37) published by the

Society of Gardeners to describe and illustrate recent plant introductions. Jacob van Huysum (*c.*1687–1740) made the drawings for both and these were engraved in the former by Elisha Kirkall and in the latter by Kirkall and H. Fletcher. Certain areas of the plate were roughened in imitation of mezzotint and these held up to three different coloured inks. There was also some touching up of the printed plates with watercolour. The results were somewhat crude and both works were published only in part, failing to pay their way. Later developments in colour printing were more successful but printing techniques rarely if ever equalled the effectiveness of careful hand colouring.

One of the results of the introduction of the Linnean sexual system of plant classification in 1735 was the enormous stimulus given to the production of botanical books. This in turn involved the recruitment of

121

draughtsmen and engravers not only with the required technical skills but also with an understanding of botany.

Of the great number of illustrated botanical works and florilegia which were produced at much expense in the mid-eighteenth century those published by George Ehret (1708–70), or in which he had a part, are among the finest and most characteristic of the technical resources then available. Ehret's unerring sense of design, his colour sense, his enormous talent as a draughtsman and his competence as an engraver, together with his wide botanical and horticultural knowledge, mark him as the outstanding plant illustrator of his time. *Plantae et Papiliones Rariores* (1748–59) was published, designed and etched by Ehret himself and we can therefore judge this to be amongst the best of its kind in that all the techniques at his disposal were controlled by the artist himself. It is clear that at this period publishers were looking more and more towards the possibility of reproducing as nearly as possible an artist's original drawings, colours and all. Clearly, if the artist was at all gifted as an engraver, and coloured the plates himself, something like a facsimile might finally be achieved. To examine, for example, plate 6 of *Plantae et Papiliones* (plate 38) is to understand how well it reveals the qualities in Ehret already mentioned. Add to these the lesser ones of elegance and refinement and it can be realised to what extent his reputation with contemporaries and posterity is justified. But for all their excellence these plates and others for which he was largely responsible, as for example some in Trew's splendid florilegium, *Hortus ... Amoenissimorum Florum* (1748–59), reveal nothing new in printing technique and nothing really in advance of those available to Robert eighty years before. But in answer to the demand of the botanists, whether individual patrons or learned societies, artists, engravers and painters sought new technical means the better to reproduce original drawings from nature. And as the artist's idea of what to observe increased with new knowledge and as new and often more exotic plants were continually being brought into cultivation, his drawings tended to change in character, more emphasis being given to the minutiae of texture and structure. This new conception of what was required of the artist naturally increased the efforts of the engraver and printer to match his efforts with new skills and improved techniques. The way ahead lay in the effective use of methods involving tone. Stipple-engraving, aquatint and mezzotint were all processes used to produce tone rather than line and therefore were particularly suitable for the development of colour printing.

Stipple-engraving, practised in France but much more popular in England with Bartolozzi and his contemporaries, was rather curiously the process employed by Van Spaëndonck, Redouté and their followers to produce some of the most technically accomplished as well as the most beautiful plant portraits ever made. The English school of botanical illustration on the other hand made no use of stipple so widely employed in other kinds of illustration. The process is an extension of etching, using, instead of lines, dots made with the needle or with the 'roulette'. These dots, bitten into the surface of the plate, lightly or more deeply, and spread more or less thickly, print as delicate gradations of tone – a more refined method

121 Celery-leaved rose, *Rosa x centifolia* 'Bipinate'. Stipple-engraving, by Pierre-Joseph Redouté, from *Les Roses* (1817–24). 355 × 260 mm.

of modelling than the traditional cross-hatching and particularly well-suited to the fragile surfaces of petals and leaves. The process had clear advantages for colour printing and in this respect Redouté claimed to have invented the method in 1796. His illustrations to A. P. de Candolle's *Histoire des Plantes Grasses* (1798) are unique in being the earliest examples in plant illustration of the use of stipple for colour printing; there was little retouching by hand. In 1802 Redouté's *Les Liliacées* (plate 39) began publication. Less well-known than *Les Roses* (121), which did not begin to appear until 1817, it was its equal in quality. In both these works the colour printing was sparingly reinforced by hand retouching. Redouté was as fortunate in his connections as in his talents. Without the enormous

123

expenditure disbursed by his patroness the Empress Josephine on her garden at Malmaison, her botanist E. P. Ventenat, her artists and printers, the succession of volumes of plant illustrations would not have been possible. Among the most splendid is Ventenat's *Jardin de Malmaison* (1803–4) with illustrations designed by Redouté. It has been observed that the original work of several of Redouté's contemporaries, the Dutchman Gerard van Spaëndonck (1746–1822) and P. J. F. Turpin (1775–1840), to name two of the most gifted, was at least the equal of Redouté's. But Redouté's tireless energy and ability to organise a team of brilliant stipple engravers and colour printers spread his fame abroad.

As the French school of botanical illustration was advancing the techniques of reproduction to a new level, other tonal processes were being used in England in an even more ambitious way. Aquatint, like stipple, was used with etching. Ways were discovered of fixing minute particles of thickly spread powdered resin to the copper plate. These resist the acid which bites into the spaces between them to give a delicate reticulated pattern. These parts of the plate print as a fine sandy grain which imitates the tones of washes of colour and, exactly as stipple, aquatint was used in printing colour. Mezzotint, the other tonal process, is distinct in that the printmaker works from dark to light. The plate is completely roughened with a 'rocker' so that if inked it would print a velvety black. The surface is then scraped away to give the design in lighter tones, the highlights showing on the print as white. The process was much used in portrait engraving in England and its extension to plant illustration by R. J. Thornton (1768–1837) in his *Temple of Flora* (1799–1807) is illustrative of the heightened romanticism of the time since the subjects could be presented in a strong, searching light. The work, properly called a *New Illustration of the Sexual System of Linnaeus*, set out to be scientific, and the plates included in the third section of the work claimed to show plants in their natural setting. But the distinguished artists employed, Philip Reinagle and Peter Henderson among others, had no special knowledge of botany and the scientific value of the plates is negligible. Visually the large prints are a *tour de force*. The settings are distinctly stagey and the flowers are often shown floodlit against a dark background or a brooding landscape. But further examination of the plates – where aquatint and mezzotint are both employed, often in different plates but sometimes together – makes clear how well the essential character of the plants has been expressed: the stateliness of the tulip (plate 41) where mezzotint is used; the metallic quality of the white lily (122) which is in aquatint; and the sharp-winged fragility of the 'Persian cyclamen' engraved in stipple. The basic colours are printed throughout but the plates have been carefully finished by hand. Much of their effectiveness results from the skill of the mezzotinters and aquatinters, Ward, Earlom and Dunkarton. The project was ambitious to a degree both in scale and in technique and not surprisingly only some twenty-eight plates out of a projected seventy were in fact published. The cost forced Thornton to abandon the work and he was reduced to poverty. But there was one attempt at imitation – Samuel Curtis's extraordinary and very rare *Beauties of Flora* (1806–20) with even larger plates after Clara

122 *opposite* 'The White Lily', *Lilium candidum*. Colour aquatint, by J. C. Stadler after P. Henderson, for R. J. Thornton, *Temple of Flora* (1799–1807). 530 × 400 mm.

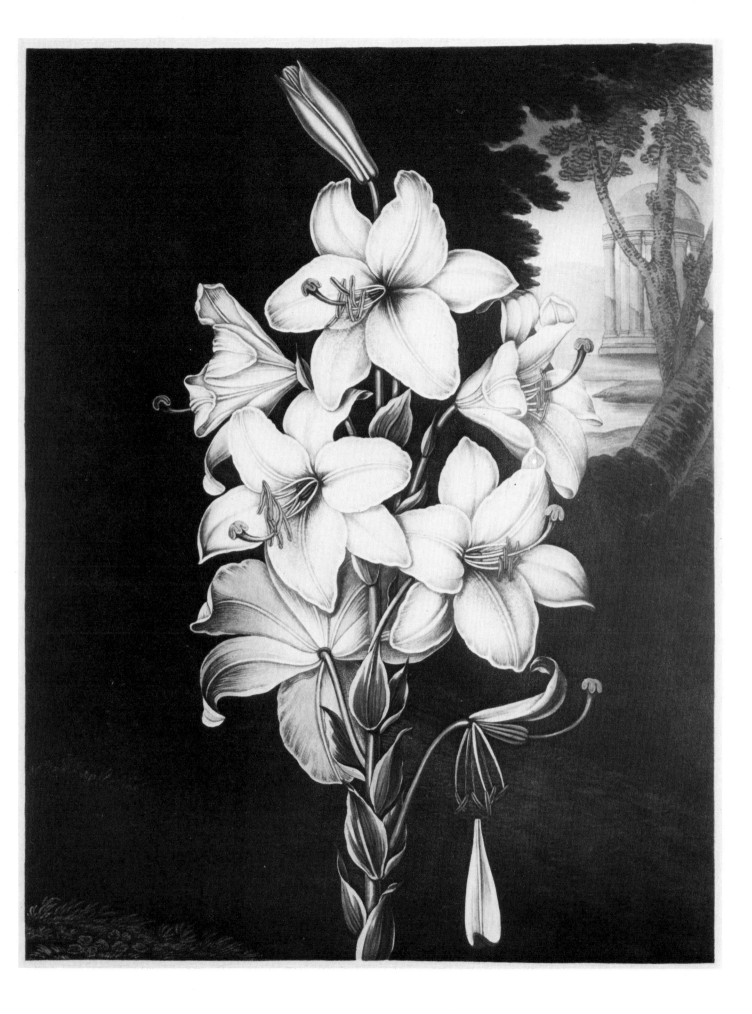

123 Thornapple, *Datura stramonium.* Wood-engraving, by Thomas Bewick after J. Henderson for R. J. Thornton, *A New Family Herbal* (1810). 140 × 120 mm.

49 *opposite* Mallow, *Malva sylvestris*; Common Spiderwort, *Tradescantia virginiana*; *Hibiscus syriacus*; Pot Marigold, *Calendula officinalis*; Knapweed, *Centaurea sp.* Watercolours and bodycolours, by Johann Walther, 1654. 606 × 465 mm.

Maria Pope. But the work was even less of a financial success.

Lithography, discovered and developed by Aloys Senefelder at the end of the eighteenth century, began rapidly to displace engraving because it was comparatively simple and cheap. The principle of the process is the antipathy of grease to water. The drawing is made with greasy ink or chalk on the smooth surface of a piece of porous limestone and 'fixed' with gum water. The surface of the stone is damped and when the printing ink, which is essentially greasy, is applied to it with a roller the drawing takes the ink but the stone rejects it. The obvious advantage of the medium for the artist is that he can draw directly onto the stone (a zinc plate is now more commonly used) and no intermediate craftsman's hand is required to interpret his design. The best lithography can produce extremely delicate qualities of tone and the line is as free as that of a pencil or pen on paper. On the other hand the brilliance and sharpness of the engraved line cannot be matched in the lithograph. Unfortunately the convenience of the process meant that by the middle of the nineteenth century its use was generally considered as essentially reproductive with all the commercial advantages that implied. Quality declined in general but not before a number of books of plant illustrations of real merit were produced, outstanding among them the giant folio volume, *The Orchidaceae of Mexico and Guatemala* (1837–41) by James Bateman with hand-coloured lithographs by M. Gauci. But the Victorian lithographer *par excellence* was Walter Fitch (1817–92) who continued for more than forty years to draw on stone for the *Botanical Magazine* after his own highly competent designs. On occasions he also interpreted in lithographs the field-sketches or finished drawings of others as he did for J. D. Hooker's *The Rhododendrons of Sikkim – Himalaya* (1849–51; plate 40).

Contemporary with the lithograph a more modest printing medium was coming into popular use – the wood-engraving. It was as old as the woodcut but had never been so widely used. It is distinguished from the latter in that the design is engraved into the surface of a hardwood block, usually of end grain boxwood, so that when printed it appears as white lines against a black ground. Thomas Bewick (1753–1828) found it to be the process best suited to his characteristic imagery which was small-scale, linear and precise. His quick eye encompassed the form and markings of birds more successfully than those of plants but he did engrave J. Henderson's plant drawings for R. J. Thornton's *A New Family Herbal* (1810; ill. 123). At first wood-engraving, which Bewick revived and which was soon practised by a school of younger artists, was employed for cheaper productions with small figures in the text; but later it was used for more elaborate illustrations of great virtuosity, often in imitation of the camera to which it finally succumbed when photographic processes of tone reproduction were developed. Before this a number of popular books in England and abroad were illustrated with wood-engravings of considerable technical merit such as W. Robinson's *The English Flower Garden* (1883) and Anton Kerner von Marilaun's *Pflanzenleben* (1887–91; ill. 124). By the last quarter of the nineteenth century photography was being used to transfer the artist's design to the woodblock. When at last fully photographic processes with

51 Garden auricula. *Primula × pubescens* 'Duke of Cumberland'. Watercolours and bodycolours, by George Ehret, 1740. 528 × 362 mm.

50 Viper's bugloss, *Echium vulgare*; Ox-eye daisy, *Leucanthemum vulgare*. Watercolours, by Hans Weiditz, 1529. From a facsimile of the original drawing in the Botanical Institute, Berne. Approx. 390 × 260 mm.

53 Bird-of-paradise flower. *Strelitzia reginae.*
Watercolours. by Francis Bauer, c. 1817.
530 × 365mm.

52 Peacock anemone. *Anemone pavonia*, var.
purpureoviolacea. Watercolours. by Pierre Turpin.
305 × 220mm.

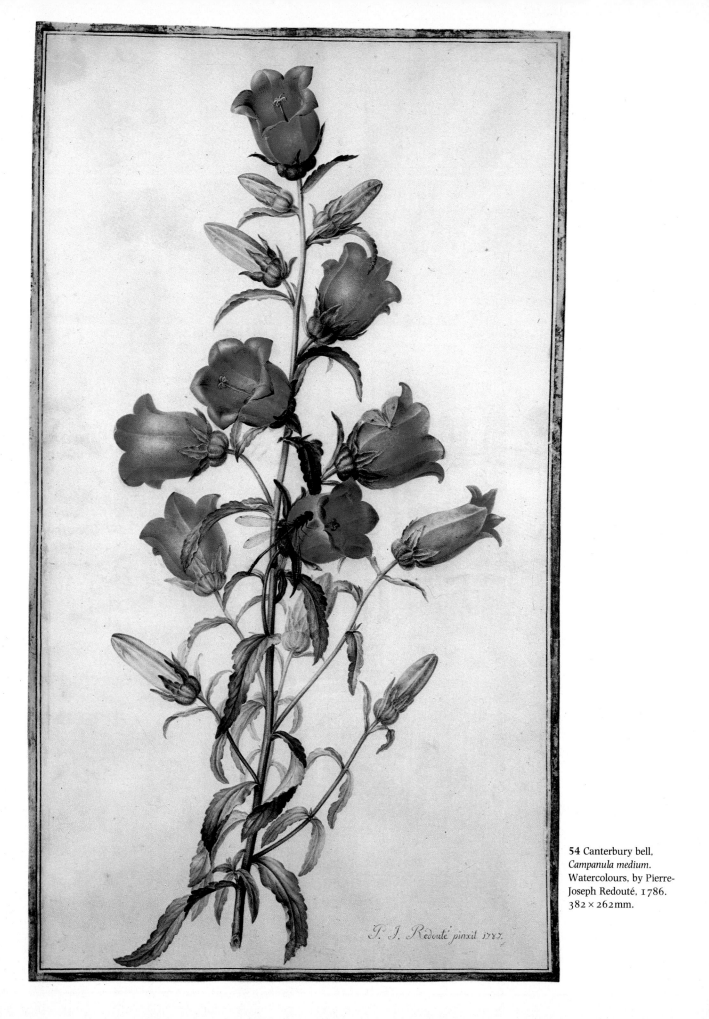

P. J. Redouté pinxit 1787.

54 Canterbury bell,
Campanula medium.
Watercolours, by Pierre-
Joseph Redouté, 1786.
382 × 262mm.

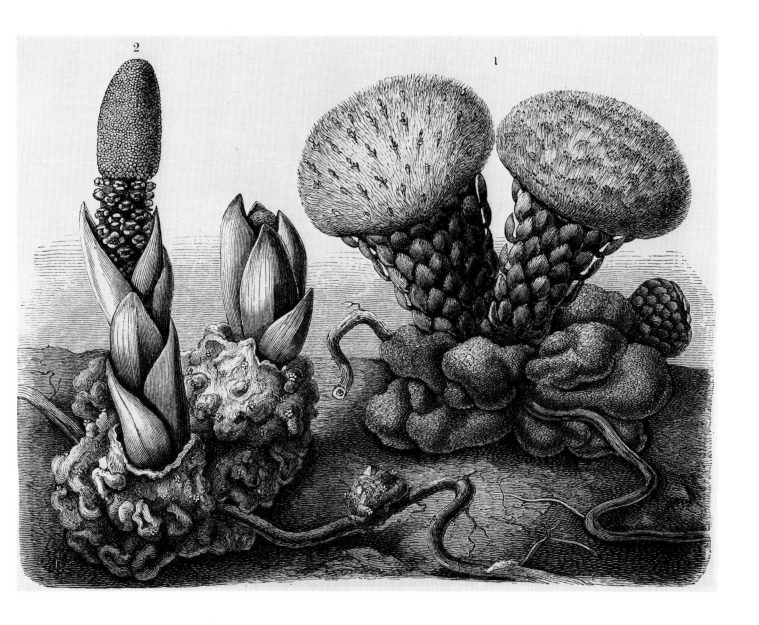

124 *Balanophora hildenbrandtii* and *Scybalium fungeforme*. Wood-engraving, from Anton Kerner von Marilaun, *Pflanzenleben* (1887). 95 × 128 mm.

colour were developed they made possible the most faithful facsimile reproductions of artists' drawings. So hitherto unpublished material could at last be reproduced without the intervention of the engraver.

The full development of photographic processes of reproduction has also freed the older print-making techniques we have described for use by artists and craftsmen who have something particular to communicate about plants and the way they wish them to be presented to the discerning eye. It is unlikely that these techniques will in fact die out so long as there are people who enjoy finely printed designs of whatever kind and are willing to pay the considerable cost of their production.

10
Art and botany

Goethe, an admirer of the best botanical illustration of his day, and of Ferdinand Bauer in particular, distinguished between the task of the contemporary plant draughtsman and that of the flower painter of the old-time florilegium. The latter had only to satisfy the desire of garden lovers to recapture certain superficial beauties while the former had the far more difficult work of portraying the true nature of his subject. His task was even more difficult when for botanical reasons he was required to portray 'the ugliest and most useless' plants. As Goethe implied, there have always been two contrary motives at work in the mind of the plant draughtsman: his instinctive response to the beauty of his subject; and the more disinterested aim of revealing its true physical character. These motives may be found together in the same artist, achieving a sort of balance, while in other artists one or other may be preponderant or be found alone. Often the artist's motive is revealed in the quality of his work and it is perhaps instructive to take a closer look at a few of the drawings of the European artists who, by general consent, are considered to have been particularly successful, and of others less well-known. Before doing so it is interesting to note that Goethe made another distinction when he commended Ferdinand Bauer for his skill in grading tones in his illustrations for Lambert's *Description of the Genus Pinus* (1803–42) by means of which the needles of his pines are seen in true spacial relationship and are not merely reduced to the flat pattern which Goethe considered characteristically 'Chinese'. He is here perhaps overstating the distinction made elsewhere in this book between the Oriental tendency to stress the decorative quality of a plant's appearance in patterns which are essentially two-dimensional and the Western artist's ceaseless efforts to explore its structure.

In Europe not until the sixteenth century was the plant treated by the artist as a subject in its own right though the plant draughtsman was exercising his skills long before this, illustrating herbals to supply means of identification, or decorating the borders of manuscripts. Though, as we have seen, he sometimes produced work of the highest quality, tradition and other factors often severely limited his means of expression. But by the early years of the sixteenth century artists were beginning to explore the world of nature essentially because of the new interest in all its manifestations which at this time was becoming widespread.

Leonardo and Dürer were only the first of a number of talented artists who within the next eighty years or so raised the status of the plant portrait to a new level. Neither artist was motivated by botanical aims as such, yet Dürer's Iris (*Iris trojana?*; plate 10) could almost be taken as an illustration to some much later work on the genus Iris, so well understood is the form, structure and texture of the plant.

There is little in the known work of Hans Weiditz, one of the greatest of German woodcut designers, to prepare us for his drawings of plants which provided the illustrations for Brunfels's *Herbarum Vivae Eicones*. He has nothing of Dürer's outgoing nature and the woodcuts carry no signature, but he is praised as their author by Brunfels in a Latin verse in the preliminaries to the work. The original drawings for the woodcuts were discovered less than fifty years ago in Berne, in the herbarium of Felix

Platter. Some of these watercolour drawings have been finely reproduced in facsimile (plate 50). Clearly, the artist's intention is to give an unpretentious but entirely truthful portrait of each plant. We might call these the first strictly botanical drawings. They are executed with delicacy and precision but freely and simply, with the leaves often wilting, showing that Weiditz portrayed them as they were, taken from the ground some little time before, and made no attempt to reconstruct their more vigorous appearance in growth. Surely Weiditz aimed at as complete and convincing a record as possible and it must be considered doubtful if he would have worked in quite the same way if his purpose had not been scientific and descriptive.

Another plant draughtsman whose aims were entirely botanical was the natural scientist, Conrad Gessner (see p. 29) – if he made most of the drawings intended for his *Historia Plantarum*. Though his field of study was wide, his predilection seems to have been for plants and plant collecting and he made or collected the botanical drawings which at last, after more than four hundred years, are being published in facsimile. They show him, or his unknown co-artist, to have been an accomplished draughtsman and to have understood the physical structure of plants perhaps better than any of his predecessors (plate 14 and ill. 125). What is perhaps more surprising is that they also have considerable artistic merit.

A younger artist, Georg Hoefnagel (1542–1600) of Antwerp, belonged to the same north European tradition by which the search was continued for ever more effective methods of representing the real appearance of the world, man-made or natural. He was a painter and landscape draughtsman of great ability but his finest and most characteristic work is found in his miniatures which are entirely in the Flemish manner. The fact that he was also a jeweller perhaps accounts for his precision and sense of design. The *Missale Romanum* which he executed for the Archduke Ferdinand and the *Four Kingdoms of Living Creatures* for the Emperor Rudolf II are the most famous of his works and contain miniatures and border illuminations of many hundreds of animals, fishes, and flowers. Less well known are his miniatures of flowers in the *Hours of Philip of Cleves* (Royal Library, Brussels; MS. IV 40). He added them to this very small and exquisite volume of miniatures, dating from about 1485, rather more than a century later. The example reproduced of rosebuds (colour plate 11) is painted as if to honour the quality of the older work. It shows at once Hoefnagel's austere sense of design, his feeling for the beauty of form, and his astonishing realism. These rosebuds, emphasised by the shadows they cast, seem in their precision and colouring almost like jewels.

The establishment of botanical gardens in northern Italy about the middle of the sixteenth century considerably increased interest in the nature and culture of plants. Giacomo Ligozzi (*c.* 1547–1626), a native of Verona, was strongly influenced by this new scientific outlook which was shared by his patron, Francesco I, Grand Duke of Tuscany. He was appointed Superintendent of the Uffizi Gallery where many of his natural history drawings are to be found; others are in the University Library in Bologna. In that city and in Florence botanical gardens had recently been

integrā pictā habec in sequente pagina (q̄ in)

148.

sepes iū n̄ expone

mūtagū mit blumē iu grossu ragyū 4 f

founded and Ligozzi doubtless derived from them the stimulus as well as the models for his plant portraits. For they are in a very complete sense portraits (colour plate 45). He first of all drew the outline of the plant very lightly in black lead over which he applied watercolour in long brush strokes, making sure that his shading was correct. He finally drew in the finer details in bodycolour and added the more delicate tonal gradations. He understood the structure of plants as well as any draughtsman before him. As with his zoological drawings Ligozzi's motive was clearly scientific but though he aimed at accuracy his work was executed with consummate artistry.

In some ways the drawings of Jacques Le Moyne de Morgues (c. 1533–88) are in complete contrast. Both before and after the expedition to Florida (see p. 28) he seems to have been occupied in making studies of plants. A large group of his watercolours, which can probably be dated in the early 1560s, are in the Victoria and Albert Museum. These are coolly observed, detached studies of flowers and fruits, all of commonly-grown garden plants, and drawn with the care and small-scale precision of the miniaturist. Some of them derive from earlier manuscript illuminations and have a rather formal quality and undeniable charm, but many others are convincing as portraits from nature (colour plate 46). Other plant studies are executed on vellum with gold or blue grounds with the emphasis on the formal and ornamental. These miniatures seem to be in the direct tradition of Bourdichon. Finally, there is another group of later watercolours dated 1585 in the British Museum which belong to his last years in London. Here the artist is no longer detached in his approach but explores the texture and structure of his plants at close range taking an obvious delight in such details as the bloom on quince fruits, the translucent quality of ripening grapes, and the stigma of the hollyhock (126). For these drawings he composed a sonnet as a sort of prologue which ends with the words, 'la moindre fleurette nous demonstre un Printemps d'immortelles couleurs'. We can share his relish in these minutiae of plant life which he executed with such delicacy and distinction. The objective here was not scientific but the pure delight of recording the often less obvious charms of ordinary plants. From these last drawings Le Moyne designed smaller simplified figures of some of the flowers and fruits which with others of birds and beasts were made into woodcuts (127). These he published in 1586 with a dedication to Lady Mary Sidney, his patroness, and a sonnet, under the title La Clef des Champs. Part bestiary, part florilegium – the earliest printed work of this kind to be produced in England – it was intended as a pattern book for the embroiderer, jeweller and other kinds of craftsmen. It was Le Moyne's last work and a labour of love.

As throughout the seventeenth century new forms of wild flowers were propagated for cultivation in gardens, new bulbous plants from Asia Minor and plants from southern Europe and America brought into northern Europe, the landowners made room for them in newly laid-out gardens. The flower-piece is one reflection of the pleasures of this new horticultural activity and nowhere was it more actively pursued than in Holland. Though the flower-piece is a genre which cannot be discussed here, some of these flower painters have left drawings from nature, though they are less

125 *left Seseli libanotis*, by Conrad Gessner (?). Pen and brown ink and watercolours. From a facsimile of the original in the University Library, Erlangen. 308 × 187 mm.

126 *left* Hollyhock, *Alcea rosea, Althea rosea*, by Jacques Le Moyne de Morgues. Watercolours and bodycolours, 1585, 214 × 140 mm. P. & D., 1962–7–14–1 (25).

127 *right* Cornflower, *Centaurea cyanus* and eglantine, *Rosa rubiginosa*. Coloured woodcuts, after Jacques Le Moyne de Morgues, from his *La Clef des Champs* (1586). Each 70 × 60 mm. P. & D., 162. a. 25.

common than their paintings. Jan van Huysum (1682–1749) was one of the later, more fashionable and sought-after of them, to whom a group of single flower studies in the British Museum can perhaps be attributed. These are quite different in kind from his elaborate drawings of flowers arranged in urns where the compositional element is all important. Here the habit of growth of the individual plant is the artist's concern. They are accomplished with great freedom and astonishing bravura (colour plate 48). Their appeal is immediate and they have perhaps more in common with the virtuosity of Oriental brushwork than with the more scientific products of European plant illustration. Apart from the explorer-artists already discussed there were many other Dutch artists, not necessarily in the first place flower painters, who have left remarkable flower studies: Aert Schouman, the ornithological painter (Fitzwilliam Museum, Broughton Collection), who put his plants into landscapes and depicted their foliage and inflorescences with all the skill and delicacy he employed in his paintings of birds (128); Abraham Bloemart; Adriaen van de Velde and Rachel Ruysch among others.

The painters of florilegia fall into two distinct categories: those who make them for their own pleasure or information; and those who commemorate the beauties of plants in their patrons' gardens by painting them for their patrons' pleasure and fame. In the former we may place the Dutch artist, Pieter van Kouwenhoorn, who painted a volume of flowers, now in the Lindley Library, of great beauty and skill, and of the most surprising maturity, for the early seventeenth century (plate 47) and the Englishman, Alexander Marshall (1639?–82), who made a large number of sheets of extremely beautiful plant studies (Royal Library, Windsor) which in Wilfred Blunt's words constitute 'botanical notebooks' rather than formal compositions but contain far more of the essence of the flower painter's

A. Schouman f.

art than his more formal studies in the British Museum. In the second category of artists we may cite two German plant draughtsmen: Johann Walther (fl. *c.* 1600–79) who painted two volumes of flowers from the garden at Idstein belonging to the Count of Nassau (Victoria and Albert Museum); and Johann Simula who in 1720 painted flowers grown by the Imperial Count of Dernatt (British Museum, Natural History) in which carnations and tulips take pride of place. Walther's two hundred studies are painted with a sensuous delight in colour and form (plate 49). There is a pronounced decorative bias – his botanical understanding is rather less strong – and there are also views of the garden at Idstein with its parterres, statues, and pavilions, as well as a portrait group of the family of the Count of Nassau, the founder of the garden which these sheets so marvellously recreate.

The incentive to record the beauties of flowers in florilegia was, and no doubt always will be, largely instinctive. But long before the time of Linnaeus the skill of the artist in the West was increasingly directed to satisfying a growing public demand for more precise and technical illustrations as aids in identifying newly-introduced plants, or in attempting to classify old-established plant species and their varieties. We have already mentioned the work of the great herbalists in the later sixteenth century. In the seventeenth century the emphasis on scientific illustration grew ever stronger. The French court from the time of Louis XIII and his younger brother Gaston d'Orléans – an enthusiastic botanist and founder of a botanical garden at Blois – patronised artists attached to the Jardin du Roi. A succession of botanically-minded royal patrons, and a long line of artists of talent often subjected to the scrutiny of renowned botanists like Antoine and Bernard de Jussieu and Tournefort, created the ideal conditions for botanical illustration in the strict sense of the term. It was no accident then that in this scientific art the French became pre-eminent. The collection of drawings on vellum, the *vélins*, formerly in the French royal collection, now in the Muséum National d'Histoire Naturelle, is unequalled anywhere for its artistry and range as well as for its scientific interest.

The first great name in the list of artists who worked in the Jardin du Roi was Nicolas Robert (see p. 119). From the *Guirlande de Julie*, an album of flowers exquisitely painted in honour of Julie d'Angennes, daughter of Madame de Rambouillet, and presented to her by her fiancé, the Baron de Sainte-Maure, the artist, now famous, went on to record the plant collection of Gaston d'Orléans at Blois. By 1660 when his patron died Robert had filled five volumes mainly with flower studies. He was then appointed miniature painter to Louis XIV. It is believed that Robert Morison, the Scottish botanist who had been Gaston's superintendent of his garden at Blois, may have persuaded Robert to concentrate on more serious botanical studies. He spent the rest of his days illustrating Dodart's great history of plants, sponsored by the Académie Royale des Sciences, and had made thirty-nine plates for the prospectus and eighty-four for the history itself by the time he died in 1685. These with those executed by Bosse and Châtillon were perhaps the most botanically exact figures of plants produced to that date though unfortunately they were not to be published for very many

128 *left* Joseph's Coat Amaranth, *Amaranthus tricolor*, by Aert Schouman. Watercolours, 382 × 257 mm.

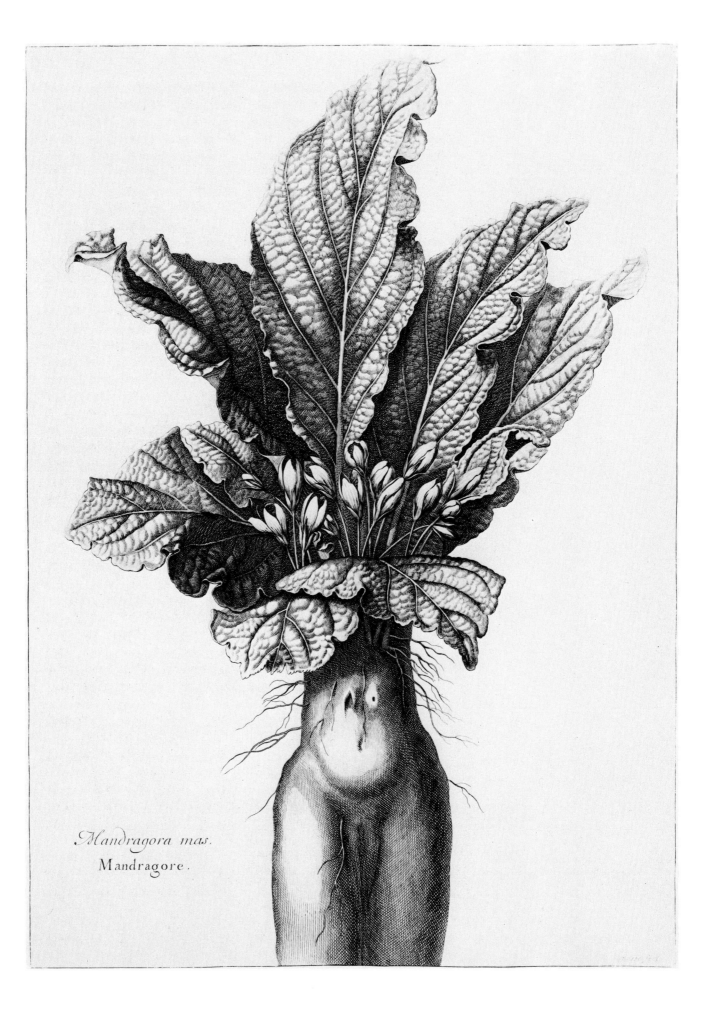

Mandragora mas.
Mandragore.

years. Great care was taken to draw the plants from nature and to indicate scale – where the subject was too large for the plate – by including a detail life size. If the juvenile plant, as often happens, showed distinctive differences from the mature plant, then a figure of it was added to the plate. Seeds and roots were always shown. It is amusing in such an enlightened work to find in the two-volume edition of the plates published in 1701 an engraving of the mandragora where the artist (his name is not given, only that of Bosse the engraver) could not resist the ancient myth and drew its stem and roots beneath ground level in the form of a woman (129). Everything above ground is wonderfully naturalistic. Van Spaëndonck, one of the greatest of plant draughtsmen, who knew Redouté well and the other talented artists of his circle, as well as Ehret, thought these plant figures the finest in existence. Looking through the hundreds of plates we are struck not only by their clarity of detail and technical brilliance but also by the almost uniform excellence of their design so that even if we are not interested in the botanical information they impart we are drawn to them as works of art. Undoubtedly the standard set by Robert made it impossible for anything mediocre or slipshod to pass. A small but interesting feature of the 1701 edition is that the last two plates of Châtillon are influenced by Chinese sources probably indirectly through European prints. In one of these a flowering plum, narcissus and bamboo, complete with Chinese characters, are placed together in un-Chinese fashion in a European landscape. In the other a plum tree in leaf and flower is growing out of a Chinese-looking rock set, however, in a European sand dune. Such exercises in chinoiserie are curious in a work otherwise uninfluenced by current stylistic fashion.

We have already discussed Claude Aubriet in relation to his work as an explorer-artist in Asia Minor. Some years after his return he succeeded to Robert's old post at the Jardin du Roi. Here he seems to have had the time, outside his official duties, to collaborate with botanists on projected books. He made drawings for S. Vaillant's *Botanicon Parisiense* (1727) and others for a book by Antoine de Jussieu which was never completed. But the linear illustrations in monochrome intended for it are kept in the Lindley Library of the Royal Horticultural Society. Their strong outlines and the way they are placed on the page give them an appearance of formality belied by the details which show how completely he understood and observed his plants (130).

If the adoption of Linnaeus's new sexual method of plant classification and his binomial system revolutionized botanical science and occasioned a flood of new books, the ground was already being prepared for such changes. Interested patrons with their newly stocked gardens in many parts of Europe were ready to finance such publications and to attract the right artists to illustrate them; Georg Ehret was one of these. An almost exact contemporary of Linnaeus, he met the great botanist in Holland who showed him his system of plant classification by examination of the stamens. Ehret drew and engraved a table illustrating the system, the original coloured drawing for which is in the British Museum (Natural History). At this time Ehret was commissioned to make drawings for George

129 *left* Mandragora, *Mandragora autumnalis.* Etching, by Abraham Bosse, after Robert (?), from Nicolas Robert, *Plantes* (1701). 410 × 290 mm.

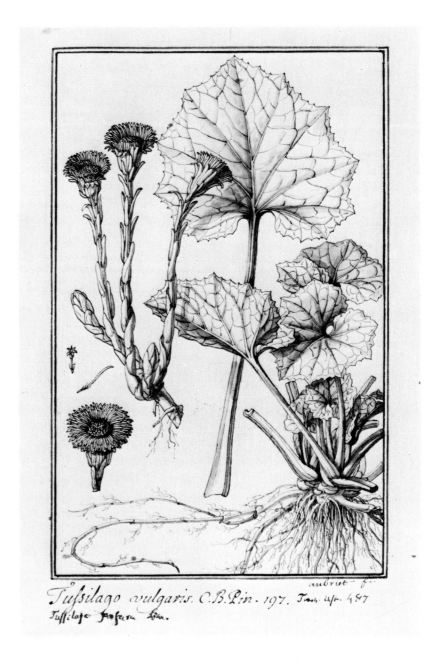

Tussilago vulgaris. C.B.Pin. 197. Tom. alt. 487
Tussilago farfara Linn.

aubriet f.

130 Coltsfoot, *Tussilago farfara*, by Claude Aubriet.
Pen and brown ink, *c.* 1730. Approx.
210 × 137 mm.

Clifford, the rich Amsterdam banker, who had already engaged Linnaeus to supervise his garden.

Linnaeus's *Hortus Cliffortianus* (1738) was not simply a description of the plants in Clifford's garden near Haarlem but the first book in which the new system of classification was used involving as it did a new style of technical description. Ehret contributed the majority of the illustrations. So at the age of thirty he was associated with a work of cardinal importance in the history of botany. Ehret kept up his friendship with Linnaeus for many years but took some offence when he was working for Clifford under Linnaeus's supervision at being considered, as he thought, 'a common draughtsman'. He could hardly have been better qualified to become in fact one of the most

complete plant draughtsmen of any age. He already had considerable horticultural experience and by the time he met Linnaeus had acquired much botanical knowledge, partly no doubt through his patron and life-long friend the physician, Dr Trew of Nuremberg, an ardent botanist and collector of plant drawings. Apart from his outstanding talent as an artist Ehret was deeply committed to the speciality of portraying plants and to no other. England was perhaps best suited to his genius and there in 1736 he settled. At this period many of its landowners and scientifically-minded men of more modest status were enthusiastic gardeners or botanists so that the new theories of Linnaeus and the presence of a botanical artist with some reputation were generally welcomed and given enlightened support. Moreover, with her colonial possessions and extensive trade in Asia and America, England was probably better placed than any country in Europe to promote, through institutions and private individuals, the active cultivation and study of new plants. Ehret sought patronage but on his own terms and judged the portrayal of plants hitherto unknown to him as perhaps his most important work. After a few years he was in touch with many of the best scholars and plant collectors and often had more work than he could properly undertake. Much of it was scientific involving dissections of plants and the use of the microscope. He also contributed to learned journals in England and Germany and on the strength of his botanical knowledge was elected a Fellow of the Royal Society in 1757 and a member of the Imperial German Academy of Naturalists in 1758. But it is probable that Ehret enjoyed his duties as a teacher of plant drawing most of all and was clearly flattered at being pressed to instruct the young ladies of the nobility. One of the houses he visited for this purpose was Bulstrode where he taught the daughters of the Duchess of Portland. Botany was a serious pastime there and Fothergill and Solander were two of the scientists often invited. Mrs Delany, a friend of the Duchess, writes to her niece about this world of writers, amateurs, artists, and naturalists, 'en attendant we have Mr Ehret who goes out in search of curiosities in the fungus way, as this is now their season, and reads us a lecture on them an hour before tea, while her Grace examines all the celebrated authors to find out their classes.'

For all his interest in the scientific aspect of plants we feel that Ehret concentrated his skill as an artist most convincingly on those which he considered the most beautiful. The auricula, one of the varieties known as the Duke of Cumberland (plate 51), is surely one of the loveliest of his drawings. It not only illustrates to near perfection the charms of this particular plant but exemplifies Ehret's technical mastery in expressing both the sturdy, almost coarse quality of the leaves and habit and the extreme delicacy of the colours and texture of the flowers. The marsh pine (131) is intended as a scientific statement but in fact is stylistically one of Ehret's more traditional drawings, evoking something of the directness and completeness of Dürer. Goethe, we feel, would have approved of the way the needles are drawn. Though there is a certain mechanical quality in some of the less attractive plant drawings of Ehret, he is capable of unpretentious sketches of great charm. An album of his work in the Fitzwilliam Museum

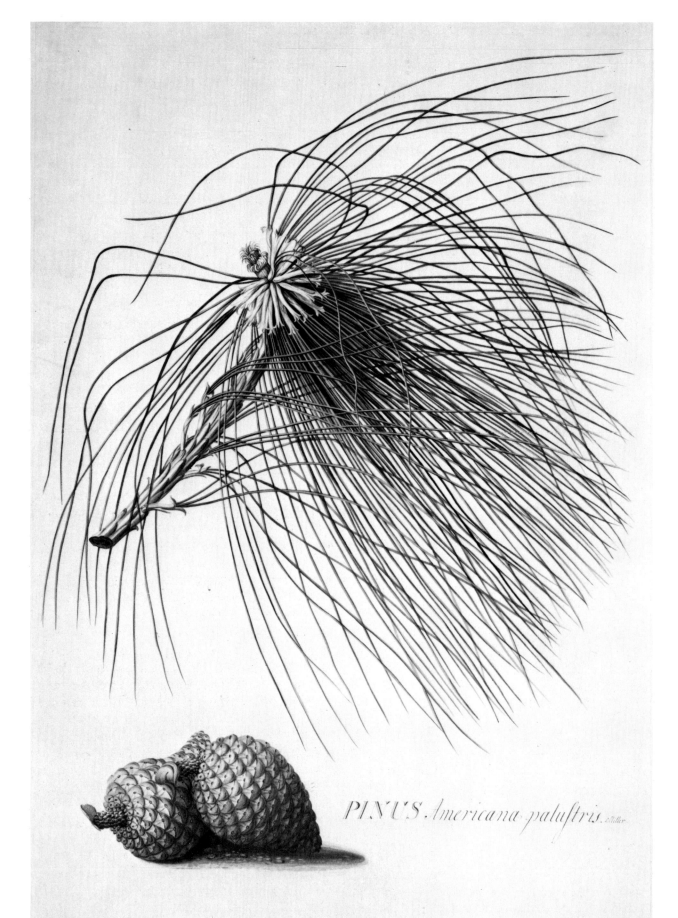

PINUS Americana paluftris. Miller

G.D. Ehret fecit

(Broughton Collection; P D 114–1973) is of this kind, as is a timeless sketch of the rhubarb plant in the British Museum (Natural History) inscribed '*in sua natura*'.

Though the scientific portrayal of plants was by this period *de rigueur*, the old kind of florilegium drawing of the plant beautiful continued to be made, more often now for the artist's own pleasure than for his patron's. T. Robins (1716–70), a little known English artist, possibly with his son, also with the initial T., produced more than a hundred drawings of flowers, many of them recent introductions, which are contained in a volume in the Fitzwilliam Museum (Broughton Collection; P D 115–1973). Though they are by no means unscientific they express above all the delicacy of plants. The medium is mainly transparent watercolour and there is a lightness of touch and a crisp directness of brushwork which makes it difficult to think of them as belonging to the eighteenth century for they contain little of the stylistic mannerisms of the time. These unselfconscious drawings, so difficult to place in any category of style or kind, are nevertheless of such quality that they cannot be overlooked.

Something has already been said about the printed work of Redouté. Its quality and beauty have done much to account for his reputation as the supreme botanical draughtsman. The point has already been made that one or two other artists of his circle were at least his equals artistically in their original work which is only to be fully appreciated in French collections. Van Spaëndonck published only one volume of plant portraits, *Fleurs Dessinées d'après Nature* (c. 1800), of superb quality. He was professor of flower painting at the Muséum and encouraged the young Redouté when he was appointed draughtsman to the cabinet of Marie Antoinette. Van Spaëndonck, much influenced by Jan van Huysum, was himself un-doubtedly a strong influence on the young artist who from the time of his arrival in Paris adopted a similar technique of painting plants in pure watercolour. The strong botanical tradition he found at the Jardin des Plantes certainly had much to do with the strength of his work. Without this scientific element his reputation would certainly have been less secure and his appeal more superficial. His early friendship with the botanist, Charles Louis L'Héritier de Brutelle, was of great importance in this respect. With him he visited England in 1786. The painting of Canterbury bells in the Victoria and Albert Museum (plate 54) was made at this time and exemplifies Redouté's special gifts which were later to win him such renown: a highly developed sense of colour; a natural elegance of style; and a technical efficiency which never deserted him. His stylishness seemed always to match the beauty of his subjects and this element is always to the fore in his drawings. As a botanical illustrator he is not in general the equal of the Bauers or of Turpin, a younger artist at the Jardin des Plantes whom we have already discussed in another context.

Of Turpin, Blunt says his 'drawings of botanical details have rarely been surpassed'. Yet his innate sense of design was such that the scientific element in the drawings seems only to have strengthened and simplified their beauty. His portrayal of an anemone (colour plate 52) comes from a volume of twenty-five highly finished drawings on vellum in the Lindley

131 *left* Longleaf pine, *Pinus palustris*, by Georg Ehret. Watercolours and bodycolours, 537 × 368 mm. P. & D. 1974–6–15–28.

Library. It exemplifies Turpin's ability to provide the botanist with the essential 'characters', executed with the greatest accuracy and finesse, and to produce at the same time a plant portrait of the highest artistic merit.

As we have seen, the enthusiastic but far-sighted patronage of Sir Joseph Banks had much to do with the development of botanical research in England and with it that of botanical illustration. The Royal Gardens at Kew by the end of the eighteenth century were in process of becoming the most advanced centre of botanical research in Europe. Banks was of the opinion 'that the establishment of a botanic garden cannot be complete, unless a resident draughtsman be constantly employed in making sketches and finished drawings of all new plants that perfect their flowers or fruits in it'. Through Banks's influence Francis Bauer was appointed draughtsman at Kew in 1790 and held the post until his death in 1840. Perhaps his most famous published work was Aiton's *Delineations of Exotic Plants* (1796) for which he made the twenty-five plates. He also made the lithographs for his own *Strelitzia Depicta* (1818) which he superbly finished by hand. He shows his particular gifts in the drawing of the bird-of-paradise flower, *Strelitzia reginae*, which he lithographed for his book (colour plate 53); the detail of the large fleshy leaf is admirably drawn and its form and structure clearly expressed. He is no less certain in his handling of the petals and other more delicate parts of his plants. But his success as a draughtsman at the time rested equally on his ability to draw details observed under the microscope for, like Ehret before him, he was a highly skilled botanist. Occasionally in other fields this gift was put to good use. In a series of remarkable drawings he demonstrated for Sir Everard Home the structure of the foot of the common house fly. His reputation both as a draughtsman and botanist was such that his *Exotic Plants* was considered by Banks to have no need of a descriptive text as the accuracy of the drawings to the minutest botanical detail would make this superfluous. But it cannot be said that his scientific motivation in any way robbed Francis Bauer's drawings of their aesthetic appeal. In him perhaps more than in any other plant draughtsman science and art were wonderfully balanced.

Francis Bauer's long tenure of the post of botanical draughtsman at Kew established a tradition which still survives. The work of a succession of artists there is reflected in the pages of the *Botanical Magazine* which was founded in 1787 by William Curtis (1746–99) and has continued publication to the present day. At first Curtis, who had produced two volumes of figures and descriptions of plants within ten miles of London, *Flora Londiniensis* (1777–87) to great acclaim but with mounting debts, devised the journal as a more likely way of making money. The *Botanical Magazine: or Flower-Garden Displayed*, as its first full title suggests, aimed to satisfy a popular demand for illustrations of decorative and exotic plants and to supply advice about their culture. But in keeping with a wider appreciation of botany which developed in the early decades of the nineteenth century, the magazine, when Sir William Jackson Hooker became its editor in 1826, became more seriously scientific. Botanical details were added to the plates and the range of plants covered was considerably enlarged. With Hooker the connection between *Curtis's*

Botanical Magazine (as it came to be styled) and Kew was established and the artists he employed worked there on their drawings. In 1841 he became the first director of the newly nationalised Royal Botanic Gardens and the relationship between periodical, gardens and herbarium, under the same eminent botanist, became still closer.

During the early period of the magazine, before Hooker, two artists figured most prominently in the making of the plates, James Sowerby (1757–1822) and Sydenham Edwards (1769?–1819). Sowerby was a gifted draughtsman, as L'Héritier recognised when he visited England with Redouté, for it was he who seems first to have employed him on botanical work. Sowerby became enormously prolific and his greatest memorial is his *English Botany* which appeared from 1790 onwards and which contained on completion 2600 plates. This enormous work was begun when he was already making some of the plates for the *Botanical Magazine* as well as for later parts of Curtis's *Flora Londoniensis*. He can be an attractive, even distinguished, artist and was a skilled engraver, but mass production is a leveller of quality. Edwards was equally competent and only somewhat less prolific. A close companion of Curtis, whom he invariably accompanied on his botanical expeditions, he designed the great majority of the plates in the *Botanical Magazine* from 1788 to 1815. His drawing of a flax (132) is a representative example of his work and of the usually high standard of illustration in the magazine.

Nothing could be more characteristic of the strictly scientific kind of botanical illustration, issued so prolifically in England during the middle years of the nineteenth century, than the work of Walter Hood Fitch (1817–92). He was discovered by Hooker who held the chair of Botany at Glasgow and trained to botanical illustration by him. He moved with Hooker to Kew but before that was making the plates almost single-handed for the *Botanical Magazine* and continued to do so for about forty years. He soon learned to lithograph. He not only worked for W. J. Hooker but also for his even more distinguished son, Sir Joseph Hooker, as well as for other botanists. Perhaps his most important work was his lithographic illustrations for H. J. Elwes's *Monograph of the Genus Lilium* (1877–80) but he is much more widely known for his illustrations to G. Bentham's *Handbook of British Flora* (1865). The requirements of accuracy and speed, as well as the enormous mass of work he achieved, perfected his technique and his botanical understanding, though at the expense of some sensitivity of line which sometimes appears mechanical. But he was the outstanding European botanical draughtsman of his day with a wonderful facility for drawing plants from dried specimens. In him it might be said that the technical and scientific elements in his work tended to outweigh the considerable artistic element.

This brief survey has necessarily been concerned with the European plant draughtsmen of the past. Though we think of the later eighteenth and early nineteenth centuries as the golden age of botanical illustration it is as well to remind ourselves how vigorous the tradition is today and that it shows no signs of serious weakening. Many fewer botanical monographs with 'original' illustrations are published today but the portrayal of plants,

though declining in quantity since the later nineteenth century, is now probably on the increase. The *Botanical Magazine* since 1948 has ceased issuing hand-coloured plates – a late survival from an earlier age – but retains in general the quality of its illustrations with good colour reproduction. Lilian Snelling (1879–1972) and Stella Ross-Craig (b. 1906) were two of its principal artists in the earlier and middle years of this century, the former combining elegance with botanical accuracy in her watercolours, the latter somewhat similar in her watercolour technique and notable in the precision of her black and white line illustrations. She is best-known for her *Drawings of British Plants* (1948). Margaret Stones (133) is representative of the high standard of draughtsmanship achieved today. Apart from her plates in the *Botanical Magazine* she has illustrated W. Curtis's, *The Endemic Flora of Tasmania* (1967–78). Her handling of the minutiae of botanical detail is indicative of unusual powers of observation and a highly effective technique. She has a strong sense of design and shows clearly in her work that she is aware of her place in a long European tradition. A watercolour drawing she made of a miniature daffodil, *Narcissus bulbocodium*, in watercolours on vellum, in technique and style and the way it is placed on the sheet is reminiscent of a master such as Le Moyne. It is plain that the work of the contemporary botanical draughtsman, who has an intelligent understanding of the artistic achievements of the past, can sometimes bear comparison with some of the finest productions of past masters.

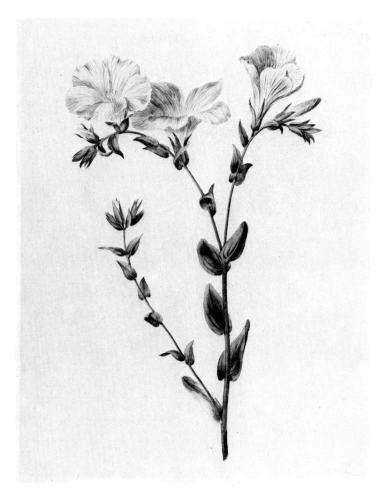

132 *right* Blue and white flax, *Linum ascyrifolium*, by Sydenham Edwards. Watercolours, 1807. For *Curtis's Botanical Magazine*, no. 1087. 255 × 180 mm.

133 *Opposite* Sunflower, *Helianthus annuus*, by Margaret Stones. Watercolours, 1973. 520 × 370 mm. P. & D., 1974-2-23-9.

Bibliography

EUROPEAN SECTION

Some books of particular relevance to the work of artists mentioned, and others of general interest.

Anon. 'Sir Arthur Church's collection of botanical drawings', *Kew Bull.* London, 1916, pp. 162–8.

Arber, A., 'The draughtsman of the *Herbarum Vivae Eicones*', *J. Bot. London*, LIX. London, 1921, pp. 131–2.

Arber, A., *Herbals, their Origin and Evolution.* 2nd ed. Cambridge, 1938.

Arber, A., 'Goethe's botany', *Chronica Botanica*, x. Leyden, 1946, pp. 63–126.

Blunt, Wilfrid, *The Art of Botanical Illustration.* London, 1950.

Blunt, Wilfrid, *Tulipomania.* Harmondsworth, 1950.

Calman, Gerta. *Ehret, Flower Painter Extraordinary.* Oxford, 1977

Camus, J. 'Les noms des plantes du Livre d'heures d'Anne de Bretagne.' *J. Bot. Paris*, VIII. Paris, 1894, pp. 325–35, 345–52, 366–75, 396–401.

Coats, Alice M., *The Book of Flowers. Four Centuries of Flower Illustration.* London, 1973; 2nd ed. 1974.

Coats, Alice M., *The Treasury of Flowers.* London, 1975

Curtis, Winifred and Stones, Margaret (illustrator), *The endemic Flora of Tasmania.* 6 vols. London, 1967–78.

Delany, M., *The Autobiography and Correspondence of Mary Granville, Mrs Delany.* London, 1861–62.

Delisle, L. V., *Les Grandes Heures de la Reine Anne de Bretagne.* Paris, 1913.

Dunthorne, G. *Flower and Fruit Prints of the Eighteenth and early Nineteenth Centuries.* London, 1938.

Ehret, G. D., 'A memoir of Georg Dionysius Ehret ... written by himself'. *Proc. Linn Soc. London*, 1894–95, pp. 41–58.

Evans, J., *Nature in Design.* Oxford, 1933

Giglioli, O. H., 'Giacomo Ligozzi'. *Dedalo*, IV. Milan, 1924, pp. 554–70.

Hamy, E. T., 'Jean le Roy de la Boissière et Daniel Rebel'. *Nouvelles Archives du Muséum*, 4th ser., III. Paris, 1901, pp. 1–120.

Hatton, R. G., *The Craftsman's Plant-book.* London, 1909.

Hulton, Paul and Quinn, David B., *The American Drawings of John White.* 2 vols. London and Chapel Hill, 1964.

Hulton, Paul, *The Work of Jacques Le Moyne de Morgues.* 2 vols. London, 1977.

Mâle, E., *Les Heures d'Anne de Bretagne.* Paris, 1946.

Nissen, Claus, *Die Botanische Buchillustration. Ihre Geschichte und Bibliographie.* 2 vols. Stuttgart, 1951, *Supplement*, 1966.

Pächt, O., *The Master of Mary of Burgundy.* London, 1948.

Pächt, O., 'Early Italian nature studies'. *J. Warburg and Courtauld Inst.*, XII, nos. 1–2. London, 1950, pp. 25–37.

Popham, A. E., *The Drawings of Leonardo da Vinci.* London, 1946.

Savage, Spencer, 'The discovery of some of Jacques Le Moyne's botanical drawings'. *Gardeners' Chronicle*, 3rd ser., LXXI. London, 1922, p. 44.

Savage, Spencer, 'The "Hortus Floridus" of Crispijn vande Pas, the Younger'. *Trans. Bibliogr. Soc.*, 2nd ser., IV. London, 1923, pp. 181–206.

Savage, Spencer, 'Early botanical painters', *Gardeners' Chronicle* 3rd ser., LXXIII. London, 1923, pp. 92–3, 148–9, 200–1, 336–7.

Singer, C., 'The herbal in antiquity and its transmission to later ages'. *J. Hellenic Studies*, XLVII. London, 1927, pp. 1–52.

Smith, Bernard, *European Vision and the South Pacific.* London, Oxford, New York, 1960.

Sprague, T. A., 'The herbal of Otto Brunfels' *J. Linn. Soc. Bot. London*, XLVIII London, 1928, pp. 79–124.

Stearn, W. T., 'Kaempfer and the lilies of Japan'. *Roy. Hort. Soc. Lily Year Book*, XII. London, 1949, pp. 65–70.

Stearn, W. T., 'Botanical exploration to the time of Linnaeus'. *Proc. Linn. Soc. London*, 169 Session, 1956–57, Pt. 3. London, 1958, pp. 173–95.

Synge, P. M., 'The "Botanical Magazine"'. *J. Roy. Hort. Soc.* LXXIII. London, 1948, pp. 5–11.

Wade, A. E., *Plant Illustration from Woodcut to Process Block.* Cardiff (Nat. Mus. of Wales), 1942.

Wegener, H., 'Das grosse Bildwerk des Carolus Clusius in der Preussischen Staatsbibliothek.' *Forschungen und Fortschritte*, Berlin, XII. Berlin, 1936, pp. 374–76.

Wijngaert, F. van den., 'De Botanische Teekeningen in het Muséum Plantin-Moretus. *De Gulden Passer Antwerp*. XXV. Antwerp, 1947, pp. 35–41.

Winkler, F., *Die Zeichnungen Albrecht Dürers.* 4 vols. Berlin, 1936–37.

ORIENTAL SECTION

Principle books in Western languages.

Akiyama, Terukazu, *Japanese Painting.* Geneva, 1961.

Archer, Mildred, *Company Drawings in the India Office Library.* London, 1972.

Archer, Mildred, *Natural History Drawings in the India Office Library.* London, 1962.

Bartlett, H. H. and Shohara, Hide, *Japanese Botany During the Period of Wood-block Printing.* Los Angeles, 1961.

Bush, Susan, *The Chinese Literati on Painting.* Cambridge, Massachusetts, 1971.

Cahill, James, *Chinese Painting.* Geneva, 1960.

Cahill, James, *Painting on the Shore. Chinese Painting of the Early and Middle Ming Dynasty, 1368–1580.* New York, 1978.

Chibbett, David, *The History of Japanese Printing and Book Illustration.* Tokyo and New York, 1977.

Edwards, Richard, *The Art of Wen Cheng-ming.* Ann Arbor, Michigan, 1976.

Ettinghausen, Richard, *Arab Painting.* Geneva, 1962.

Fong, Wu and Fu, Marilyn, *Sung and Yüan Paintings.* Metropolitan Museum of Art, New York, 1973.

Gray, Basil and Barrett, Douglas, *Indian Painting.* Geneva, 1963.

Gray, Basil, *Persian Painting.* Geneva, 1961.

Grube, Ernst, 'Materialen zum Dioskurides Arabicus' in *Aus Der Welt Der Islamischen Kunst* (Ed. R. Ettinghausen). Berlin, 1957.

Hillier, Jack, *The Uninhibited Brush. Japanese Art in the Shijō Style.* London, 1974.

Hillier, Jack, *Hokusai.* London, 1955.

Hillier, Jack, *Utamaro.* London, 1961.

Impey, Oliver, 'Watanabe Shikō: A Reassessment' in *Oriental Art.* London, Winter 1970.

Lee, Sherman, *The Colours of Ink.* New York, 1974.

Mitchell, Charles, *The Illustrated Books of the Nanga, Maruyama, Shijō and Other Related Schools of Japan. A Bibliography.* Los Angeles, 1972.

Mizuo, Hiroshi, *Edo Painting: Sotatsu and Korin.* Tokyo and New York, 1972.

Sirén, Osvald, *The Chinese on the Art of Painting.* New York, 1963.

Takeda, Tsuneo, *Kanō Eitoku.* Tokyo and New York, 1977.

Tschichold, Jan, *Die Bildersammlung der Zehnbambushalle.* Zurich, 1970.

Yashiro, Yukio, *2000 Years of Japanese Art.* London, 1958.

Yonezawa, Y. and Yoshizawa, C., *Japanese Painting in the Literati Style.* Tokyo and New York, 1974.

Indexes